LOOKING AT
PAINTINGS

To the memory of my father

LOOKING AT
PAINTINGS

A PRIVATE VIEW

RICHARD COTTRELL

MURDOCH BOOKS

To me Art's subject is the human clay
And landscape but a background to a torso
All Cézanne's apples I would give away
For one small Goya or a Daumier

W.H. Auden, *Letter to Lord Byron III*

CONTENTS

INTRODUCTION

There are many books about painting, most of them written by experts. They may be experts in a period, in a school of painting, a style of painting, or the work of a particular artist, but they're usually academically qualified art historians. I am not an expert and this is not that kind of book.

Painting was not, initially, the passion it has become for me. If I gave pictures any thought at all it was to dismiss them as 'boring'. But in my teens my father dragged me to an exhibition of Impressionist paintings. I can hear him saying to me, 'Go in close, old boy, and then move back slowly.' And when I did this and gradually the hodge-podge of dots and lines and daubs of colour resolved themselves into an achingly beautiful landscape by Monet or Van Gogh or Seurat, I was intrigued, amazed, struck dumb: how did that man know those splodges (or those myriad little vari-coloured dots in Seurat's case) would look like that when the viewer took a step back and then another and another and … from the canvas? Painting suddenly revealed itself to be something out of the ordinary, a mystery, an adventure, a window to somewhere else.

There's a lot of fun—and excitement—to be got from looking at pictures. And the longer you look, the more carefully you look, as you realise how and why the artist has done what he or she has done, the more you find yourself on a journey of discovery. Our attention span in the 21st century is shorter than it used to be: everything has to be instant, immediately appreciable, 'bite-sized'. This has resulted in the 'dumbing down' of art, often by well-intentioned arts practitioners. In the theatre, plays have become shorter and authors who can write an extended scene are disappearing. In the cinema, very fast cutting demands that audiences switch focus rapidly. In television, commercial breaks oblige the viewer to disengage continually.

But art, whatever the medium, isn't that easy. It needs our time and our attention if we are to approach the artist's goal. A play by Tom Stoppard—who can write an extended scene, of course—has to be listened to actively, as does a symphony by Mozart. To get the most out of a painting, you have to stop and look at it—stop moving, pause, and look. The picture has to be given the chance to do its work, to come to you and tell its story. It can't manage this in 'bite-sized' fragments.

What is an artist? Pablo Picasso, who lived for 92 years, worked in every visual medium, and revolutionised Western art with the invention of Cubism, said, 'Every child is born an artist. The problem is keeping the artist alive when the child grows up.' Children play; children are inquisitive, curious; they have a sense of wonder; explore fearlessly; children are difficult and wayward. The child remains with us as we grow up, stays inside us. But most of us suppress him. Then we stop being artists.

In Arthur Miller's play *A View from the Bridge*, the lawyer, Alfieri, says, 'Most of the time now we settle for half and I like it better.' But the artist, not having suppressed the child, doesn't settle for half, demanding that life be a continuous journey of search, discovery, change and development. The child sees to that, difficult, anti-social and impossible though its adult may be. In another American play, Tennessee Williams' *Camino Real*, Lord Byron says, 'Make voyages. Attempt them. There's nothing else.' Most artists would relate to that. Paul Cézanne, at the end of his life when he had achieved fame if not fortune, wrote, 'You always

think you've got it but you haven't … I could paint for a hundred years, a thousand years without stopping and I would still feel as though I knew nothing.'

Many other painters have written about the continual struggle to get it right, but dedication does not necessarily bring fame or wealth or happiness. Vincent van Gogh, whose canvases are sold for many millions today, only sold one painting during his life; Alfred Sisley, the devotee of landscape, his family ruined by the Franco–Prussian War of 1870–71, died unrecognised and in poverty; Rembrandt, perhaps the greatest of all painters, went out of fashion and was declared bankrupt; Francisco Goya and Jacques-Louis David, both revolutionaries in their way, ended their lives in exile; Edgar Degas, one of the most perceptive observers of human behaviour, went blind.

Art is a political statement, whether conscious or not, because it cannot but be a comment on the world in which the artist lives. This applies equally to pictures such as landscapes or still lifes or abstracts, because the way in which the artist paints reflects the time in which he or she lives.

Art changes constantly: one way of looking at the world becomes outmoded or irrelevant so there is a continual state of revolt. It is a natural, evolutionary process. Sometimes you can see it coming: for instance, the number of colours Delacroix used to produce a drop of water—red, yellow, blue, green, white—leads straight to the experiments of the Impressionists and of Seurat. Sometimes it bursts upon an astonished world like the proverbial lightning out of a clear sky, and there have been few revolutionary explosions to match the impact of Picasso's *Les Demoiselles d'Avignon* in 1907. Acceptance of the new is generally gradual. Revolutionary artists naturally have a difficult time gaining recognition: the avant-garde is, by definition, 'caviar to the general', as Hamlet describes an unsuccessful play. Pissarro was 67, Cézanne 56 before their achievements were recognised. Matisse and Picasso had an easier time of it but early works of both aroused cries of outrage from critics and public alike. Yet Vermeer, with the calm of his domestic interiors, and Gainsborough, with his celebration of the landed gentry, mirrored their times just as much as these more controversial artists or Francis Bacon and Jackson Pollock did in the turbulent twentieth century.

'If it appeals to our sense of beauty, we may look at it for a long time without needing to know what it represents or what story it is telling. It can be enough just to be there, to take it in. Then the picture can reach out to us, can reveal its story.'

Initially, all an artist has to do is excite our curiosity: 'Hey, what's this? What's going on here?' A painting can do this by shape and colour alone, and this is as true of Kandinsky as of Caravaggio, of Klee as of Corot. More than this, it can be the way in which the colours or shapes are arranged: as true of the Dadaist collages of Picabia as of the seventeenth-century idylls of Poussin, as true of the Cubism of Picasso as of the Mannerism of Pontormo. If the painting is figurative, an image of something real, questions arise such as 'Where is this? Who is this person, these people? What's happening, what's the story?'

But we won't look for very long if the painting doesn't also appeal to us on another level, deeper than that of mere curiosity. If it appeals to our sense of beauty, we may look at it for a long time without needing to know what it represents or what story it is telling. It can be enough just to be there, to take it in. Then the picture can reach out to us, can reveal its story. But in art, as in life, the perception of beauty is a highly subjective affair. So the fact that, for instance, one may prefer Fragonard to Boucher, Chardin to Greuze, Miró to Kandinsky means only that; it's an individual response.

Like a conjuror or a magician, an artist creates a window where before there was only a wall. Something takes place between the painter and the spectator: through that window we're invited to share a journey, to go somewhere else. It can be dangerous, that somewhere else, comical, saddening, calming, sexy, terrifying but, whatever else, it will be something that holds our attention, something that is, in the broadest sense, enjoyable.

I've been working as a director in the theatre for 40 years and when I became aware of how much I could learn—was, indeed, learning—from painting that would relate to my own work, I began taking notes when I visited museums and art galleries. Studying the composition of a picture, working out how the artist directs the viewer's attention, taught me, and still does, about grouping, the use of colour, the focus of light. Often a chance encounter with the work of a particular artist has helped me find my way into a play. Painting has been a trigger, helping me to understand what I think an author is trying to say.

In the course of writing this book, I came to realise that as a theatre director I've been painting myself too, albeit in a very crude way: learning that to put an actress in a red dress in a red room will make her disappear, or that a blue band around the neck to echo the blue in a dress and shoes will complete the picture of an eighteenth-century lady is, in a sense, painting. So is placing a group of actors in such a way that the audience is directed at whom to look.

The 55 pictures painted by 20 artists from 25 museums around the globe described hereafter are an eclectic bunch culled across 600 years, from Botticelli's *Venus and Mars* (1485) to William Robinson's *Dome of Space and Time* (2004). From the fifteenth century come Cranach, Carpaccio, Botticelli and Bartolomeo Bramantino; from the sixteenth century, Bronzino, Titian, Tintoretto and Caravaggio; from the seventeenth, Rembrandt and Hals; Fragonard from the eighteenth century; Goya, Manet, Seurat, Cézanne and Pissarro from the nineteenth; and from the twentieth, Picasso, Sidney Nolan, Russell Drysdale and William Robinson.

Some of the paintings are of religious, Christian subjects, such as Caravaggio's *Supper at Emmaus* and Bramantino's *The Resurrected Christ*; some depict mythological or pagan stories,

such as Botticelli's *Venus and Mars* or Titian's *Diana and Actaeon*; some are portraits: Rembrandt's *Man with a Magnifying Glass* and *Woman with a Pink*, Seurat's *La Poudreuse* and Drysdale's *Joe* and *Maria*; some landscapes, as with the Nolan and Robinson paintings. Many of the artists painted pictures far better known than those included here—my choice has been dictated by paintings that have fired my imagination.

I have given myself two rules: to write only about pictures and artists I love, and not to write about any picture I have not actually seen in the original. Just as there's no substitute for live theatre, opera, music or ballet, so even the best reproduction of a painting is only a poor stand-in for the real thing. One can examine a reproduction with pleasure and attention but the picture cannot speak to you.

But poetry, prose, music and drama all make an appearance in these pages too: just as the playwright William Congreve 'could never look long upon a monkey, without very mortifying reflections', so I rarely look at a picture without some literary reference in relation to it coming into my head. Art is to me what a madeleine biscuit was to Proust: it summons up a line of prose or verse, a sound, a memory from some other discipline.

The essays can be read in any order for this is not an academic treatise. If you say, 'Who on earth is Bramantino?' and then find out; if you read the Fragonard piece and think, 'Next time I'm in New York, it's The Frick Collection first stop'; if you exclaim, 'Wow, these Australian painters are amazing!' then I'll be fulfilling my aim in writing this book: to share something I find absorbing and exciting.

The reason that painting can inform us, entertain us, stir us deeply is that although schools of painting come in and out of fashion, human nature doesn't change. So Tintoretto's *The Crucifixion of Christ* will never be irrelevant any more than the plays of Shakespeare will. Because little boys will cry when they're stung by a bee, we can relate to Cupid in Lucas Cranach's picture; we can smile at the burgeoning of love in Fragonard's *The Lover Crowned* and stand appalled at the horrors in Picasso's *Guernica*. A picture may have been painted 600 years ago or only yesterday but we are looking at it because art is about us, now.

A HIGHLY ABBREVIATED HISTORY OF WESTERN ART

IF YOU THINK THIS CHAPTER LOOKS LIKE BEING HEAVY GOING, FEEL FREE TO SKIP IT AND GO DIRECTLY TO THE PAINTINGS.

The beginning of Western art as we know it was enabled by the patronage of the Christian Church. While few significant religious paintings appeared after the end of the seventeenth century, great works of art were created from the thirteenth century on for some 400 years. The Church was the major and almost the only patron until the fifteenth century. So artists, some of course inspired by their faith, others by their need to eat, created mostly religious paintings.

Alexander Pope, in his 1733 *Essay on Man*, wrote:

Know then thyself, presume not God to scan
The proper study of mankind is man.

Painters had understood this essential truth long before and humanity puts in an appearance with the work of Duccio (1255–1319) and Giotto (1266–1337). The waxen, Byzantine, icon-like images of earlier painting disappeared and recognisable human beings took their place. One might say that this is the first evolutionary, if not revolutionary, movement in art. By the end of the fifteenth century, the first secular paintings appear with the portrait, such as *Portrait of Lionello d'Este* by Antonio Pisanello (1397–1455). The widening of the range of non-religious art continues in the battle scenes of Paolo Uccello (1396–1475), the allegories of Sandro Botticelli (1445–1510) and the pagan, mythological works of Antonio del Pollaiullo (1433–98). Next, with Tommaso Masaccio (1401–28) and Andrea Mantegna (1471–1506) we see the arrival of perspective, which might be defined as a believable way of creating three-dimensional illusions on a two-dimensional surface.

From this grew the High Renaissance, the era of some of painting's greatest heroes, Leonardo (1452–1519), Michelangelo (1475–1564) and Raphael (1483–1520). This extraordinary period was characterised by a luminous physical perfection in an idealised depiction of the human body, and a sense of harmony between man and nature. We can see this very clearly in such famous works as Leonardo's *The Virgin of the Rocks* and Michelangelo's masterpiece, the huge frescos decorating the Sistine Chapel.

Then, in the sixteenth century, a new school of painters arose, led by Jacopo da Pontormo (1494–1557), his adopted son, Agnolo Bronzino (1503–72) and Parmigianino (1503–40). These artists saw life in a less idealised, less secure way. Mannerism, as it is now called, questioned the perfection of the world, and distorted the human figure to express man's inner anguish. Its apotheosis was reached in the tortured, etiolated figures of El Greco (1541–1614) or the fantastical realism of Giuseppe Arcimboldo (1527–93) with his faces constructed out of vegetables or fish or flowers.

Art, in the many petty states of which Italy was made up, tended to be localised. Although the 'star' artists would accept commissions and travel from Rome to Venice to Milan to Florence, a megastar like Titian (1488–1576) would accept commissions from the King of Spain but execute them at home in Venice,

where over the next 100 years a string of major painters appeared—Giovanni Bellini, Vittore Carpaccio, Giorgione, Paulo Veronese and Jacopo Tintoretto.

The art of painting was not confined to Italy of course, as the inclusion of El Greco, a Greek from Crete who worked in Spain, implies. In France—dubbed 'Mother of the arts, of arms, of laws' in the sixteenth century by one of my favourite poets, Joachim du Bellay—no really great works were created, apart from the idyllic, classical landscapes of Nicolas Poussin (1594–1665) and Claude Lorrain (1600–82), until the eighteenth century, when art in Italy went into relative decline. But in the fifteenth and early sixteenth centuries, northern Europe produced major painters: Jan van Eyck, Roger van der Weyden, Hans Memling and Jerome— better known as Hieronymus—Bosch. They were followed by Albrecht Dürer (1471–1528), the Cranachs, father and son (1472–1553), and the Breughels, also father and son (1525–69)—though in both cases the father is incontestably the more important painter. The elder Breughel's many paintings of peasant life—earthy, vigorous, ribald, 'warts and all'— were a new and only temporary departure to which painting didn't return until Jean-François Millet (1814–75) found an unsentimental poetry in the life of the agricultural labourer.

Until the sixteenth century, communication and travel were both difficult. Then advances in printing techniques made reproductions of artworks possible and these were widely disseminated; the roads became considerably safer and art became more international. Sir Peter Paul Rubens (1577–1640) criss-crossed Europe between Holland, Spain and England. At this time, too, the status of the artist rose and the travelling superstars were used for diplomatic as well as artistic purposes: for negotiating a treaty between Spain and England, Rubens was knighted by Charles I.

Michelangelo Merisi da Caravaggio (1571– 1611), whose paintings range from the intensely religious to the homoerotic, was one of the greatest artists of the time and hugely influential. With his unsparing realism, he led the reaction against Mannerism. He was also enormously innovative in his use of light. Even Rembrandt van Rijn (1606–69) in Holland learned from him, as did Diego Velasquez (1599–1660) in Spain and Georges de la Tour (1593–1652) in France. His influence extends across the centuries to the English painter Joseph Wright of Derby (1754–97).

The seventeenth century was the golden age of Holland, not only politically but artistically: in addition to Rubens and Rembrandt, the major artists were Frans Hals, Johannes Vermeer and Jacob Ruisdael. While Vermeer, like many others, owes something to Caravaggio, his triumph is less the source of light, which is Caravaggio's major and dramatic achievement, than in what happens to light in the picture. Vermeer's paintings—not many survive—are distillations of a moment in time, often domestic interiors, very rarely landscapes, not so much frozen as preserved in a lucent quietude. And he's a wonderful insinuator of the story before and after the moment on the canvas.

The eighteenth century produced the first notable English painters, largely society portraitists, Sir Thomas Gainsborough, Sir Joshua Reynolds and Sir Henry Raeburn, as well as the landscapes of John Constable. But

'Though artists are often represented as people with their heads in the clouds, art is never divorced from the world around it …'

the greatest art of the period is French: Jean-Antoine Watteau, Jean-Honoré Fragonard, François Boucher and Jean-Baptiste-Siméon Chardin. Chardin painted scenes of middle-class life, domestic, below stairs, mainly women and children: clear, truthful, deeply engaging, entirely unsentimental. The other three celebrated the world of the court and the boudoir, a privileged, licentious way of life that was soon to disappear forever. Watteau's paintings of travelling actors and *fêtes galantes* have about them an autumnal sadness as if he knew of the coming Revolution.

With that seismic event, art in France changed and the cold, clear light of Jacques-Louis David (1745–1825), the official artist of the Revolution, with his politically themed scenes of the struggle for liberty in ancient Rome, came in. David's most famous picture, however, is the record of a contemporary event: the death of Marat, one of the leaders of the Revolution, murdered in his bath by the Royalist Charlotte Corday. With

David's enormous canvas of Napoleon's coronation in 1804, which was followed by other huge pictures celebrating Napoleon (who said, 'Nothing is beautiful unless it is large') by David's contemporaries Antoine Gros, Eugène Delacroix and Théodore Géricault, we move almost imperceptibly from Neo-Classicism—so called because of the artists' admiration for ancient Rome and Greece, as exemplified by the work of David and Jean-Auguste-Dominique Ingres (1780–1867)—to Romanticism.

Here the past begins to touch the modern world. In old age, Ingres counselled Edgar Degas (1854–1917): 'Draw lines, young man, draw lines from nature and memory.' Camille Pissarro (1830–1903) was a pupil of Jean-Baptiste-Camille Corot (1746–1875) and passed on his teacher's advice—'Being oneself is the only way to move others'—to Henri Matisse (1869–1954), who never forgot it.

Though artists are often represented as people with their heads in the clouds, art is

never divorced from the world around it and the Napoleonic wars inspired paintings such as Géricault's *Officer of the Guards Charging* (1812), while his masterpiece, *The Raft of the Medusa*, attacked the government of the day, as did Goya's *The Executions of the Third of May, 1808* (1814) in Spain.

The political axis of the Romantic movement was devoted to the cause of liberty, democracy, freedom from oppression. This is as true of literature as of painting—witness the British Romantic poets such as Byron and Shelley. Delacroix, whose most famous painting is the romantic and heroic *Liberty on the Barricades* (1830), is the major painter of the period. All the Impressionists were much influenced by him, Picasso too. Van Gogh said that Delacroix 'spoke a symbolic language through colour alone', while the poet and critic Charles Baudelaire wrote of him: 'It is as if the colour thinks for itself, independently of the object it envelops.' Delacroix drew much from Byron and from Shakespeare, whose plays he attended on visits to England, where he also saw the work of the greatest British artist, J.M.W. Turner (1775–1851), who equally amazed Claude Monet (1840–1926) and Pissarro when they saw his paintings while in England as refugees from the 1870–71 Franco–Prussian War.

Elsewhere, Romanticism takes a different form to the French with their exotic and colourful scenes of dramatic action. In Germany, the isolation and insignificance of man compared to the immensity of nature is exemplified by Caspar David Friedrich (1744–1840), whose sense of mystic communion with nature is encapsulated in Keats' lines:

Then on the shore
Of the wide world I sit alone, and think
Till love and fame to nothingness do sink.

But the wild card in the Romantic pack, outside the mainstream of these different movements, is Francisco Goya (1746–1828), who progressed from court painter to prophet of modernity, an unsparing chronicler of the depths to which humanity can sink. His influence stretches across the centuries: his 'Disasters of War' (1810) directly inspired the equally horrifying series of lithographs, 'War', by the German artist Otto Dix (1891–1969).

Then the world changed and art, the mirror of society, followed suit. The turning point was 1848, 'the Year of Revolution', when popular uprisings all over Europe signalled the decline of autocratic government: 100 years later only the constitutional monarchies of Britain, the Low Countries and Scandinavia remained. The invention of the steam engine, the railway (which enabled the Impressionists to live in the country while remaining within dining distance of Paris) and the camera extended the range of human possibilities and artists became interested in the realities of everyday life and ordinary people.

Millet, Corot and Gustave Courbet (1819–77) led the way—though Corot's easily recognisable landscapes are more impressionistic than realistic—leading to Edouard Manet (1832–83) and to Impressionism, a volcanic eruption of new ideas and techniques which was felt as far away as Australia, inspiring such artists as Arthur Streeton (1867–1943) and Tom Roberts (1856–1931). With the Impressionists began the story of what may be called 'Modern Art'.

The Impressionists and Neo-Impressionists include Manet, Monet, Pissarro, Degas, Pierre-Auguste Renoir, Sisley, Cézanne, Paul Gauguin, Van Gogh and Georges Seurat: for the first time in the history of art, a group of painters banded together to encourage each other and to find a new direction. They were a group of men and women passionately committed to their art, and through thick and thin, despite sometimes violent disagreements, they supported each other and never questioned each others' integrity.

The Académie des Beaux-Arts (the mere mention of which would drive Degas into a frenzy of fury) had for many years selected works for the annual 'Salon', from participation in which commissions, sales and success usually followed. Without acceptance by the selectors of the Salon, you were nowhere. But there were rules: paintings, unless still lifes or portraits, had to be 'about something', while large canvases were required to depict religious or historical subjects. But Manet's *La Musique aux Tuileries*, a large group of people standing and sitting in the Tuileries Gardens to listen to a concert, isn't 'about anything' any more than is Renoir's *Le Moulin de la Galette*, an enchanting record of ordinary people enjoying themselves. So there were rejections and frustration, and when Monet exhibited a picture called *Sunrise—An Impression*, a hostile critic called the group 'Impressionists' and the name stuck. From 1874, the Impressionists held group exhibitions independent of the Salon and did so until 1886 when they split up to pursue their different aims. Success and acceptance did not come easily and some—Sisley, Van Gogh, Seurat—died before their genius was recognised.

Thereafter art has been through a vast range of 'isms': Fauvism, Cubism, Expressionism, Futurism, Surrealism, Constructivism, Abstractionism to name only those immediately successive— it's a long list, a process of often very rapid development, fragmentation, change and redevelopment. The fantastic improvements in communication during the twentieth century have meant that art has become international, no longer isolated by distance, unrestricted by geographic boundaries. Revolution is immediate.

MAN'S INHUMANITY TO MAN
FRANCISCO GOYA, EDOUARD MANET, PABLO PICASSO

In 2006, as the centrepiece of their celebration to mark the 25th anniversary of the return of Pablo Picasso's *Guernica* to Spain, the Prado and the Reina Sofia museums in Madrid, with a stroke of imaginative brilliance, brought together three other famous 'protest' paintings and juxtaposed them with Picasso's masterpiece.

All four paintings deal with the horrors of war. In none do we see troops in combat. Francisco Goya's *The Executions of the Third of May, 1808* and Picasso's 1951 *Massacre in Korea* show the murder of civilians by an occupying power: by the French during the Peninsular War of 1808–14 and by the Americans in the Korean War of 1950–53; Edouard Manet's *The Execution of the Emperor Maximilian* depicts the execution of a civilian ruler by rebel troops in Mexico; while *Guernica* shows the bombing of a little town near Bilbao by the German air force during the Spanish Civil War.

At the Reina Sofia Museum, Goya's work and Picasso's *Guernica* faced each other. Manet's and Picasso's other painting were similarly placed so that the four pictures made a cruciform.

The combined effect of these paintings was shattering, emotionally extremely demanding. I have never seen the potential of art to stir, to rouse, to deeply affect its audience realised more clearly or more movingly.

GOYA: **THE EXECUTIONS OF THE THIRD OF MAY, 1808**, 1814

Night. The source of light is a very large lantern with opaque sides, resting on the ground. In the distance and to the right, a church, Madrid; to the left and rising upwards, a desolate hill, the Monteprincipe; above, the night sky, no moon nor stars, an anonymous dark.

To the right of the painting, a number of French soldiers with their backs to us are executing anyone suspected of taking part in the previous day's uprising, ordinary citizens of Madrid, and therefore enemies of the French occupying army. Between them and their victims, the lantern illuminates the horrendous scene.

To the left are three bodies—one seems to have been shot in the face, the other two in the chest. There's a lot of blood on the ground. The soldiers are aiming their rifles at a group of six men in the centre and are leaning forward, one knee bent. So Goya tells us these men are about to die and are not the first to face this firing squad. To the right of the victims, a long line of men and women, stretching beyond our vision into the darkness, tells us they are not to be the last either.

It seems that these murders are taking place in groups of three at a time: in the central group, three men are kneeling while another three wait behind them, also kneeling.

The focus of the painting is a young man in yellow trousers and a white shirt that symbolises his innocence. His arms are held high and spread wide. He is exposing himself fully to his murderers. He is terrified but faces his death with resolution. Beside him a man, lips tightly closed, looks defiantly at the soldiers, to his right is a monk, tonsured and in a grey habit, with a fixed stare and hands tightly clasped together, perhaps in prayer.

Of the three behind them, one has his hands over his eyes, another has covered his ears and averted his face, the third is barely visible, almost hidden behind the young man in the white shirt.

To the left of this group people shuffle up a slope, awaiting their turn to die. Though Goya renders them impressionistically, we know it's a long line, that many are going to meet their deaths. We can see only the first four clearly—the man in front is covering his face with his hands; beside him is a woman in white; then there's a bearded man holding his hands in front of his mouth,

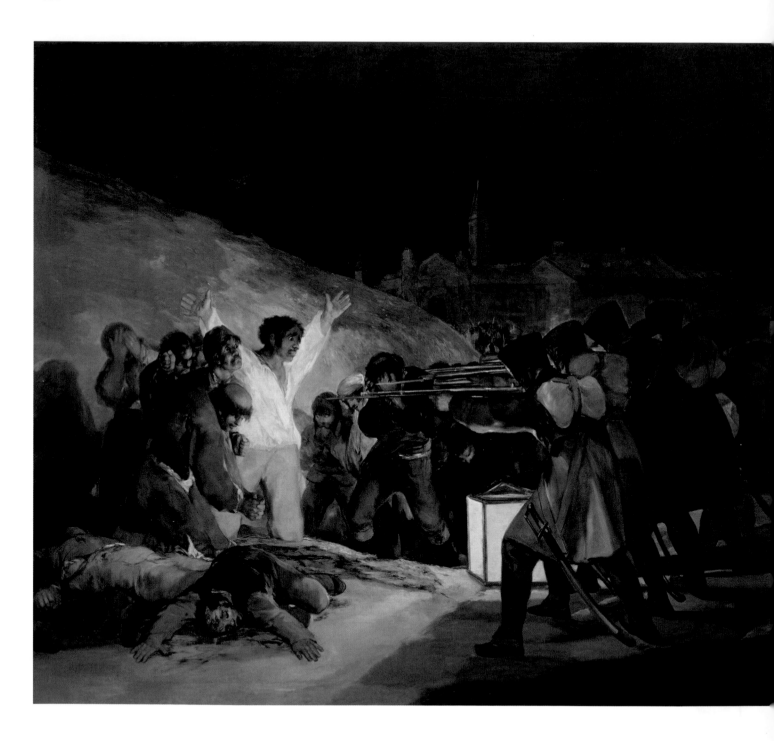

perhaps praying, perhaps trying not to vomit; while the fourth is a man with his head bowed down to the ground.

What Goya doesn't tell us is why these men and women are consenting to this obedient queue of death. We can see what appears to be only seven soldiers—why don't they rush them and overwhelm them? Even so did the victims line up for the gas chambers. Something tells people that there is no escape, that their deaths are inevitable—and they abandon hope. Once hope is abandoned, they are lost to life.

In this painting, as in his so-called 'Black Paintings', Goya changes his style utterly, abandoning his usual perfection of technique, the graceful lyricism, the light, gay colours, the sensual naturalism. All these are gone and in their place is an urgent, passionate shorthand—he is not painting pictures for or of patrons of the court, these are paintings that *had* to be painted, to release emotions which could be released in no other way.

He doesn't show us the faces of the French soldiers—they are the engines of tyranny, no more. The fact that this is happening at night, lit by the lurid light of the lantern, intensifies both the drama and the criminality of the act.

We know the innocent and heroic young man stands for Spain, a country which was not to find true freedom for another 150 years until after the death of General Franco, but like all great artists, Goya goes beyond the actual event he is portraying—the murders which took place on 3 May 1808 on the Principe Mountain outside Madrid—to make a universal statement about man's inhumanity to man. The young man represents all or any person who has the heroism to stand up to his oppressors and defy them to commit murder.

The painting has a delayed action effect. I realised almost immediately that the resolute young man in the white shirt was about to be shot, but it was only gradually, as I took in the painting bit by bit, person by person, that the overall horror of the event became clear and I couldn't look at it without a cumulative sense of dread, of outrage.

Neither, apparently, could Manet or Picasso, for in their paintings of other massacres both deliberately used the grouping of Goya's masterpiece with all the reverberations that might bring.

The Executions of the Third of May, 1808, Francisco Goya, 1814

MANET: **THE EXECUTION OF THE EMPEROR MAXIMILIAN**, 1868–69

Maximilian, brother to Franz-Joseph of Austria, had a claim to the throne of Mexico and, encouraged by the vaingloriously foolish Napoleon III, established himself as Emperor with the support of French troops. At the first protests by Mexico's neighbour, the United States—which can hardly have been unexpected—Napoleon withdrew his army. Maximilian and two Mexican generals who remained loyal to him were captured by the Mexican Republican troops and shot. Public indignation in France was fierce and Napoleon was blamed for the assassination. Manet, who was no stranger to controversy (both his *Le Déjeuner sur l'Herbe* and his *Olympia* created huge scandals when first exhibited), painted four versions of the event and the paintings were banned by the authorities because, to show where the blame should be apportioned, Manet dressed the firing squad in French uniforms.

The composition of the picture is similar to Goya's—firing squad to the right of the canvas, victims to the left. Behind them is a grey brick wall topped with red tiles, which runs straight across the painting. Peering over the wall are some ten people watching the executions with interest—a terrifyingly pervasive human characteristic throughout time as we can see, for instance, in Tintoretto's *The Crucifixion of Christ*, painted hundreds of years earlier.

Manet is not concerned to tell us much about these observers but one woman, in the centre of the group, is leaning her elbows on the wall and resting her chin in both hands, surveying the scene with concentration, as is a man in a white shirt to the right of the group, his arms and face resting on the wall. Next to the woman, a man in a white bandanna is shouting—his mouth is wide open—and gesturing violently in, perhaps, an echo of the young man who is the focus of Goya's painting.

Behind the wall and its spectators is a hill studded with trees and to the left is a cemetery: trees again and vases, crosses, urns on a large memorial scale. The foreground—and Manet makes us feel as if we're almost on top of it—is the killing ground. He paints the exact moment of execution: smoke and flame erupt from the barrels of the rifles of the firing squad, the general to the left is

'… smoke and flame erupt from the barrels of the rifles of the firing squad, the general to the left is already beginning to fall backwards. In the blink of an eye the flames will have gone and the three men will be on the ground.'

already beginning to fall backwards. In the blink of an eye the flames will have gone and the three men will be on the ground.

To the right and closest to us, the officer in charge is already reloading his rifle. He and his men are in dark uniforms with white belts and hangers; the soldiers wear white gaiters. The officer, a moustachioed, impassive man concentrating on his immediate task and not looking at the execution—why should he, he knows what the result will be—has, in addition, a white sling to his rifle and a red cap edged with white. The six soldiers—there was a firing squad of seven in Goya's painting so Manet uses the same number here—are grouped in an untidy circle. They're not likely to have missed their victims as they are barely a metre away from them, so close that they don't need to lean forward and even the officer, at the rear of the group, is only about 2 metres off.

The generals flank the Emperor, both in white shirts symbolising their innocence, like the central figure in Goya's picture. The Emperor wears a dark suit and a grey sombrero. At the moment of his death he has wanted to make clear his identification with Mexico. In his right hand he holds a handkerchief. His hair and beard are auburn and he is very pale.

There is little colour in the scene, which takes place on a sunny day, as we can tell from the shadows on the dry and sandy soil. There is white in the soldiers' accoutrements and, in little patches, amongst the group on the wall, just enough to make us aware of their presence.

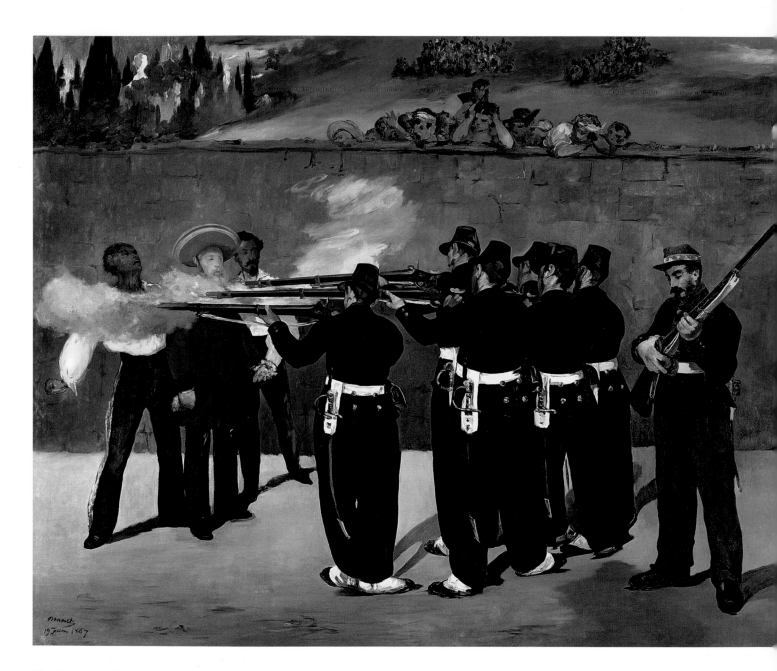

The Execution of the Emperor Maximilian, Edouard Manet, 1868–69

'He paints the exact moment of execution: smoke and flame erupt from the barrels of the rifles of the firing squad, the general to the left is already beginning to fall backwards.'

White, too, in the generals' shirts and the smoke billowing from the rifles. There's red in the officer's cap and a small flash on that of one of the soldiers; orange in the flames spurting from the rifles. A patch of blue sky beyond the cemetery. And that's all. For the rest Manet uses browns, black, grey.

The firing squad occupies the centre of the painting; Maximilian and his generals are further away from us and well left of centre; the officer, the only military face we see, closest to us at down right. Manet manages the focus of the picture with immense skill, even bravura. The officer's red cap and closer face could have made him the focus but the use of white on the military uniforms leads the eye unavoidably up to the white smoke and the generals' white shirts. There the Emperor's extreme pallor—the

generals on either side of him, being Mexican, are darker—and the sunlight creating a rim of white around the top of his sombrero make it clear that it's his story Manet is telling.

Goya unleashed the passion of his emotions in the choices he made: night, the artificial light, the body language of the victims, the defiance of the young man. Manet, by his choices, has controlled them. But this doesn't make his statement or his painting less emotional. In fact, the lack of comment from the artist opens up the spectators' reactions.

In broad daylight, a group of soldiers are executing three men, watched from a distance by a group of largely unprotesting civilians. The brutality is accentuated by the extremely close range at which the soldiers are firing. The man to the right of the Emperor clutches his hand, the

only visible trace of emotion in this painting apart from the man shouting on the wall. It's the juxtaposition of this simple human contact born out of need, of love, of terror, of support, of despair, of comfort with the expressionless faces of the victims that makes this painting such a powerful and disturbing indictment. Because the soldiers are so close to the front of the picture, Manet makes us feel as if we're there too, by inaction complicit with the executions. If we do not protest against injustice, one day it will be us in front of the firing squad. Manet's painting, like Goya's, transcends the specific occasion it is recording to make a statement outside time about the human condition.

PICASSO: **MASSACRE IN KOREA**, 1951

The same may be said of Picasso's 1951 painting about the murder of civilians by American troops during the Korean War.

This massacre is taking place in open country with brazen indifference to its being observed. There is no indication where the soldiers or the victims have come from—though there may be a clue in the half-bombed building at the top of a hill in the background. The landscape is hilly and barren. A grey stream divides the two groups, a division that may symbolise the two halves of the ancient country in which this war is being fought. Picasso, like Manet, follows Goya's composition: murderers at the right of the painting, victims to the left.

The painting is far more naturalistic than might have been expected from the man who revolutionised our concept of Western art by the invention of Cubism with his seminal painting *Les Demoiselles d'Avignon* as early as 1907, who painted *Guernica* 30 years later and *The Charnel House*, his response to the revelation of the German death camps, in 1944.

The centre of the picture would be open were it not for the upraised, space-age weapons levelled at the eight victims. There are perhaps five men aiming at the women and children who are about to die. These soldiers are naked except for their faces, which are heavily protected by futuristic helmets. Their faces are not human but an android, robotic concoction, though their bodies

are strongly muscled, masculine human forms. Their officer, at the rear of the group like the officer in Manet's painting, has his back to them but his face, in a typical Picasso rearrangement of the human form, is turned towards them. In one hand he holds a thunderbolt; his other arm is raised and a sword, held in his clenched fist, points at the victims.

On the left of the painting are four women and four children. Two of the women are pregnant. All are naked. Furthest left, the most heavily pregnant woman, very near her time, clasps a child to her side with one hand, while the other is raised to her hair as if about to tear it out in despair. The face of the woman next to her is a shriek of grief and terror; she holds a baby in her arms, one of its arms around her neck, its face uplifted to hers, its embrace squashing her cheek. To her left, the third woman, also pregnant, has both hands with palms turned out in an odd gesture of resignation or submission. Beside her is a young girl. One hand is covering her breasts. Her other arm is held by a child of seven or eight who is looking back at the space-age Americans in terror. He has just turned away from them—one leg is uplifted in flight. At the girl's feet, a baby is playing on the ground, unaware of what is about to take place, unconcerned by the soldiers. The young girl's face is impassive; those of the three other women are masks of anguish. Immediately behind them is the edge of a pit into which their bodies will shortly fall.

There is green grass, and sunlight seems to be coming from off the canvas to the right. It touches the officer's thunderbolt, parts of the legs and thighs of the soldiers, and illuminates the belly of one of the pregnant women and one of her out-turned palms, part of the child running away and the pit behind them. In the background, it picks up a hillock and, higher up the slope, the ruin of the bombed building. Around the top of the picture and running halfway down each side, Picasso has painted in a pale mount, with a touch of pink, some of the sunlight's orange dabbed along it. This forces us into the scene.

These three great artists all make clear their horror at what is happening in different ways. Goya by his dramatic use of light, the furtive secrecy that such an event taking place at night must indicate, and by the heroism of his young protagonist. Manet by

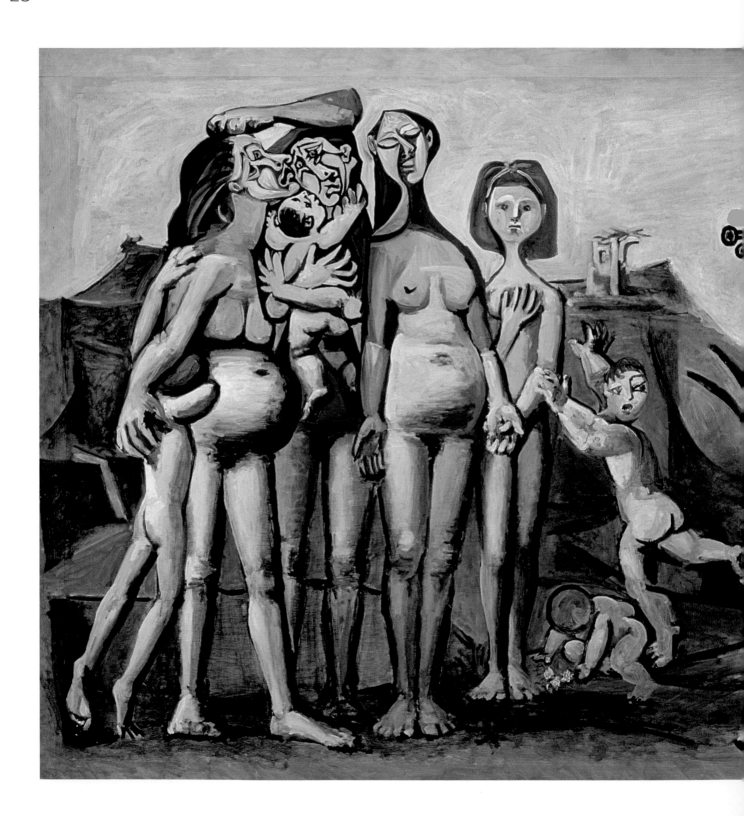

keeping his emotional response in check but giving one small instance of the brotherhood of man that the event taking place seeks to negate. Picasso exposes the massacre, choosing for it to take place in broad daylight, in open country, with no effort at all to conceal it. Its murderers are not human and this, together with the horror on the women's faces, tells us the artist's response to the crime. As in Goya's painting, the victims are non-combatant civilians, their nakedness underlining their innocence of any wrongdoing.

All artists, in whatever medium, put their sub-conscious as well as their conscious into their work—they cannot help but do so. However, Goya was the first modern artist, the first to express the sub-conscious through painting, a universe of nightmare—though it might be argued that Bosch anticipated him—and the first to use painting to make politically subversive statements. But Picasso's unique take on the world and its inhabitants—and as the inventor of Cubism the adjective is justified—communicated his outrage and revulsion more clearly and directly than his predecessors could ever have anticipated. And nowhere can we see this more clearly than in *Guernica*.

PICASSO: **GUERNICA**, 1937

The story of the creation of *Guernica*, perhaps the greatest painting of the twentieth century, is well documented. In 1936, the Republican government of Spain, seeking to boost its image internationally, asked its countryman to create a new work for the Spanish Pavilion at the 1937 World Fair in Paris. General Franco's military uprising against the government was very far from being suppressed and the government wanted to bring the support it had amongst artists and intellectuals to the world's attention. Picasso, who lived in Paris, was the most famous Spanish artist of his day.

He had just finished his poem *Dream and Lie of Franco* and hoped that the etchings on which he was working to illustrate it might be his contribution. The Spaniards, however, wanted him to do a big mural. Picasso hesitated but on 26 April 1937

PREVIOUS PAGE:

Massacre in Korea, Pablo Picasso, 1951

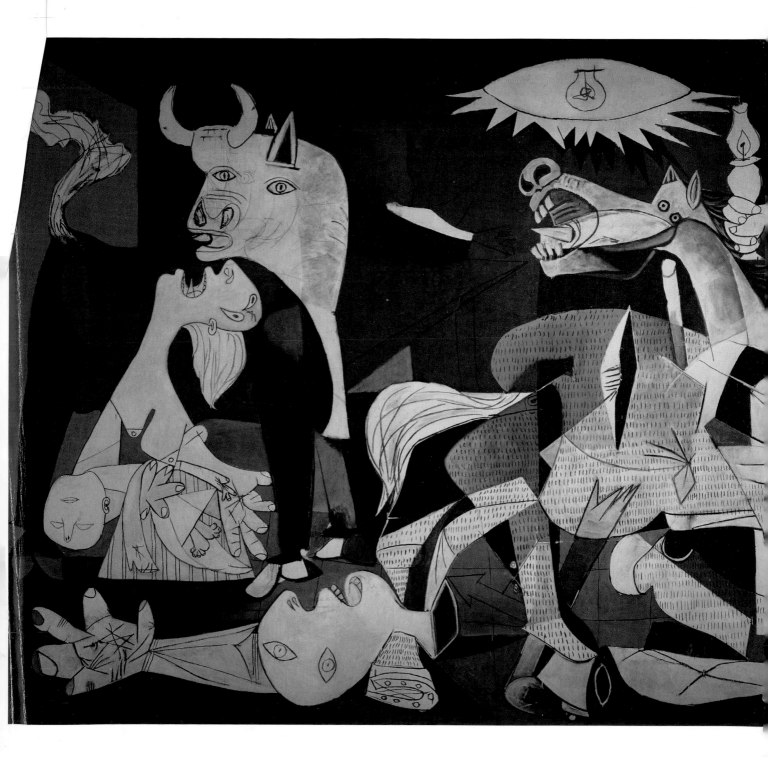

'I wonder if monochrome was to Picasso what the key of D-minor was to Mozart, whose use of which was a sign of unhappiness and despair. Colour is part of life's assertive force and colour has no part to play in the grim massacre of *Guernica*.'

the German air force, which was supporting Franco, dropped 1300 kilograms of bombs on the little town of Guernica in northern Spain, pursuing those who tried to escape from the town with low-flying fighter planes and gunning them down. Nearly 2000 people died and nearly 1000 were injured. Two days later, on 28 April, the first photographs of the atrocity appeared in the French newspapers. On 1 May Picasso drew the first of his preliminary sketches for *Guernica*—he made nearly 50 in all—and in a month the canvas was completed.

Guernica is a very large painting—some 8 metres long and 4 metres wide. It is painted entirely in white, grey and black. I wonder if monochrome was to Picasso what the key of D-minor was to Mozart, whose use of which was a sign of unhappiness and despair. Colour is part of life's assertive force and colour has no part to play in the grim massacre of *Guernica*.

But monochrome does not mean still or motionless. On the contrary, the huge canvas is bursting with an anguished frenzy of movement—even the dead soldier lying in the foreground seems to be screaming, mouth wide open, eyes staring.

Apart from the soldier, there are four women and a child in the painting, a horse, a bull and a bird. The child, in its mother's arms, its head bent down to the earth, is clearly dead. Its mother, her head lifted upwards to the sky, is screaming her grief. Behind her, in

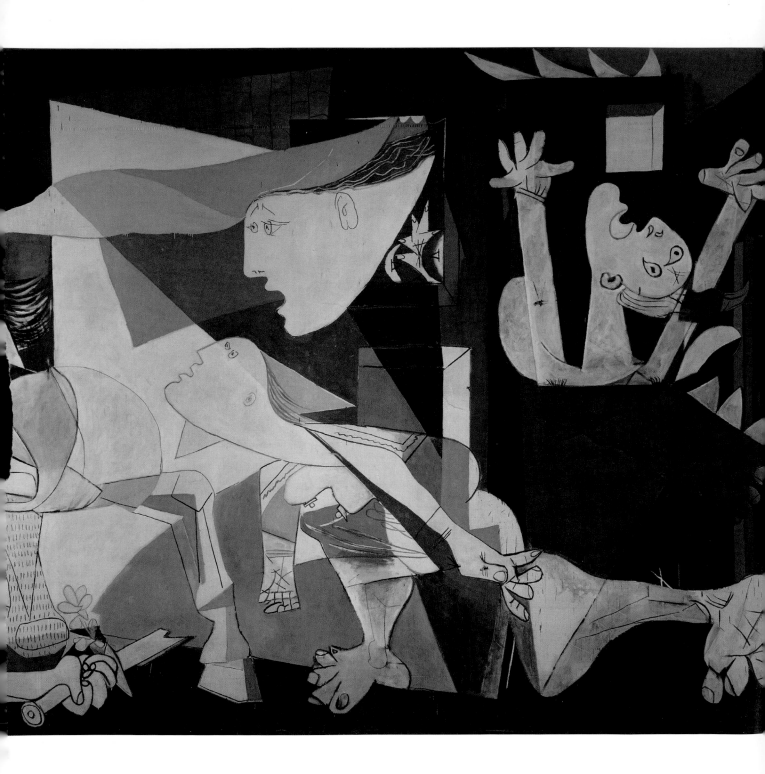

the left background, is the bull, the only motionless creature. In Picasso's preliminary sketches, the bull goes through a series of metamorphoses, sometimes still, sometimes in movement, once as a Minotaur, but in all of them it is uninjured. Its body faces into the scene of carnage but its head is turned away, looking off the canvas. Perhaps it stands for Spain. The Spanish Civil War was seen by many people all over the world to be a defining struggle between Fascism and Democracy. This may be why the bull stands to one side of the human tragedy, removed from it yet, Picasso said, 'a symbol of brutality and darkness'.

Next to the bull is a horse, mortally wounded, a spear thrust through it and coming out the other side, its guts spilling out in a position not related to the wound but to where it would be gored by a bull in the ring, its jaws wide open, trumpeting its pain. A scream in the form of a triangular dagger jabs out of its mouth, as it does from the mouth of the woman with the dead child. Picasso disliked explaining his work but he revealed that 'the horse represents the people'. Between the two animals, barely visible, a dark outline on a dark background, is a bird, head turned up to the sky, beak opened. One wing, which might be broken, is a white slash.

The tangle of limbs that is the horse and the dead soldier adds to the panic of movement at the right half of the canvas. Here, there are three women. Picasso paints one full length, in an elongated stride—a desperate attempt to escape, perhaps, from the building to the upper right in which a second woman is burning, arms up-stretched, trapped, head back in a scream of fear and pain, flames emerging from the roof and the side of her home. Beside her, a woman's head, with an arm holding a lamp, leans from a window, crying out for help.

Above the horse's head and beside this lamp is the sun, with black as well as white rays, in the oval shape of an eye, a light bulb at the centre as its iris. The dead soldier has one arm outstretched, the strange striations of the lines of his fortune black on his palm. The dying horse's hooves straddle him. His other arm, also outstretched, this one towards the centre of the painting, clutches a broken sword. Beside it, growing from the ground, is a small flower.

Guernica, Pablo Picasso, 1937

'... Picasso is not asking us to view the painting naturalistically or even logically. The picture is intentionally dislocated and fragmented to reveal the chaos and destruction of war ...'

In the panic, fear, grief and destruction of *Guernica*, there is no evidence of hope for the future, let alone for a better future, arising from this massacre of innocent people by an unseen enemy in the sky except, possibly, this solitary flower surviving amidst flames and carnage.

Confronted with the frenzy of activity which is so overwhelming in *Guernica*, the advice of William Burroughs, author of *The Naked Lunch*, is useful: 'Don't look at a picture, reaching out with your eyes, let the picture look at you. Some detail, which I call "a port of entry", will jump out and engage your attention.'

Just as there is no substitute for watching and listening to live musicians or real people acting out a story, so it is difficult, perhaps impossible, for even the best reproduction of a painting to convey not just the technical effects of colour, light and shade, but, more importantly, the emotion which animates it. And of no picture can this be truer than of *Guernica*. All our preconceptions about painting, about space, about architecture are overturned. *Guernica* could be taking place indoors, outdoors and is probably taking place in both. The sun is the sun and a light bulb and an eye, the bird is standing on a roof or a table, the soldier's body may change colour—these questions do not matter because Picasso is not asking us to view the painting naturalistically or even logically.

The picture is intentionally dislocated and fragmented to reveal the chaos and destruction of war, to present an event in progress, which is still going on, not tidily completed, which will be repeated tomorrow if we, the spectators, don't do something about it. With its sword, its light bulb, spear and oil lamps, it shows us Guernica on 26 April 1937, at the same time leaping backwards and forwards in space and time to tell us: *This is war—condemn it, prevent it.* In fact, *Guernica* was the first picture to raise money internationally in a political cause.

I had no conception of its shattering effect until I was standing in front of it. The painting silences the spectator. We stand quietly, awed, appalled, angered, and go away quietly, drained, humbled, purged, perhaps, by pity and terror. But not, it is to be hoped, deprived of will or determination.

The opportunity of seeing these four great polemic works of art was sobering but also inspiring because the emotional responses they elicit are witness to the power of art in our lives.

W.H. Auden wrote a poem called *Spain, 1937* which ends:

The stars are dead; the animals will not look:
We are left alone with our day, and the time is short and
History to the defeated
May say Alas but cannot help or pardon.

We have to try to do better. But Goya, Manet and Picasso warn us how unable the human race is to learn from the past.

THE PLEASURES OF SUMMER
JEAN-HONORÉ FRAGONARD

When the Danish writer Baroness Blixen, better known under her nom de plume of Isak Dinesen, knew that her life was drawing to its close, she went to New York to say goodbye to the Fragonard Room in The Frick Collection. The museum opened early especially for her; she sat, alone, for an hour with those astonishing and exquisite paintings and then returned to Copenhagen, where she died shortly after.

I've never discovered whether or not the story is true but, if so, it reflects well both on the Baroness and on my favourite museum and I can never tell the story without weeping. Why this emotion? Something to do with an institution's generosity of spirit, something to do with an old lady loving art so much, mostly to do with those paintings. For if, near the end, we follow the poet's advice to 'Look your last on all things lovely', there can be few better summations of what art can realise than this large room panelled entirely with paintings by one of the great eighteenth-century French artists.

Watteau and Chardin are, perhaps, the greater painters of the period but I love Fragonard the best, with a warmth and enjoyment similar to my feeling for Carpaccio. '*Le bon Frago*', as he was affectionately called in his lifetime, is one of those painters with whom I feel simultaneously astonished and at home. His was a fortunate life. He trained under both Boucher and Chardin, the two greatest painters of the day, and won the Prix du Rome, which gave him five years at the French Academy in Rome. A little fellow, barely a metre and a half tall, he seems to have been loved and even spoiled all his life long. On his return to Paris, the picture he painted as an admission card to the Académie, essential for an official career, was enthusiastically accepted and he never looked back, becoming the most sought-after artist of the reign of Louis XVI. Somewhere along the way, he befriended David, who became the official painter of the Revolution and who, on the return of Frago and his family from Grasse in 1791 (just a year before 'the Terror'), gave him protection and a job. Frago's star as an artist waned very considerably but, despite being penniless, he doesn't seem to have been downcast. Always cheerful, always loved, he had the happiness of seeing his son, Alexandre, become a successful painter and died at the age of 74 after a short and painless illness.

Frago originally painted four large canvases in about 1771. Commissioned by Madame du Barry, Louis XV's mistress, they were designed for a pavilion in the garden of her new chateau at Louveciennes. They represent the progress of a love affair and Fragonard called them *The Pursuit*, *The Meeting*, *The Lover Crowned* and *Love Letters*. Madame du Barry did not like them and they were never hung in her house. It can hardly be, stupid woman though she was, that the paintings themselves did not meet with her approval. The most convincing theory is that they didn't suit the new 'Classicist' style of the architecture. At all events, Joseph-Marie Vien, the architect, painted replacements: severe, sterile pieces on the same theme, which certainly suited the Neo-Classic style of the building, and Fragonard took his pictures back.

Poor Madame du Barry. Twenty years later, in the last days of the Terror, she was dragged, screaming, up the steps of the guillotine. Her desperate appeals, from the tumbril that rattled her from the

'The main impression of the Fragonard Room is of silver and grey, a sylvan park whose trees are of the most beautiful misty blue and green, with white clouds in the sky that in no way deflect the heat. The haze of summer hangs over everything, as transient as the bloom of a rose.'

Conciergerie prison to the scaffold, to the people that she was one of them were met only with curses and catcalls. Although she came from nowhere to be the most powerful woman in France, nobody was minded to pity one of the hated Bourbon kings' whores, whatever her roots.

> Base fortune, now I see upon thy wheel
> There is a point to which when men aspire
> They tumble headlong
> — the Younger Mortimer's lament in
> Christopher Marlowe's Edward II

It may be fortunate for us that she rejected the pictures: what happened to them subsequently ensured their survival. Had they remained in Madame du Barry's possession they might well have been destroyed. But, in 1788, Frago's daughter, Rosalie, died at the age of eighteen. She was his first child and her death affected the painter so grievously that his doctor advised a long stay in Grasse, the town in the south of France where Fragonard had been born. So off they went, Frago, Madame Fragonard and their son, Alexandre. The four rejected canvases went with them and were later installed in the salon of the house owned by Fragonard's cousin. To complement the paintings in their new space, he painted two large pictures, which he called Reverie and Love Triumphant, four narrow decorative panels of hollyhocks and four little paintings of Cupid for above the doors of the salon.

And there they remained until the end of the nineteenth century when they moved to New York.

Not surprisingly, given the interval of nearly twenty years between the painting of the original four canvases and the other ten pictures, they don't all—looked at individually—quite make a whole. The Cupid door panels and the hollyhocks marry with the four originals but the two new larger paintings are markedly different. In *Reverie*, the young girl, seated at the base of a column topped by Cupid balancing on a globe, is painted in very pale colours: a white dress with shimmering blue highlights and the palest pink overskirt. The feel of the trees surrounding her, of the whole picture, is distinctly autumnal. In *Love Triumphant*, a painting of equal length but only two-thirds the width of the others, there are no human beings at all, just Cupid and a group of putti rising from a brown and red landscape—is it on fire?—into a cloudy but cerulean sky. Certainly the cherub closest to the ground is seriously alarmed while those safely above the level of the smoke are blithely unconcerned.

But with the four pictures of the 1770s, Fragonard depicts the time of year that suits him best: summer.

The main impression of the Fragonard Room is of silver and grey, a sylvan park whose trees are of the most beautiful misty blue and green, with white clouds in the sky that in no way deflect the heat. The haze of summer hangs over everything, as transient as the bloom of a rose.

We're within the confines of a park and on a terrace: there are stone balustrades, cream or grey, urns cascading with roses, statuary all featuring Cupid—in two of them entreating Venus for a favour. Nature seems to have run riot: there's none of the sterile order we often see in eighteenth-century gardens, none of the formality of Versailles. No gardener has attended to these terraces in a long while; the roses—pink, white, red—grow uncontrolled, and the surrounding woods are more like a jungle than the carefully arranged spaces of landscape gardeners such as Le Nôtre or Capability Brown.

The architectural elements tell us of people not far off, controlling mothers and fathers, guardians, chaperones, while the rampant fertility of a neglected garden suggests the perfect place for a young lady, like Shakespeare's Malvolio, to 'enjoy her private', for a lover to surprise her, for a rendezvous, a tryst, a place where the young and beautiful may make holiday from the decorum and constraints of the adult world.

THE PURSUIT, 1771–73

In *The Pursuit*, three girls, two of them little more than children, have been surprised by the young cavalier of the eldest. He's come along the terrace from the left of the painting and, feathered hat in one hand, holds out his offering of a pink rose with the other. Not exactly a rarity in this garden. She has risen and is moving away from the intruder, the haste of her reaction revealing an ankle, both arms outstretched in surprise or rejection. She wears cream silk with a little white choker and a pale-blue rosette pinned to one side of her bodice, the ribbons attached to it blown round her waist by the suddenness of her movement. The small girl to her right, dressed in the palest blue, has jumped up too but is looking downwards in amusement while her other companion, in pink, sits on the ground, hiding behind her elder's white skirt. They've been having a little picnic: in the bottom-right corner of the painting, on the low plinth which bears Fragonard's signature, is a white cloth with apricots or nuts—it's hard to tell which—grapes and two red apples arranged on it.

The background is hazy woodland; before it, but still in the darkness of shadow, two cupids are atop a dolphin from whose mouth water pours, making a silvery cascade just behind the balustrade. The foreground is bright with the sunlight shining across the canvas, lighting the stone urn at the far left, the young cavalier, and at its warmest on the group of girls. We don't know what will happen next.

THE MEETING, 1771–73

In *The Meeting*, or *Storming the Citadel* as it's sometimes called, we find out. Again, it's a perfect summer's day; the scene has moved to another part of the terrace. Fragonard painted *The Pursuit* on the horizontal—we were like the audience in a proscenium theatre and the balustrade in front of which the action took place ran straight across the stage. But here he chose to use the diagonal. Woodland, coming from far up left to the centre, is cut off by a large plinth topped with a statue of Venus and Cupid.

The Pursuit,
Jean-Honoré Fragonard, 1771–73

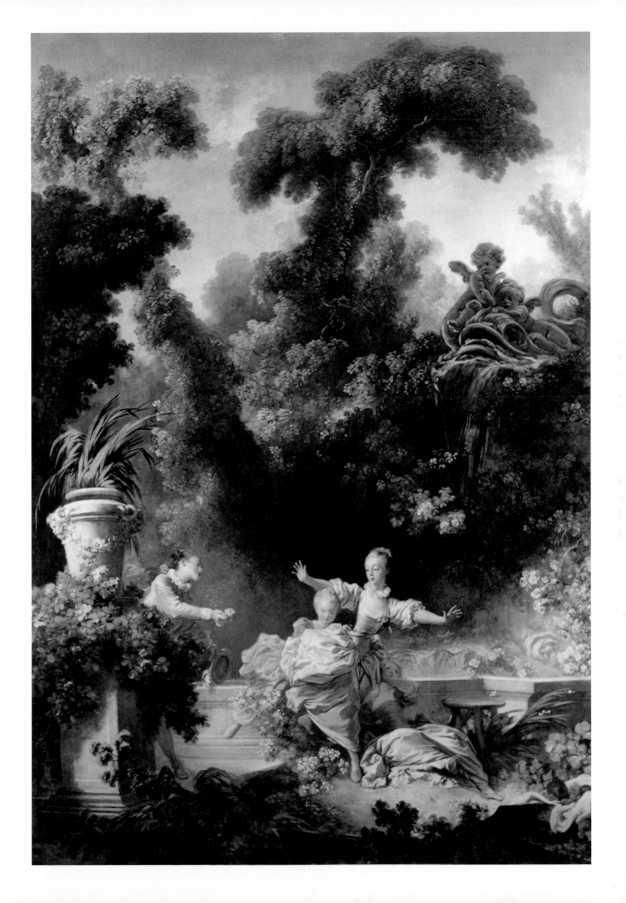

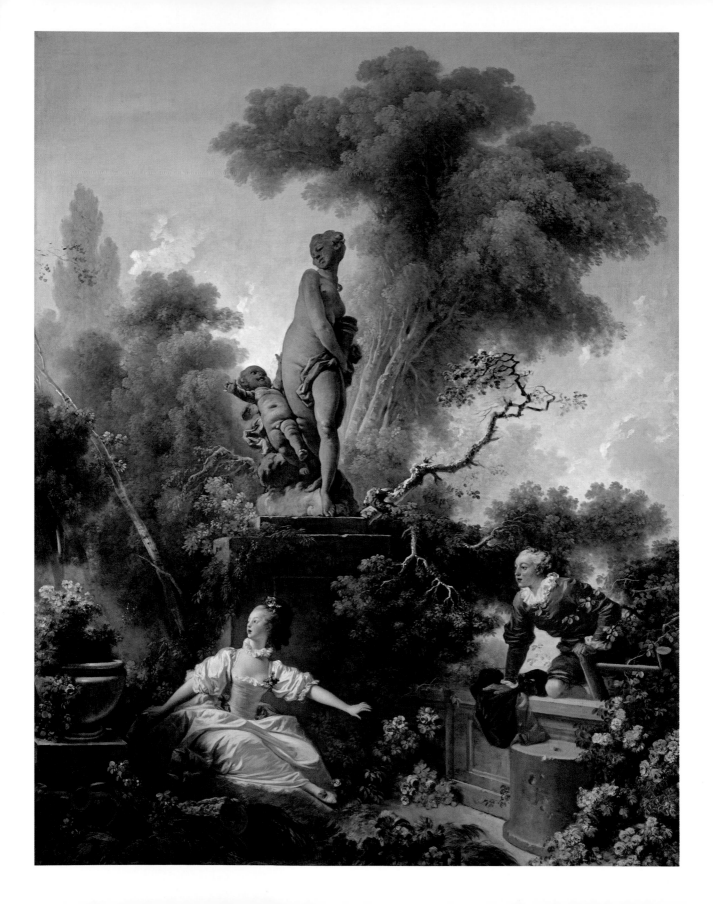

A balustrade runs from the plinth to down right and out of view. There's a profusion of pink roses in the right corner and, upstage of it, in front of the balustrade, is a circular pedestal somewhat in need of restoration. At the extreme left is a round ornamental bowl with roses growing from it, which balances the neglected pedestal just as its roses balance those at the right of the picture. Beside it is an old log. There is an air both of greater seclusion and of greater neglect and the area, though it's clearly part of a long terrace, feels more enclosed than in *The Pursuit*.

The terrace is higher than the surrounding park for the cavalier just climbing over the balustrade has needed a ladder to get there. He wears a red silk jacket with a little lace ruff, lace at the wrists and a blue rosette, just like the one the young lady was wearing in *The Pursuit*. He has dark-blue breeches, white stockings and carries a dark cloak. He's fair-haired. He's not the same man we saw in *The Pursuit*. That spark was very young, only about sixteen or seventeen, the same age as the girl, and he reappears in the last two paintings, *Love Triumphant* and *The Lover Crowned*. This wooer is definitely a man, not a stripling, a well-built fellow in his twenties and his air is determined, albeit cautious. Some critics have seen in him a resemblance to Louis XV and advanced this as the reason for Madame du Barry's rejection of the paintings.

The young lady, this time alone, has been sitting at the base of the statuary. Waiting for him? She wears the same dress, though without the blue rosette, and the pink rose which the young man offered to her in *The Pursuit* is in her hair. Her arms are, again, spread wide but this time it is to indicate the need for caution. She looks anxiously off the canvas to the left and he's looking that way too.

The idyllic scene is painted in blues and greens again, soft pink flowers, cream and white in the girl's dress, yellow worked into the green of the trees. Amidst this gentle landscape, the young man in bright scarlet is therefore quite a shock. Although the picture moves diagonally from centre left to down right, the two lovers are on an intersecting diagonal and as the sunlight, again, comes from the left, the young girl and her pale frock get the same amount of focus as the young man's scarlet.

THIS PAGE: *The Meeting*, Jean-Honoré Fragonard, 1771–73
FOLLOWING PAGE: *The Lover Crowned*, Jean-Honoré Fragonard, 1771–73

'In front of the trees, painted with that extraordinary whitish blue—or is it green?—that is Fragonard's speciality, there is the usual large piece of statuary: Cupid reposing this time, perhaps exhausted by his labours to bring them together, dark in contrast to the sunlit centre of the painting.'

On a thrust stage, which has the audience sitting on three sides of it, the energy of the space comes from one's awareness of the double diagonal and this is what Fragonard taps into here and, again, it's a dramatic moment he's chosen to record.

THE LOVER CROWNED, 1771–73

In *The Lover Crowned*, the need for caution and secrecy has gone. In the right-hand corner of the picture sits a young man in red, a red bow in the back of his hair, a red cloak behind him and red rosettes on his shoes. He's in half profile and has a sketchpad of black paper on his knees and is about to start drawing the young lady and her cavalier. She is certainly the same girl as in the two previous pictures and he's the boy from *The Pursuit*, the first canvas, so the young man in the second painting didn't win her heart. She is seated in the centre of a grassy bank and he is kneeling to her left, one hand round her waist, the other holding one of hers, his face uplifted adoringly to her. He is dressed in red, like his friend with the drawing board. She has changed her dress—well, time has passed and in any event ladies at this period changed their dress three times a day—and is in warm yellow silk with an ivory underskirt. Blue reappears in a blue butterfly pinned to the middle of her bodice and in the ropes of blue flowers draped about her arms.

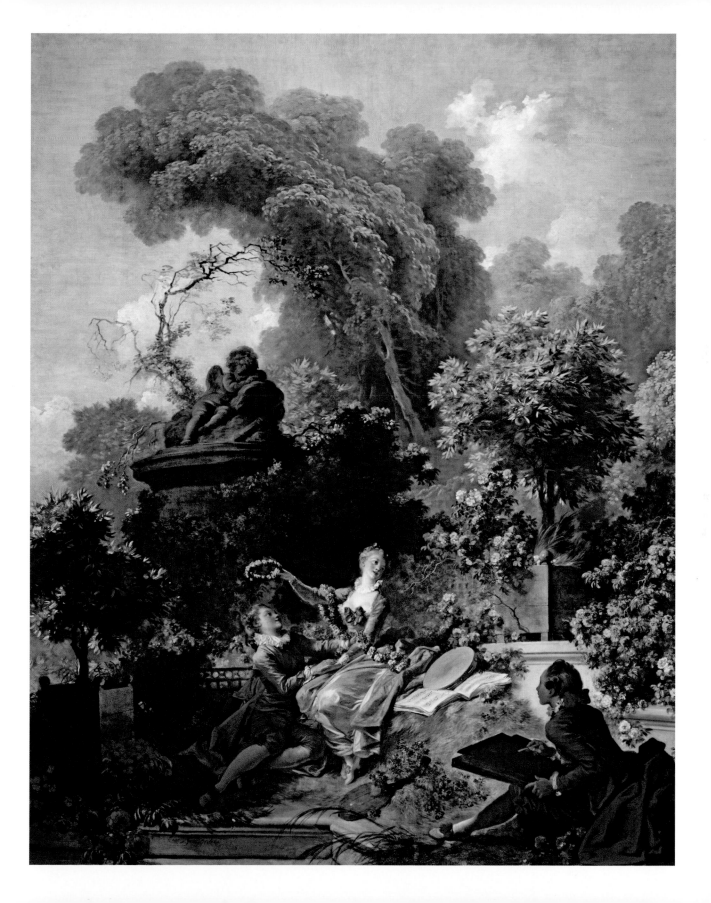

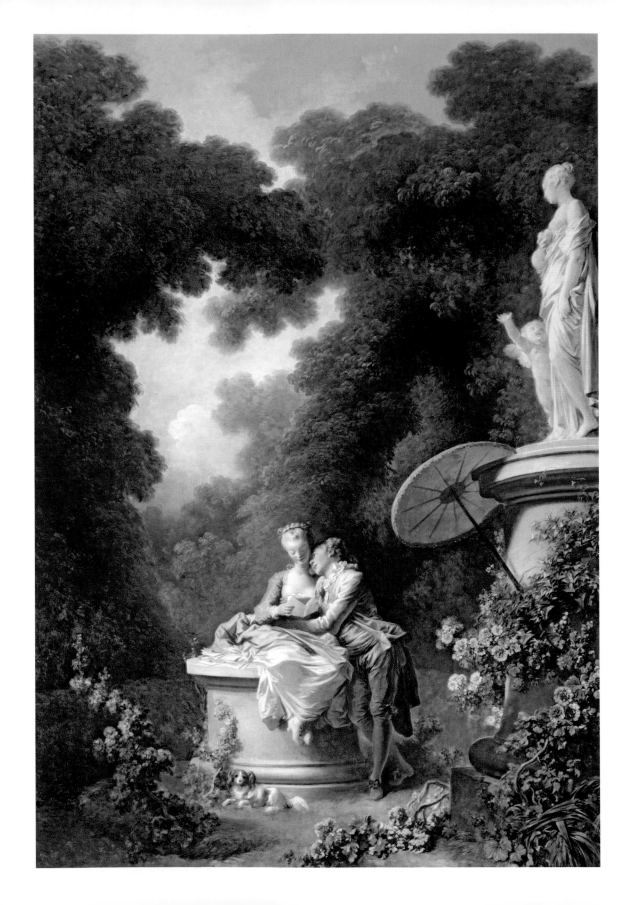

She is about to crown her gallant with a wreath of flowers but, quite properly, is looking not at him but at the artist who is about to start drawing her, her head tilted a little to one side as if to say, 'See, this lovely man has won my heart.' An open book of music and a tambourine lie beside her, while at the foot of the bank is a lute or small guitar with some blue flowers growing, rather improbably, across it. So this is a convivial and social gathering, not a lovers' tryst.

Once again the sun comes from the left, picking up the man's face and torso and making the girl the focus, despite the sunlit roses and terrace beyond her. In front of the trees, painted with that extraordinary whitish blue—or is it green?—that is Fragonard's speciality, there is the usual large piece of statuary: Cupid reposing this time, perhaps exhausted by his labours to bring them together, dark in contrast to the sunlit centre of the painting. Again, roses in profusion, those in the bottom left of the canvas a stronger red, linking up to the kneeling cavalier and then across to the artist at the right. Orange trees grow in tubs; one, behind the group, is covered with fruit. The deep yellow of the girl's dress connects with the oranges but there's also some red introduced into the colour which makes her, in this oasis of delight and serenity, the harmonious centre and focus between the two men in red.

There is, however, an energy in *The Lover Crowned*—the artist leaning forward attentively; the cavalier, you can feel, longing to leap up and embrace his girl; she filled with the exuberance of bestowing love.

LOVE LETTERS, 1771–73

In the final canvas, *Love Letters*, the mood is one of repose and fulfilment. The girl, in a pink dress, its white underskirt highlighted in blue where the folds catch the light, is seated on a round pedestal high enough for him to have needed to lift her up there. He is in yellow with a blue sash, matching rosettes on his knee breeches and shoes. It's the same boy from *The Pursuit* and *The Lover Crowned*. He looked somewhat wimpish in *The Pursuit* but we may account for this by its being his preliminary overture

Love Letters,
Jean-Honoré Fragonard, 1771–73

to her, to the difficulty of her sisters being there too, and by *The Pursuit* being the only painting in which he's in right profile. We all have a good side and a bad side, as any actor will tell you.

Here he stands beside her, his head resting tenderly on her shoulder, his arms round her waist. She is reading a letter—the painting is called *Love Letters* so that's presumably what it is, though I, with a director's penchant for a certain amount of logical analysis, would rather believe it's a poem that he's written for her. If it's a love letter, why would she be reading it when he's beside her?

The sky is a deeper blue than before and the trees immediately behind the happy couple are in shadow, protectively darker. Roses are growing all across the foreground, highly decorative, if somewhat in defiance of the laws of horticulture. At the base of the pedestal lies a brown and white King Charles spaniel, whose pricked-up ears suggest it's aware of us spectators although the lovers, of course, are oblivious to everything but each other.

Sunlight picks up the rim of a pink parasol, which echoes the girl's pink overskirt and pale-purple roses. It is affixed to the pedestal of a large Venus and Cupid at the right, and it leans out across the picture towards the lovers. The parasol is a deeper pink than the girl's dress but its colour and its tilt put the focus, despite the strongly lit Venus and Cupid, on to the happy pair.

And there Fragonard leaves them: to a happy future, their courtship continuing, now blessed, presumably, by the parents or guardians who have been a powerful, if offstage, presence throughout. We though, with the doubtful but unavoidable benefit of history, must hope that in the coming Revolution they will evade the fate of Madame du Barry, who earns our gratitude as the 'onlie begetter' of these beautiful pictures which show Fragonard at his best: romantic, tender, lyrical.

He and the early seventeenth-century poet Samuel Daniel evoke conjointly the transience of nature, of love, of youth:

Beauty, sweet love, is like the morning dew
Whose short refresh upon the tender green
Cheers for a while, but till the sun doth show,
And then 'tis gone as it had never been.

THE GOOD BURGHERS
FRANS HALS

When people are rich, they want themselves recorded for posterity. They may want their houses or their gardens similarly immortalised; usually their wives and children; sometimes their pets and domestic animals. For their choice of art, they will tend to relax with the charm of still life or the delights of the changing seasons as seen from a peasant perspective.

What they don't want is to be threatened or criticised. Few are the artists like Caravaggio who will show the fruit going bad or the maggots devouring it; even fewer the artists who will show life as it really is—Hogarth did, so did Callot, most famously, Goya. But even they had rich patrons whose portraits they painted to keep themselves afloat.

The 'Golden Age' of Holland, the period of its greatest expansion and power in the seventeenth century, produced a pantheon of great artists: Rembrandt, Vermeer, Rubens, Hals, Hobbema, Ruisdael—I don't have to tax my memory, the names spill out automatically. Many of them were specialists—Hobbema and Ruisdael painted landscapes. Rembrandt never did; most of his paintings, with their emphasis on the human being, are interior, as is much of Vermeer's tragically small output. In general, the scene covered by these artists was rural or domestic.

Sometimes military or naval achievements were celebrated on a more monumental scale—the creation of an empire requires memorialising. Cornelius van Wieringen's large canvas in the Rijksmuseum in Amsterdam celebrates the successful *Siege of Gibraltar*. The Spanish flagship has just been rammed by a smaller but triumphant Dutch opponent. It is on fire and its magazine has, at the exact moment of the painting, exploded. Bits of objects plus the odd arm or leg and even one or two whole people are going, literally, sky high. You can sense the artist's exuberance at his country's victory.

With the exception of Rubens—who travelled constantly and died a very wealthy man in a serene old age—many of the artists never left Holland and yet what moves and engrosses us in the art of Rembrandt, of Vermeer, of Hals is what they tell us about the human condition. Rembrandt, the Shakespeare of painters, tells us most because he goes deep and exposes that inner core of the self which is never manifested publicly. But if Rembrandt paints King Lear, what delights us in the work of Frans Hals is that he portrays the Merry Wives of Windsor.

Not a great deal is known about Hals. He was born in Antwerp around 1580, never travelled abroad, spent most of his life in Haarlem. He had two wives, twelve children and frequently couldn't pay his bills. He lived very long for the time, over 80 years, and, like Rembrandt, like Vermeer, died a poor man—in the workhouse that, ironically, is now the Frans Hals Museum.

His paintings are spread pretty evenly about Europe and America but what makes the trip to Haarlem more than worthwhile—and I rate the Frans Hals Museum as up there with The Frick Collection in terms of ambience, layout and consideration for the visitor—are the eight large pictures he painted over a period of 50 years.

There are five huge canvases of various Civic Guards painted between 1616 and 1639; another of the Regents of St Elizabeth's Hospital of 1641; and his two last works, executed in 1664 when he was over 80 years old, one of the Regents of the Old Men's Almshouse and the other of the Regentesses, both groups of whom were responsible for its administration.

What makes all these paintings so remarkable is that Hals had a genius for perceiving human character and the ability to reveal it. His best-known work is probably *The Laughing Cavalier* in the Wallace Collection in London. And his group paintings of the Civic Guards of Haarlem show similar, very largely confident, even complacent, well-to-do, well-fed men. Men who know who they are, where they stand in society and who are by no means displeased with themselves or their circumstances.

THE LAUGHING BOY, 1625

But my own favourite is a little circular picture that hangs in the Mauritshuis at The Hague called *The Laughing Boy*, painted around 1625. He's a child of about seven, his cheeks glowing with health, with thick hair that hasn't encountered a brush or comb lately, white teeth, full red lips and a broad grin. From the little we can see of the rest of him, he seems to be well dressed but his lace collar is scrumpled up—this is no posed portrait but a moment in a child's life caught for posterity, and it looks as though it was painted with the speed of a

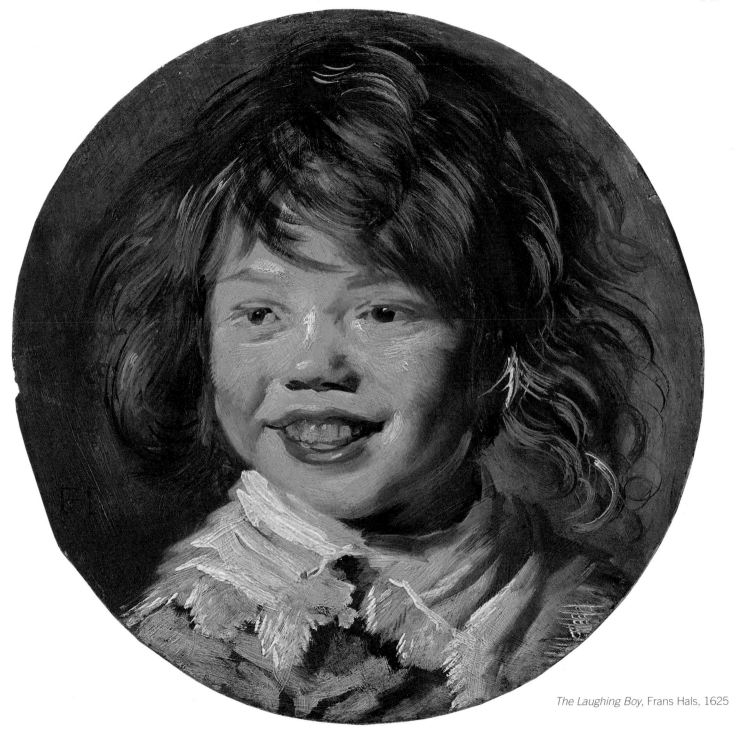

The Laughing Boy, Frans Hals, 1625

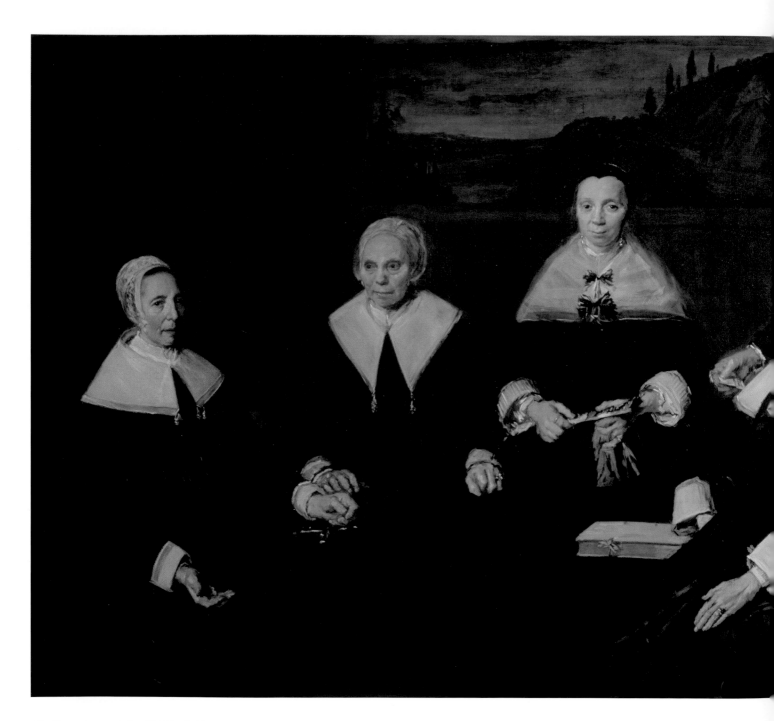

The Regentesses of the Old Men's Almshouse, Frans Hals, 1664

snapshot. There's no attempt at painstaking naturalism: Hals paints with swift, broad strokes and impatient highlights. The essence and the energy of the subject are perfectly captured, as are his innocence and vulnerability. This is a little boy joyously alive and one turns away from the painting hoping that life will be kind to him, will not diminish that innocent vitality which anticipates no ill.

THE REGENTESSES OF THE OLD MEN'S ALMSHOUSE, 1664

Forty years later, *The Regentesses of the Old Men's Almshouse* suggests that Hals' view of life has changed. What old man's heart would not palpitate with terror at the sight of these unyielding, obdurately severe, old women! Alert, watchful, implacable, you'd get justice from this quartet no doubt, but not mercy. Human kindness is conspicuously absent from these faces.

The painting is very dark—though it has faded over the centuries as well—and the picture seen dimly in the background, so dimly that now it is impossible to tell what it is, was probably the story of the Good Samaritan: an inventory of 1786 lists such a painting as hanging in their room.

They sit at a black table unrelieved but for a large brown folio with ribbon ties—the Bible? An account book?—on which the head lady's arm rests. The walls are dark; the women are all in black. The house mother responsible to them stands in the right background, leaning forward in anxious deference, holding out a small notebook. All of them wear big white collars that throw their faces into focus. The feel of the picture, apart from their hands, faces and the folio, all in shades of brown to yellow, is of black and white.

In front of the house mother sits the most important lady. Like all the others whose hands we can see, she wears a wedding ring. A black skullcap conceals her hair, and highlights in the folds of her dress suggest a richer fabric than that of her colleagues. Her dominant position is established by her possession of the large tome, by being in the strongest light, by her modest but unmistakeable pearl earrings and, most of all, by her posture. She

is upright, relaxed with the consciousness of power, unshakeably convinced of her rectitude and importance. Woe betide any who cross or displease her, the head lady. She surveys us with a confident hostility.

Standing to her left, the first of her three co-Regentesses, also with pearl earrings and a black cap, is more elaborately dressed: her white collar of some voile-like, translucent stuff has two elaborate bows and she carries gloves and a fan. Oddly, her wedding ring is on her index finger—perhaps because her ring finger is cruelly swollen. There's something smug about the set of her lips and the look in her dark eyes, both of which suggest a gloating malevolence.

The third Regentess is seated, in a white cap and a white collar with big revers. She is the most watchful of the group: those dark eyes have been alert to the least trace of dust for many years and she has reduced many a servant to tears and terror. She is the quickest to rage—we should be wary of her, though she's probably the least dangerous.

The final member of the quartet sits at the left end of the table, one hand resting on what might be a metal crucifix, the other with palm turned up—an odd posture. The hand seems to be resting on her knee, not uplifted, but the upturned palm seems at the least to be demanding: 'Where's your money?' She has a strong face with an expression somewhat withdrawn, tentative, even cautious. She looks the most fair-minded of the group.

The light source comes from down left, off the painting, and goes across to the head honcho, catching the collar of the house mother behind her and the right side of the Regentess at the far right.

What can the ladies and their husbands have thought of this painting that, presumably, they had commissioned? Two years earlier, the city of Haarlem gave Hals an annuity. He was one of them, had been a resident of the city for over 50 years and in two years time would be dead at the age of 84. Even if the commission had been an act of charity, the Trustees of the Almshouse were not obliged to display it and the painting was hung, not hidden away or destroyed, the usual fate of pictures that displeased an artist's patron.

'What old man's heart would not palpitate with terror at the sight of these unyielding, obdurately severe, old women! Alert, watchful, implacable, you'd get justice from this quartet no doubt, but not mercy.'

But it's only recently that everybody wants to be loved, wants to be shown as kindly and well disposed to their fellows. These are honest, respectable, God-fearing, leading citizens of Haarlem, doing a necessary work of administrative charity in the twilight of their years. None of them is under 50 and life expectancy at this period was well below that. Hals, it must be said, is harder on these women than he was on their male counterparts. The Regents—again painted against a very dark background; men dressed in black with big, white collars; seated and lit like their female colleagues; only the house father, standing again at the back on the right, looking beneficent—show a diversity of character and some sternness but none of the implacability of the Regentesses. But the ladies would not have expected to be flattered nor would they have wanted to be portrayed as smiling philanthropists.

They are not philanthropists; they are men and women doing their duty, a civic duty to keep the poor off the streets and a religious duty to assist those who are less fortunate than themselves. If they look stern and unyielding, that, too, is their duty. They would want to be seen as incorruptible, as models of uprightness so that the Almshouse may be seen to be properly administered.

So whatever subversive intentions the artist may have had, these ladies may have been well pleased with the fashion in which the old man portrayed them. With an attitude more sentimental than realistic, I see the acceptance of this wonderful group portrait as an act of defiance: 'Dislike us if you dare'—and though I'm very glad I'm not one of the poor at the receiving end of their alms, I enjoy looking at them hugely because of this enigma that the painting presents.

Renoir, centuries later, wrote, 'If a painting could be explained, it would no longer be a painting; it would no longer be art.'

Enough said.

A FIERY SOUL
MICHELANGELO MERISI DA CARAVAGGIO

Michelangelo Merisi da Caravaggio, one of the greatest and most influential artists, spent most of his life in trouble of some sort. His often brutally realistic treatment of the sufferings of the Christian martyrs and saints caused his paintings sometimes to be rejected by the churches that had commissioned them. His habit of using the people of the streets as models—a well-known prostitute appeared as both Mary Magdalene and St Catherine—caused outrage.

Apart from the pictures themselves—works of genius—much of what else we know about Caravaggio comes from the police records of contemporary Rome. Libel, assault, boy trouble—a charge not pressed—wearing an unlicensed sword, affray and, finally, murder. Despite having lived under the protection of two cardinals during his time in the Eternal City, Caravaggio's high-placed connections couldn't save him. From his hideout at Pugliano, he escaped from the papal jurisdiction that had condemned him to death to the Kingdom of Naples, thence to Sicily, then Malta, where he was imprisoned for some unrecorded offence, escaped from a maximum-security fortress and fled back to Italy where he died, aged 39, perhaps of malaria, perhaps murdered, on a lonely seashore.

These two versions of *Supper at Emmaus*, painted five years apart, are a wonderful illustration of Caravaggio's development in the art of storytelling. In the theatre, I've always held that a director's primary function is to tell the story as clearly as possible, which is why I'm fairly contemptuous of the 'Let's do *Salome* on rollerskates' school of direction, and I think that in narrative painting, the same should be true.

The composition of both canvases is similar: Christ sits at a table facing us, with a disciple on either side and the innkeeper or a servant—two in the 1606 painting, but all wearing white caps—in attendance. The table has an embroidered or figured tapestry on it over which there is a white cloth covering just its top. In both pictures there is a meal on the table and the light source comes from the left.

SUPPER AT EMMAUS, 1601

In the 1601 painting, this light is strong. It highlights the white cap and clothes of the innkeeper who stands to the left of Christ and who is listening intently. The light throws his shadow on to the wall behind Christ.

On the left of the picture, it picks out the head of a younger man, seated almost with his back to us, the upper half of his dark-green coat, worn at one elbow, and a brown cloak which lies over the back of his chair. Both his hands are on its arms and he seems about to rise.

Christ, naturally, is brilliantly illuminated, as are his red robe and the white cloak draped over one shoulder and across his body. He has one arm outstretched, the other hand slightly raised from the table, as if admonishingly or restrainingly.

The elderly disciple on the other side of Christ might be St Peter or might not. He has a shell fixed to his brown leather jerkin, which could make him St James as the shell is his emblem. Under the jerkin is a white shirt, the downstage sleeve of which, like Christ's, catches the light, as does the white napkin on his lap. He has both arms outstretched wide in amazement.

The table is well stocked: a bowl of fruit, some of it starting to go bad—an image beloved of Caravaggio, passionate as he was to show life as it is—a scrawny roast chicken on a platter; bread before all three diners; a glass carafe, half-filled with water; a jug; a solitary glass of white wine. There is much to look at.

Something has just happened but it's not clear what. Christ, a round-faced, beardless, rather feminine-looking man, has his eyes cast down. We know from the Gospels what the story is, though only St Luke tells it, and we can deduce that the younger man must be Cleophas, whose wife, St John recounts, was one of the women at the foot of the Cross:

And behold, two of them went that same day to a village called Emmaus ... and they talked together of all these things which had happened. And it came to pass that, while they communed together and reasoned, Jesus himself drew near and went with them. But their eyes were holden that they should not know him ... and one of them, whose name was Cleophas, said unto him, 'Art thou only a stranger in Jerusalem and hast not known of the things which are come to pass in these days?' ... And they drew nigh unto the village whither they went; and he made as though he would have gone further. But they constrained him, saying, 'Abide with us: for it is towards evening and the day is far spent.' And he went in to tarry with them. And it came to pass, as he sat at meat with them, he took bread and blessed it, and brake, and gave to them. And their eyes were opened and they knew him; and he vanished out of their sight.

So the subject is a well-known one and has been painted by many artists—stupendously by Rembrandt. But although Caravaggio's picture is wonderfully executed, the story doesn't quite cohere. There's a brilliantly painted supper table and four equally brilliant portraits but they don't connect entirely, don't come together. The innkeeper needn't know who Christ or the other men are, of course; they're just customers who've stopped for supper. Yet he is listening, nonetheless, very intently to what Christ, the focus of the painting, is or has been saying. So intently that he

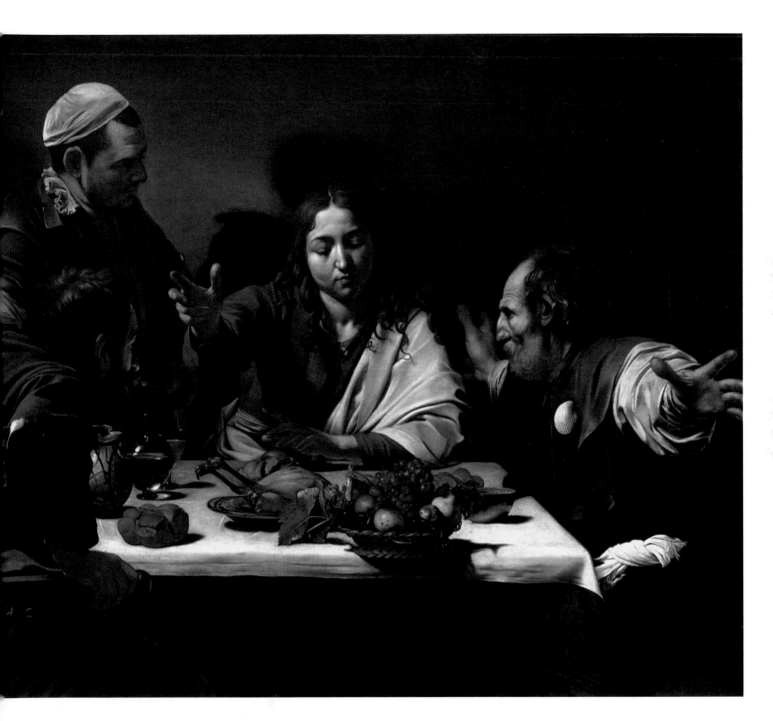

Supper at Emmaus, Michelangelo Merisi da Caravaggio, 1601

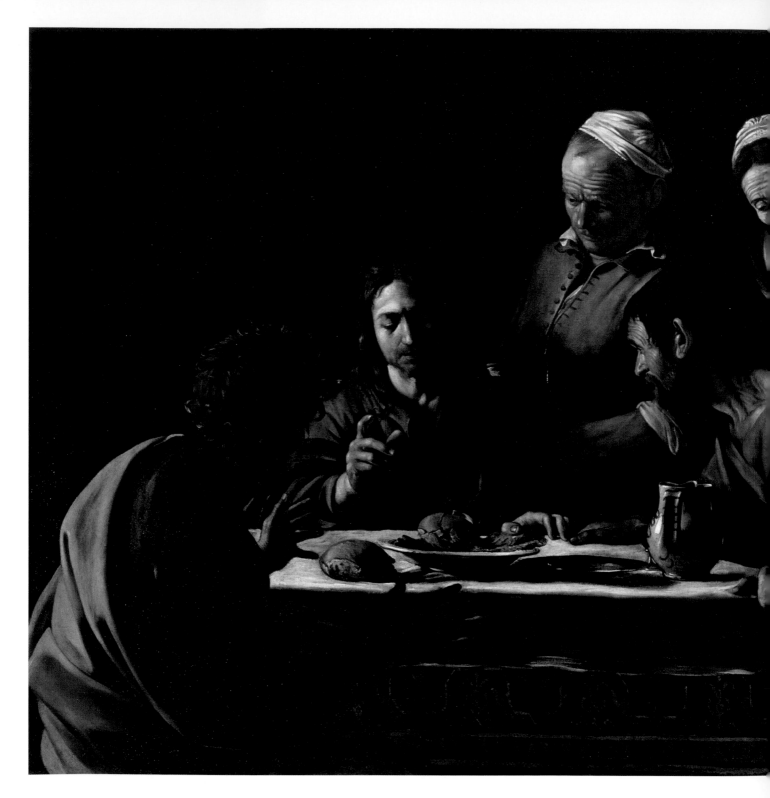

Supper at Emmaus, Michelangelo Merisi da Caravaggio, 1606

seems unaware of the dramatic, physical reactions of Peter and Cleophas. We have to assume that Christ has broken, or is about to break, bread and that the two disciples have suddenly, at this instant, realised who he is. Christ himself is solemn but impassive, doughily unanimated. Without the benefit of knowing the story, we might assume that an argument was in progress.

Five years later, when Caravaggio was in hiding on the estate of Filippo Colonna at Pugliano on the run from a murder charge in Rome, he painted the picture again. Five years is a fair while and life had changed for Caravaggio and so, maybe, had his attitude to life. There's a difference between being the toast of artistic Rome and facing a charge of murder of which you know you're guilty.

Whatever the reason, the second picture is compellingly different, both in atmosphere and in the way the story is told us.

SUPPER AT EMMAUS, 1606

In 1606, Caravaggio's palette is darker, more restricted, even restrained. Though the light source comes from the same direction in both paintings, there's a lot less of it here and there's no one between it and the face of Christ. The innkeeper, an older man this time with an anxious, lined face, is on the other side of Christ, to the right, and has been joined by an old woman, more careworn than he, holding a dish of what looks like roast meat and, like him, wearing a white cap. The innkeeper, like his predecessor, is listening intently. I'm not sure she is—like a patient, old animal, she's just standing there, her mind an exhausted vacuum, waiting till she can put the meat down on the table and go back to the kitchen.

The disciples, in contrast, are younger. The Cleophas figure has his back to us entirely; Peter is leaning forward to Christ. His hair and beard are dark, he has big ears and his age is visible in his neck.

Christ is older than the portrayal of five years before, bearded and handsome—a man. A man, moreover, whom you'd think worth listening to; a man whose knowledge has been gained through experience and suffering. I wouldn't give the impassive, puddingy

'Caravaggio has an unsparing devotion to reality—the boys are not idealised, they have dirty fingernails or tangled hair or callused palms; and he won't paint a bowl of wholly perfect fruit, there'll always be a spot of decay or a worm having lunch.'

Christ of 1601 very much of my time but this man is a thinker and is speaking seriously, one hand raised in emphasis.

There are no unanswered questions to distract us from the painting—in this dimly lit, sombre room something important is being said and all the subsidiary characters are focused intently on the protagonist.

Caravaggio never lapses into prettiness or sentimentality. Even with his defiantly patent predilection for adolescent males, he's never soupy about them. I find some of them drearily tarty, but that's a matter of personal taste, and certainly the wonderful St John the Baptist that hangs in the Kansas art museum is a seventeen-year-old with whom anyone would be pleased to share a wilderness. Caravaggio has an unsparing devotion to reality—the boys are not idealised, they have dirty fingernails or tangled hair or callused palms; and he won't paint a bowl of wholly perfect fruit, there'll always be a spot of decay or a worm having lunch.

He knows that life is tough and rough and he shows old age and man's inhumanity to man as it is. I can hardly bear to look at his *Crucifixion of St Andrew*—though I've only, alas, seen it in reproduction; we have to go to Ohio to see the real thing—because the poor saint is so old, his body is so shrunken and wasted, his face so filled with the agony he has endured for two long days, you think, 'Oh poor old bugger, why did they have to do that to him?' So with the servants in this wonderful *Supper at Emmaus*: they have worked hard all their lives and are still working because there's no alternative and will be none until they die.

Caravaggio's greatest and most famous achievement is in his use of light. Most successive artists learned from him—even Rembrandt. But despite, for me, Rembrandt's status as the greatest of painters, the Shakespeare of painters, Caravaggio is supreme in his challenging, immensely dramatic, use of light.

It's not just a way of focusing our attention; he makes us re-examine a story we already know. He's not afraid of darkness or shadow. If it's not important to the story, he'll leave it out. The 1606 *Supper at Emmaus* is set against a dark and anonymous background. The interior decoration of the room isn't relevant, so he doesn't bother with it.

There's a similar refinement with the table. In the earlier painting, it's brightly lit and crowded with distractions ('Oh, look at that chicken's legs, the spots on that apple'), but five years later, Caravaggio's stripped it to the minimum needed to tell the story: bread and a jug which could contain wine—the body and blood that are the elements of Communion.

These two pictures perfectly illustrate the way in which this troubled and troublesome genius refined his art in the course of his short life, darkening and deepening it both literally and metaphorically.

As Dryden wrote of the Earl of Shaftesbury:

A fiery soul, which working out its way
Fretted the pygmy body to decay
And o'er-informed the tenement of clay.

THE FIRST MODERN PAINTER
FRANCISCO GOYA

Until the Peninsular War of 1808–14, Goya was a distinguished and extremely successful court painter: a dab hand in diverse fields of artistic endeavour, of enormous technical skill and with a radiant use of colour. What marked him out was a perhaps surprising interest in the grotesque, the mad, the supernatural, the Inquisition—still a potent force—all of which he rendered in a style very different from the luminous delicacy of his celebrations of beauty and wealth and using a vastly different palette. Essentially, however, he was, like many artists, obliged to run with the hare and hunt with the hounds, concealing his true beliefs so that he might be accepted by his patrons and by the court on whom he depended for a livelihood. This may or may not have been easy for him but he did it—although with his unsparing portrait of the oafish Ferdinand VII he sailed pretty close to the wind.

But the war, long, drawn out, bloody, inhuman and inhumane, stirred him to greatness, to a furious vision of the darkest corners of human violence and cruelty. *The Colossus*, 'The Disasters of War', 'Los Caprichos' and the mysterious and terrifying 'Black Paintings' reveal him to be the father of modernity, the possessor of a unique and bleak vision of the human condition, which anticipates the horrors of the twentieth century.

There are certain pictures that haunt the memory. These are not necessarily paintings one loves. But they hover on the fringes of one's mind like a half-forgotten dream, ready to be prodded into remembrance. Like a recurrent nightmare, they're always there, waiting at the portals of consciousness, ready to re-enter and terrorise you once more.

The Colossus is one such picture. Goya painted it in 1811, three years into the war and, despite its nightmarish atmosphere of menace and panic, it is recognisably the court painter Goya. The authenticity of the painting has been questioned lately and in a recent Madrid exhibition the Prado did not include it. The dispute continues but, for a non-art historian like me, who the painter was doesn't matter enormously. It's still a terrific and disturbing picture.

THE COLOSSUS, 1811

Against a lowering sky stands a colossal man, strong and well proportioned, fists raised threateningly, naked, with his back to us. He is dark and bearded and from the left of the canvas the setting sun—or maybe the glow of fire—picks out a fist, an upper arm, his torso, his face, tingeing his body with pink. A range of low hills rises to his upper thighs, giving us an idea of how huge he is, as do the low clouds, also tinged with pink, about his thighs and buttocks.

In the valley behind him, and closer to us, a multitude of people, stock animals, wagons and carts are stampeding, fleeing in panic, some down the valley to the far left, some towards the hills in the foreground. The valley is enclosed on three sides. Cows, now forgotten by their panic-stricken owners, are running directly away from the giant towards us, while the human train of wagons and carts fleeing to the left must be making for a pass leading out of this dangerously confined space. Horses, perhaps dependent on or attached to man, flee with the humans. In the very left corner of the painting, a man on a galloping horse is disappearing off the edge of the canvas while a dog races frantically to keep up with its master; behind it another man is falling off his horse. Further back a white mule stands still, waiting to be directed.

'It's the tension of uncertainty that makes this picture—apparently painted by Goya for himself since he neither sold nor exhibited it—stick in the memory, that creates a nightmare dread. This giant human is a terror from the depths of the unconscious.'

On the hills to the right of the painting are the outlines of what might be or might have been a town. We can imagine that the people fleeing along the floor of the valley have been its inhabitants.

We have no idea if the Colossus has harmed anyone or anything. It's not necessary for him to have done so to create this terrified exodus. Here is this thing of unimaginable size, Gulliver among the Lilliputians, and clearly, though turned away from the valley, hostile. At any moment he could swing around and scoop up people, wagons and animals in his massive hands, scattering them like confetti to the sky.

What gives us the feel of phantasmagoria is that nothing has happened yet but at any moment it could. Will we manage to escape in time? Come, run, run, run! It's the tension of uncertainty that makes this picture—apparently painted by Goya for himself since he neither sold nor exhibited it—stick in the memory, that creates a nightmare dread. This giant human is a terror from the depths of the unconscious.

In 1819, at the age of 72, Goya bought La Quinta del Sordo, an isolated farmhouse in the country near Madrid. Here he painted fourteen pictures, 'The Black Paintings', directly onto

The Colossus, Francisco Goya, 1811

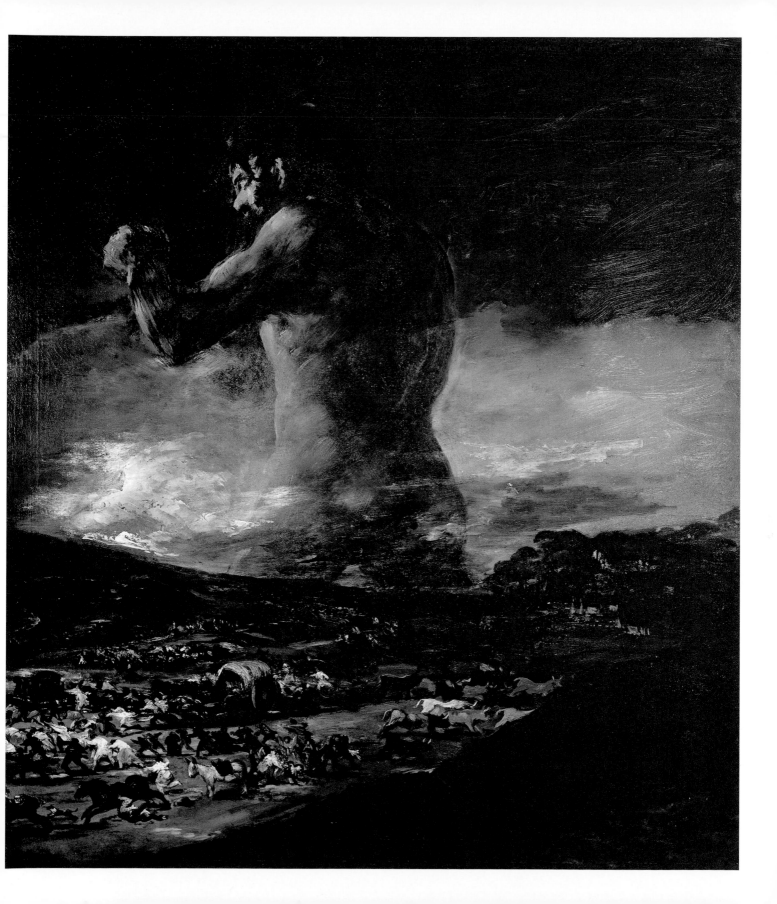

The Dog,
Francisco Goya, 1821–23

the walls of the two largest rooms in the house. He painted them for no one but himself for they had not been heard of until they were 'discovered' 50 years after his death. Five years after purchasing La Quinta, he went into self-imposed exile in France where he remained until his death, apart from one brief visit to Madrid; he therefore probably never saw 'The Black Paintings' again. Already there is mystery. At their discovery they were found to be in a deteriorating condition and their transference to canvas damaged most of them still more. The paintings, individually and collectively, are, to say the least, enigmatic.

THE DOG, 1821–23

One of the most disturbing pictures is *The Dog*. It's rather a large canvas, twice as high as it is wide. Three-quarters of the picture is an impressionistic rendering of, probably, the sky. It is painted in brown and yellow over a grey background which, where the grey is allowed to show through, suggests the blue of sky. Dark at the top with a large ochre section to the right, it becomes paler towards the bottom of the canvas and light comes from the lower left. Here, in what is only a sixth of the painting's height, is what turns out to be a dark hill once it begins to slope upwards from the middle of the painting. As the hill begins to climb, there is the head of a dog in profile, looking up the hill and off the canvas. Just its head. Its ears and the back of its head are whitened by the light source from the left; its face, muzzle and nose, facing away from the light, are dark. Its visible eye is outlined in white. That is all that's in the picture.

We are immediately worried about this dog, anxious for its safety. Though patient, it looks upwards in appeal. Perhaps it is waiting for its master. Perhaps it is trapped, unable to move. The postcard on sale in the Prado bookshop calls it 'Dog half submerged in sand'. This is an imaginative leap forward not entirely warranted but it recognises a universal concern for the dog and intensifies it.

Is it sinking in quicksand? Probably not—for if it were it would be struggling to free itself, and as far as we can tell the dog is not even anxious or impatient. It's just there, waiting for something. If Goya's painting were a 'story' picture with a title like those beloved of the Victorians, it would be called 'Are You Coming?'

But we're still worried for the dog. It is so very alone. And why are we only seeing its head? Is it waiting, like the patient tramps, for some canine Godot? It looks as if it's a nice dog, and the more we stare, the more we see the appeal in its eye, in the language of its head raised to look up the hill. There's nothing in the picture except the dog so the dog must be what the picture's about.

We walk away from the painting troubled, unsatisfied, turn back in case … what? In case the dog has moved or help has arrived while we haven't been looking?

E.M. Forster raises the philosophical question of reality and illusion in *The Longest Journey* as his undergraduates discuss whether or not the cow in the field is there only when there is someone to see it. But Mr Forster took an entertaining chapter of his novel to explore this idea. Goya does it in this painting.

Is it a beautiful painting? Would we like to own it? I don't think I would—the dog would make me feel guilty. But guilty about what? It's

not my dog. I wish it were, then I'd whistle for it and it would come to me or I'd go down and help it. Goya's getting at me in this picture. Getting to me as well, getting under my skin. Perhaps he's saying not just that we're alone but that we are responsible for each other nonetheless. That, at least, makes me feel better about the dog.

This may not sound as if I take the painting very seriously. But I do: I'm puzzled, intrigued, challenged. But, most of all, troubled by it. And once seen it sticks in the memory.

SATURN DEVOURING ONE OF HIS SONS, 1821–23

The most frightening of 'The Black Paintings' is *Saturn Devouring One of His Sons*. Saturn's father, Uranus, treated his progeny with great cruelty and so, armed with a magical scythe made of metal drawn from the bowels of his mother, Saturn emasculated his father so he could produce no more children to ill treat. In gratitude, Saturn's brothers gave him the throne provided that he never reared any male children. They evidently didn't want their brother to establish a dynasty. Saturn therefore devoured his sons as they were born. Another story tells of a prophecy that he would be usurped by one of his sons, so that became the reason he devoured them all. All except Jupiter who, concealed by his mother, survived to become king of the gods and to defeat his father as his father had defeated his.

Saturn is often shown as old and sick, frail but armed with his scythe. His Greek name is Chronos, so even relatively uneducated people would recognise him as Time, the oldest of the gods. Goya would, of course, have known this, as would his educated contemporary viewers had 'The Black Paintings' been intended for public exhibition.

In the painting—roughly the same size and rectangular shape as *The Dog*—Saturn is a huge, skinny old man with dishevelled white hair and beard, both knees bent, almost crouching, with wide-staring, barely human eyes. You look at nothing else because the background is unrelieved black. His face is weather-beaten, his naked body much paler, and his mouth is unnaturally large, a

Saturn Devouring One of His Sons,
Francisco Goya, 1821–23

'… some hideous automatic pilot has taken him over. He may be mad with grief or with terror at what he's done, what he's doing, but he won't stop, he can't stop.'

square black hole. His eyes stare into the void with compulsive hysteria. They're circles of black, these eyes, completely surrounded by the whites of the iris; it's as if they're leaping out of his head. Wanting to do what he's doing or not wanting to do what he's doing doesn't come into it: he's driven to it, he can't stop himself—some hideous automatic pilot has taken him over. He may be mad with grief or with terror at what he's done, what he's doing, but he won't stop, he can't stop.

The figure he holds has had an arm bitten off at the elbow and Saturn is thrusting the remainder, streaming with blood, into his open mouth. He has already eaten the head and the other arm so the top of the body is thick with red. He grips his victim tightly by the waist—so tightly that blood oozes from the top of his hands, from between his fingers.

So far, so legendary. But the victim's pendent buttocks and rounded thighs never belonged to a man or a boy. To me, at least, it is clear that Saturn is eating one of his daughters.

This doesn't make the picture either more or less alarming. But, as with *The Dog*, we are haunted by 'what does it mean?' The answer can only be subjective, conjectural, as Goya left no clue as to what his intention was in executing these fourteen paintings: he didn't entitle them, he didn't intend to sell or show them; didn't even intend them to be seen. They are paintings for himself, the expression of a deeply troubled psyche. Man is a destroyer. Is Saturn man? Or Goya himself? Or Fate?

THE WITCHY BREW, 1821–23

As Goya didn't christen the pictures himself, one must beware not only of the names they have been given but also of the English versions of them. *The Witchy Brew*, a flight of fancy if ever there was one, is called more simply in Spanish *Dos Viejos Comiendo* (Two Old People Eating), or *Los Brujas* (The Sorcerers). Old age is not normally an agreeable experience: everything

The Witchy Brew, Francisco Goya, 1821–23

begins to fail. My mother used to say 'old age is no picnic'; while Oscar Wilde, more famously, declared that 'the trouble with age is not that one is old but that one is young'. Memory, sight, hearing, taste begin to fade; the body won't do what it used to without any thought or effort on your part. Finally, according to Shakespeare, it's 'sans eyes, sans teeth, sans taste, sans everything' to bring 'this strange, eventful history' to an often longed-for conclusion. Goya was, for his time, a very old man when he made these

paintings between the ages of 74 and 77. So it's easy, tempting, to see in *The Witchy Brew* a masochistic, self-hating revulsion at what we may become.

She, balding, swathed in a ragged bundle, eyes staring fixedly, perhaps malevolently, lips stretched in a toothless grimace, holds a soup spoon poised over a bowl. Her other gnarled hand points off the canvas. Behind her, the old man, a skull with a fringe of hair, his eyes mere cavernous sockets, points too, the same index finger outstretched in the same direction as hers. They don't wish whoever they're looking at well, yet their age renders them defenceless. I'd like them to be witches—that would at least grant them some power, albeit a malign one. But equally the title *Los Brujas* given the painting by Charles Yriarte, the first person to provide names for 'The Black Paintings' in 1867, many years after Goya's death, may be completely misleading: they're not a witch and her grotesque consort at all who, having prepared some noxious concoction, are saying, '"Will you walk into my parlour?" said the spider to the fly.' Perhaps they are merely two old people about to eat.

The painting evokes T.S. Eliot's verse on the Jacobean playwright John Webster, words that could equally apply to Goya's portrayal of old age:

> *Webster was much possessed by death*
> *And saw the skull beneath the skin;*
> *And breastless creatures underground*
> *Leaned upwards in a lipless grin.*

This couple are not dead nor do they wish to be. They are very much alive. Their vitality, inappropriate as it may seem to compassionate viewers of the painting younger than they, is real, avid, and whether or not they draw pleasure from being alive, they are determined to continue in that state for as long as possible. But, equally, the unseen intruder may be death and their pointing fingers recognise and invite him in. Whichever it may be, whatever it may be, like *The Dog*, like *Saturn*, once seen these two old people are not to be put away in a box marked 'Forgotten.' You can't get rid of them.

'This is an ambush: no one has seen them except, perhaps, the couple floating in the sky; which might be the cause of the young man's distress.'

ASMODEUS, 1821–23

With the painting called *Asmodeus*—also called *Asmodea* by those who see the central figure as female—we can spend a great deal of time delving into the legends surrounding this angel, sometimes known as 'the Angel of Death'. But since 'The Black Paintings' were only titled by Goya's friends, and by scholars and critics subsequently, it may be better to give the pictures space and to let them speak, to tell their own story. We can then approach the painting without worrying about an angel or if he/she is indeed one and just look at it instead.

Where Goya first directs us is to a woman in a white dress and a rose-coloured cloak floating in the sky—the same livid-coloured sky as in *The Dog*—apparently supporting a young man airborne beside her. He may be deranged; he is certainly deeply disturbed. She looks off to the left of the canvas, he to the right. Lips in a rictus of terror or anguish, with his left hand he points to the mountain in the background which occupies the other half of the canvas to the aerial couple. On its mesa-like summit is a fortified town.

At its base is a considerable concourse of people, horses and wagons, the line of which stretches away into the distance off to the left of the canvas. They are advancing up a road that winds away to the right, round the side of the mountain and leading, we may infer, to the town. These people, refugees perhaps, seem to be escorted by a number of cavalrymen in white-plumed helmets. Or perhaps these soldiers have come down from the mountain-top town to meet the cavalcade.

In the extreme right-hand corner of the painting are two French soldiers. They have their backs to us—like the French soldiers in Goya's *The Executions of the Third of May, 1808*—but we can tell they are French from the shape of their hats and from the red plume in one of them. Their rifles are raised and they are taking aim at the cavalrymen and the procession of refugees. This is an ambush: no one has seen them except, perhaps, the couple floating in the sky; which might be the cause of the young man's distress.

So this is a painting in which something is about to happen. Of this much we can be sure: the soldiers are ambushing a group of their

Asmodeus, Francisco Goya, 1821–23

adversaries or a train of refugees who may be on their way to seek refuge in the town on the mountain top. This is the palpable tension in the canvas: an incident in a war—one which happened many times during the brutal conflict of 1808–14 no doubt. The rest is problematic.

Other writers on the picture see the two figures in the sky as both female. Robert Hughes, in his fine book *Goya*, even describes the figure I perceive to be a young man as 'somewhat like Katharine Hepburn far gone in old age'. He sees the other figure as clinging to this person whereas I see her as supporting him. This is not to take issue with so distinguished a critic but merely to indicate that the enigmatic quality of these paintings 'may admit of a wide solution'.

The boy is not trying to warn the cavalrymen of their impending destruction. Mouth wide open and eyes staring in terror, he is pointing to the mountain top while looking beyond but in the same direction as the Frenchmen. There may be more soldiers beyond them whom Goya has not chosen to portray. His companion, possibly equally distressed, is looking in the opposite direction to the ambush.

The painting is beautiful, suffused with an aureate haze. The strange airborne couple create a distancing, almost surreal effect that prevents too close an involvement with the fate of the other people in the picture, who are anyway in the background. But the rose-pink cloak in the upper left of the canvas carries us diagonally across to the red plume in the Frenchman's hat at bottom right. Apart from this, the picture is muted—black, white, brown, yellow, hints of blue in the mountain and the sky. But the two points of colour intentionally and inevitably link the two components of

Asmodeus: an ambush and two figures floating in the air. We may puzzle and wonder at what the connection is but we know it is there.

DUEL WITH CLUBS, 1821–23

Duel with Clubs, also called *Two Strangers*, is the most direct and the most confronting of 'The Black Paintings'. The setting is rural, isolated. Day with large patches of blue sky breaking through the clouds—one of the few of these pictures not shrouded in darkness. A farmhouse in the distance, grazing cows. Not a pastoral scene, however; the countryside is too untended for that. Like all 'The Black Paintings' it is set in a mountainous and inhospitable region.

Occupying the foreground of the left half of the canvas are two men. They are up to their knees in earth or sand so they cannot move. Each has a raised cudgel and they are going to keep fighting each other until one of them is dead. There is a frightful inevitability in the brutality of this scene.

The man on the left, his cudgel upraised to bring down on his opponent, is dark, curly haired and bearded. His face and neck stream blood from wounds to his eye, his ear, his throat. The other, one arm raised to shield his face and head from his enemy's blows, looks younger. His weapon is swung back at waist height, about to attack again. There is no sign he has yet been wounded.

What appals one about this picture is that, as neither of the men can move, this fight will continue, has to continue, to the death. Some say that this horrible confrontation was a way of settling grievances, of ending a blood feud,

Duel with Clubs, Francisco Goya, 1821–23

in certain peasant communities. But it seems unlikely that Goya is concerned merely with the tabling of primitive customs. In its barbarity, its lack of sense and humanity, it may be emblematic of the destruction Spaniards wrought upon each other in the conflict which Goya recorded in his series of great etchings 'The Disasters of War', a brutality which continued in the internecine struggle of the Spanish Civil War in the twentieth century.

There are no dark powers at work here, no supernatural or demonic agencies to seduce or corrupt and thereby excuse human folly as there are in *The Witches' Sabbath* or in *The Fates*. Here is mankind on its own, irredeemably stupid and brutal, destroying itself. There is no hope for humanity, no future. These two men didn't get here by chance, suddenly both find themselves mired in mud to their knees, unable to move, armed, coincidentally, with identical weapons. This hideous ritual has been deliberately set up.

Shakespeare, in *Troilus and Cressida*, depicts a time of chaos when man:

Must make perforce an universal prey
And last eat up himself.

This is what Goya depicts in *Duel with Clubs*, the nadir of the anguished pessimism that forced him to create this enigmatic but unforgettable series of paintings.

EXOTIC TALES
VITTORE CARPACCIO

Some painters stab me through the heart, others make my jaw drop, give me the giggles, turn me on, but with Vittore Carpaccio there is such a richness of incident, such a wealth of detail, such jewel-like colour, such well-told stories, that 'delight' best sums up the sensation and emotion which his art arouses in me. Standing before one of his paintings, I'm like a child examining the pictures in a lavishly illustrated book of fairytales.

Sometimes, it might be argued, these gifts carry him away and subsume the story of the painting. His *Miracle of the Relic of the True Cross*, for instance, in the Accademia in Venice, purports to be about the Doge effecting a miraculous cure, but the real subject and focus of attention is Venice with all its colour and bustle, its merchants, its idlers, its skyline with curious chimney pots, its gondolas, its inhabitants with their fascinating clothes and hats and hairstyles, all going about their diverse businesses.

In Carpaccio's monumental cycle of paintings depicting the life of St Ursula—which made his name when, in 1497, it was first exhibited to a delighted public—Venice is never absent despite the peregrinations of its central character. London and Cologne look just like Venice and everyone is dressed in the height of quattrocento fashion. Not that this detracts from the paintings—one is too intrigued even to think about logic or naturalism.

However, somewhat off the beaten track, heading towards the Arsenale, is the Scuola di San Giorgio degli Schiavoni. Within it are a number of pictures by Carpaccio, painted between 1502–07, and set in exotic and legendary locations—if anything can be more exotic than Venice itself. These are pictures small enough for us to delight in if we were lucky enough to have one of them at home, hanging above our fireplace.

Here is St Augustine at his desk in an elegant and spacious study filled with interesting objects, receiving a vision through the window beside him and completely upstaged by a small white dog at the other side of the painting, waiting, alertly, to be taken for a walk.

Here is St Jerome, accompanied by the lion whose paw he made better by the removal of a thorn, returning to his monastery. Terrified animals, birds and, especially, monks are fleeing from him and his companion. The saint is trying to explain that the lion is harmless and the lion himself is helpfully extending the injured paw. But it's to no avail and these white-robed young men, in surprisingly pretty blue surplices, are legging it to safety as fast as they can.

Here is St Trifone, having exorcised a demon from the daughter of the Roman Emperor Gordian I. The small saint, a little boy, has his hands clasped in thanksgiving and is just about succeeding in not looking pleased with himself. The demon, a dog-sized animal with a nice curly tail, the head of a small ass, curious wings and a mouth wide open in astonishment and disapproval, has been ousted from the body of the emperor's daughter unexpectedly and is not happy about it.

Best of all, here is St George, incapacitating the dragon in one picture, decapitating it to the applause of the local townspeople in a second, and, in a third, converting the entire population to Christianity.

The city of Selene had long been terrorised by this dragon, a creature initially content with animals for its sustenance but latterly demanding human food. Lots were drawn to fulfill this unfriendly requirement from which no one was exempted and finally the sultan's daughter drew the short straw. By the happiest of coincidences, just as the unfortunate princess had been deposited in the dragon's feeding grounds, the cavalry, in the person of St George, came to the rescue, which is what Carpaccio shows us in the first picture, *St George and the Dragon*.

ST GEORGE AND THE DRAGON, C. 1507

Here we see, on the outskirts of Selene, its tower crowded with phalanxes of interested spectators, the dragon being attacked by a blond and handsome St George. It has the body of a large dog with leathery, scaled wings and a very long serpentine tail. The saint has a concentrated and determined expression and

is mounted on a charger, which is courageously ignoring the unpleasant detritus over which it has to leap. St George's long red lance has gone right into the dragon's mouth and out the other side, through the back of its head. The impetus has snapped the lance in two. The dragon's mouth streams blood and its claws, which look more alarming than the rest of it, have been upraised to strike.

To the right of the picture is the princess, hands upraised in 'I hope he pulls it off' entreaty and dressed in red, linking her to St George's lance and his horse's harness and who, but for the intervention of the saint, would presumably have been the dragon's next meal.

The dragon has not been much of a challenge for St George— not nearly so much as the dragon in Uccello's version of the story in the National Gallery in London. This is a huge, green-winged monster with really threatening incisors; a fearsome beast, despite the coloured circles on its wings.

But Carpaccio's must be a pretty nasty dragon nonetheless because the ground in his picture is littered with the grisly remains of its previous repasts—the upper half only of a fair-haired princess, many skulls and bones, some arranged tastefully together, a skeleton propped against the side of a sandpit and, under the path of St George's horse, the body of a man on whom the dragon has obviously snacked from time to time—it has eaten both arms and one leg. Snakes, toads and a number of lizards are hissing angrily at the intruders while a baby dragon stares greedily at the dismembered man's crotch.

St George and the Dragon,
Vittore Carpaccio, c. 1507

THE TRIUMPH OF ST GEORGE, c. 1507

In an adjacent painting, *The Triumph of St George*, the saint has arrived in the town square. He has dismounted from his charger and, in the middle of the canvas, is about to decapitate the dragon in front of an admiring crowd of city fathers, who must be looking forward to the boom in tourism that this timely rescue will open up. While the dragon never looked really formidable, though possessed of a nasty temper and a voracious appetite no doubt,

'But Carpaccio's must be a pretty nasty dragon nonetheless because the ground in his picture is littered with the grisly remains of its previous repasts …'

'More citizens crowd balconies and rooftops while in the background is a handsome hexagonal building with a fine dome and flags all round it, fluttering bravely in the breeze.'

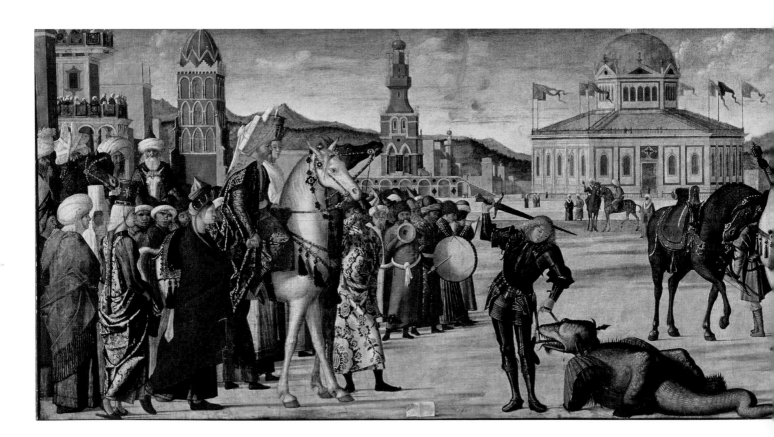

The Triumph of St George, Vittore Carpaccio, c. 1507

it seems much less ferocious now—a poor, pathetic pantomime shell, the remnants of the saint's lance still in its head.

To St George's right are the sultan and sultana, impressively robed, she in a white dress and a red hat, he in a white hat and red robes, mounted on white and black horses respectively. By her father's side and holding his hand is the rescued princess. A pity St George had to be a saint.

Behind them are dignitaries in big white turbans and colourful robes, and further upstage is a band with near-Eastern trumpets and drums, perhaps, and I hope, playing 'Hail the Conquering Hero Comes'. More citizens crowd balconies and rooftops while in the background is a handsome hexagonal building with a fine dome and flags all round it, fluttering bravely in the breeze.

Behind St George and to his left is his horse, pawing the ground and surveying a riderless white mare beside him, whose head is turned skittishly away from him. Then more dignitaries, some on handsomely caparisoned mounts, some on foot. All the inhabitants of this appealing city boast an impressive array of turbans and robes in whose textures and patterns Carpaccio has given himself an entertaining challenge—to which, of course, he is more than equal.

THE CONVERSION OF THE SELENITES, c. 1507

In the third painting, *The Conversion of the Selenites*, the saint, a red cloak draped over his black armour, stands to the right of the canvas at the top of a flight of white steps decorated with red lozenges. He holds a bowl of water and is about to baptise the sultan and his daughter, who are kneeling before him. With an unexpected concern for his wardrobe, he has pulled his cloak away from the action with his free hand to prevent it being splashed. A supercilious-looking page stands beside him, holding a large and ornate jug containing, presumably, further baptismal supplies. He does have the entire population to christen, after all.

The sultana stands behind her husband, and at the bottom of the steps are three gorgeously robed men on their knees, awaiting their turn. One has thoughtfully removed his red and white turban

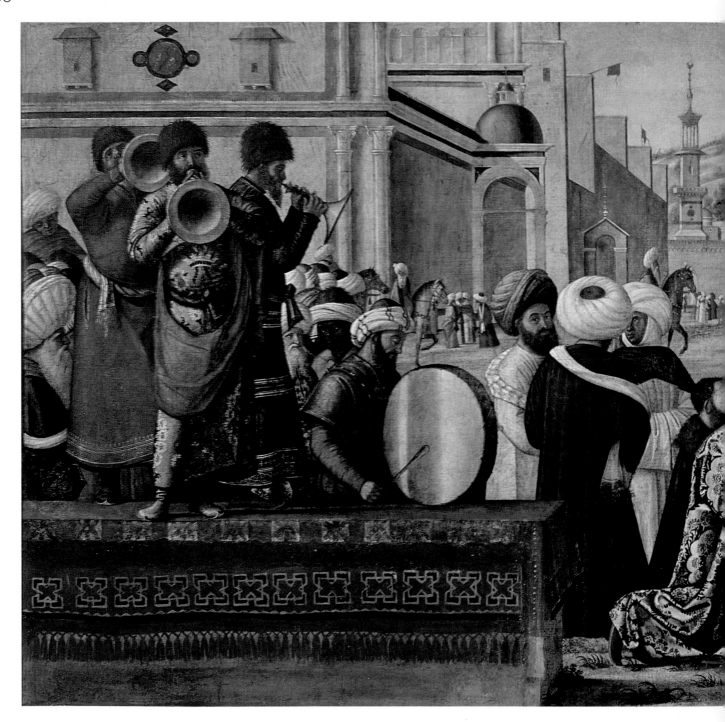

The Conversion of the Selenites, Vittore Carpaccio, c. 1507

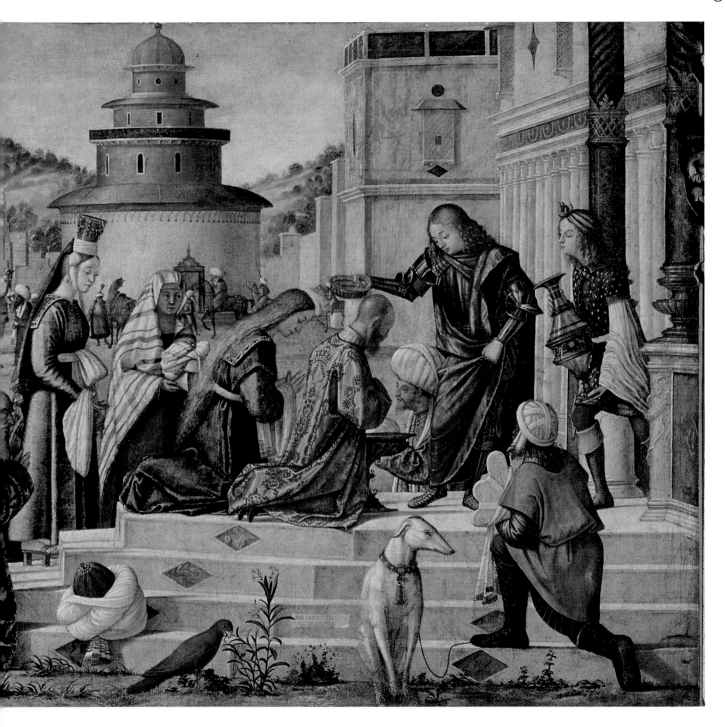

'I don't wish my light-hearted description of these beautiful and engrossing paintings to suggest any disrespect for Carpaccio. His pictures give me such undiluted enjoyment that my response to them bubbles over with pleasure.'

in readiness. Carpaccio is a good storyteller. Beside the turban, at the foot of the steps, is a large red parrot, lunching on a nearby plant and further along a white greyhound is looking off the canvas. Sensible creatures, they have no particular interest in human activities and are absorbed in their own avian and canine worlds.

To the left of the painting, on a narrow platform covered by a rich red carpet with geometrical designs in black and white, are our old friends, the band, wearing the same red hat somewhat in the Persian style and blowing away for all they're worth.

The saint looks gentle, humble even, and benign. As if it is this work, rather than the slaying of dragons, for which he's really here. *The Conversion of the Selenites* is not as interesting a picture as its two companion paintings, both of which contain more—and more dramatic—action. But its triumphal serenity is the outcome of the two preceding dramas, so *St George and the Dragon* and *The Triumph of St George* would be incomplete without it.

I don't wish my light-hearted description of these beautiful and engrossing paintings to suggest any disrespect for Carpaccio. His pictures give me such undiluted enjoyment that my response to them bubbles over with pleasure. His gift for storytelling, the humanity which makes the many people in his canvases individual, his delight in animals, his wonderful sense of space and use of colour, all make him the most accessible of painters. You feel he's your friend, and his art is such, as Sir Philip Sidney required of poetry, as to 'hold children from play and old men from the chimney corner'.

LIFE'S CLAWS
REMBRANDT VAN RIJN

In his short story *Gooseberries*, Chekhov wrote:

> *Someone ought to stand with a hammer at the door of every happy contented man, continually banging on it to remind him that there are unhappy people around and that however happy he may be … sooner or later life will show him its claws …*

It could be a thumbnail sketch for the life of Rembrandt.

Unquestionably the greatest Dutch painter, most of Rembrandt's life was spent in Amsterdam. Successful from his early twenties, married to a rich and beautiful woman before he was 30, he became internationally famous. He made money, but spent it extravagantly on art, antiques, making financial commitments he couldn't keep. Then life showed him its claws. His wife, Saskia, died and he went bankrupt in 1656. Seven years later his common-law wife, Hendrickje, died, then his son, Titus—a loss from which he never recovered. His work, which developed enormously over the years, went out of fashion. One of his greatest paintings, *The Conspiracy of Julius Civilis*, was rejected by the City Hall of Amsterdam, who had commissioned it. He died alone, poor, unhelped by any of the friends of his prosperity. As Sophocles said:

> *No man can be called happy until that day*
> *He carries his happiness down with him into the grave.*

For me, he is the greatest of painters because he reveals more of his subjects' souls than anyone else.

THE POLISH RIDER, 1655

The Polish Rider, in The Frick Collection in New York, is one of my favourite pictures—atmospheric, dramatic, mysterious, enigmatic. I'm always happy to stand in front of it for a long time, just gazing and wondering. Its title is all that is definitely known about it and though there's been much speculation about the rider's identity and purpose and, indeed, about Rembrandt's purpose in painting the picture, nothing else is known for certain. But in this lies its fascination—here's a window to another world that Rembrandt invites us to enter and our imagination must supply the rest.

It is evening, nearly night. All the fire has gone out of the sky and the foreground has that monochrome look that marks the moment when day descends into night. The last rays of the sun, coming from the west and the left of the picture, are pale yellow. To the right and east, the sky is grey with the shadows of the coming darkness and is only faintly tinged with colour. It is the moment, in *Macbeth*, when:

> *The west yet glimmers with some streaks of day;*
> *Now spurs the lated traveller apace*
> *To gain the timely inn.*

On the western summit of the hill that fills the background of the painting is the outline of a castle with, perhaps, extensive fortifications. In the background and to the right, there is the outline of what might be a bell tower with what might be trees in front of it. At the base of the trees, Rembrandt has painted a small, orange-red triangle. You don't notice it at first but, once you do, it is unavoidable. Is it a watchfire? Below it is another triangle, inverted, also orange-red but fainter. Is this the reflection of that watchfire, mirrored in water?

In the foreground is a young man mounted on a white horse. He wears a red hat edged with brown fur, with a black fur trim outlining the red. His long riding coat, padded and buttoned to the neck in Cossack style, is white and lined with a brown fur similar to that of his hat. The young man's clothes suggest that he is an Eastern European. His hose are red, matching his hat, while his brown leather riding boots link with his horse's reins and bridle.

The Polish Rider,
Rembrandt van Rijn, 1655

'All great figurative artists—and, very often, lesser ones as well—know that their art must include the telling of a story. This is essentially the director's job in the theatre too: to tell the author's story as clearly as possible.'

This handsome young man must be a warrior for he is heavily armed with bow and arrows, while under the skirts of his white coat a sheathed sword is visible. One hand holds the horse's reins; the other, on his hip, clasps a war hammer, a light but formidable-looking weapon. Both his clothes and weapons make this a contemporary painting of the mid-seventeenth century.

Two of the horse's feet are raised—it is in motion or has been caught by the painter in its first step forward.

The detail—the young man and his horse—when Rembrandt chooses to make it so, is stupendously naturalistic. The rest—sky, fortifications, hill, watchfire and foreground—are impressions only, as if the painter wanted nothing to distract from the central focus, rider and horse.

One knows instinctively that the young man is setting forth on his journey, not arriving at a destination, although he is unconcerned to reach shelter before night finally falls. He looks out of the picture at something behind us to the south-west. Is he making sure he's not being followed? His gaze is watchful but calm, filled with an inner certainty. He will brook no interference in his journey.

So off into the night, eastwards, he goes. Where? Why at night? For what purpose? Love? War? Adventure? He carries neither provisions nor equipment but, again instinctively, one knows his journey isn't going to be a short one.

All great figurative artists—and, very often, lesser ones as well—know that their art must include the telling of a story. This is essentially the director's job in the theatre too: to tell the author's story as clearly as possible. Just as Shakespeare's plays are full of clues about the character and how to play him or her, so the odd, unfocused details in *The Polish Rider* may give clues about the circumstances that have given rise to the situation we see in the painting.

At any rate, one can weave a story about this enigmatic young man's journey from them. But it is always going to be an enigma, of course, which is why we keep looking.

Uptown from The Frick Collection, only a few blocks away in a room in the Metropolitan Museum, there hang, side-by-side, *Man with a Magnifying Glass* and *Woman with a Pink*. Rembrandt painted them at about the same time, in the early 1660s, and they are pictures of virtually identical size. There are other pictures in the room, a number also by Rembrandt, but I've never been able to remember what they are. I saw these two paintings on my first visit to America nearly 40 years ago. They've remained with me all that time and I go and visit them whenever I am in New York.

Another artist, Jan Victors, once a pupil of Rembrandt, apparently painted the same two people about ten years earlier but it's not known who they are or whether they were in any way connected. Despite this and despite the lack of a shred of evidence to support me, I know, absolutely and unshakeably, that they were lovers and that the affair ended unhappily.

MAN WITH A MAGNIFYING GLASS, EARLY 1660s

The man is pale, with a wide forehead and dark hair, highlighted with silver. His nose is long and he has a moustache and a carefully trimmed imperial beard. Rembrandt shows just the edge of the collar of his white shirt, which leads up to that pale face. He is richly dressed in the costume of an earlier period—the mid-sixteenth century perhaps, the same period in which Rembrandt dressed himself in his self-portrait of 1658. It's a deep red silk, almost purple, with orange highlights and he's wrapped in a dark cloak with a gold chain draped across his shoulders. In his almost preternaturally large hand he holds what the Met's information sheet advises us:

> ... *appears to be a 'thread counter' which was a lens used to examine samples of cloth. Such an attribute would identify the man's profession which he evidently shared with the five main figures in Rembrandt's* Syndics of the Amsterdam Drapers' Guild *of 1662.*

This prosaic but useful information saves me from the speculative trap of what loss, what betrayal, the magnifying glass symbolises—though it may fulfil a dual function, of course.

The background is dark and featureless. The man's face is turned somewhat to the left—Rembrandt has painted him in three-quarter profile—but his dark eyes are looking into yours, wherever you happen to be standing to view the picture. The expression in them is sad and resigned. A great love comes only once in a lifetime, perhaps. It may be succeeded by others but they will be less life-changing, less threatening, less ecstatic, without the selflessness that marks the thunderstroke of a great love.

He knows that the love he had will not come again. He is calmly bereft.

Though La Fontaine re-unites his 'Two Pigeons' after their travels and travails, at the end of his most famous fable, he knows that for himself, as for Rembrandt's *Man with a Magnifying Glass*, something has passed him by irrevocably:

Alas, will such moments ever come again?
Will I ever feel that spell which stops me short?
Am I too old for love?

WOMAN WITH A PINK, EARLY 1660s

Woman with a Pink is also painted in three-quarter profile, and though her eyes are cast down, her head is turned to the right so that these two, though without the directness of eye contact—I tend to forget that they are two separate paintings—remain aware of each other.

Like the man, she is richly dressed in the costume of a bygone era, in colours similar to his. Like his, her clothes seem to weigh her down. She wears a profusion of jewellery. The Met tells us that though the Jan Victors portrait shows her in contemporary dress, it has the same accent on jewels.

Around her elaborate coiffure are draped ropes of gold and pearls, with a single pearl on the top of her forehead. She wears a long earring with a pendant pearl and elaborate rosettes round

Man with a Magnifying Glass,
Rembrandt van Rijn, early 1660s

the shoulders of her dress. There is a gold bracelet on her left hand, which lies across her lap.

In the background is the lower edge of a picture frame, though we can't tell the subject of the painting as only the frame is caught in a shaft of light and the background is as dark as in the other picture. Between the thumb and forefinger of her right hand she holds the pink, which Rembrandt has highlighted with white. He's also given her a white undersleeve that leads us up to the flower and its highlights. The pink is a symbol not only of marriage but also of fidelity so we don't have to assume she's married.

She is blonde, the same age as the man with the magnifying glass, with the same high forehead and the same long nose, the same sad flesh moving towards dissolution. She is looking down and out of the picture, not at us but in deep contemplation. She is not resigned like the man; she is deeply unhappy. But, like him, she has her mind on something that has gone forever. As Lord Byron wrote in a rueful postscript to what must have been a similar relationship:

So we'll go no more a-roving
So late into the night,
Though the heart be still as loving,
And the moon be still as bright.

For the sword outwears its sheath,
And the soul wears out the breast,
And the heart must pause to breathe,
And love itself have rest.

Though the night was made for loving,
And the day returns too soon,
Yet we'll go no more a-roving
By the light of the moon.

Woman with a Pink,
Rembrandt van Rijn, early 1660s

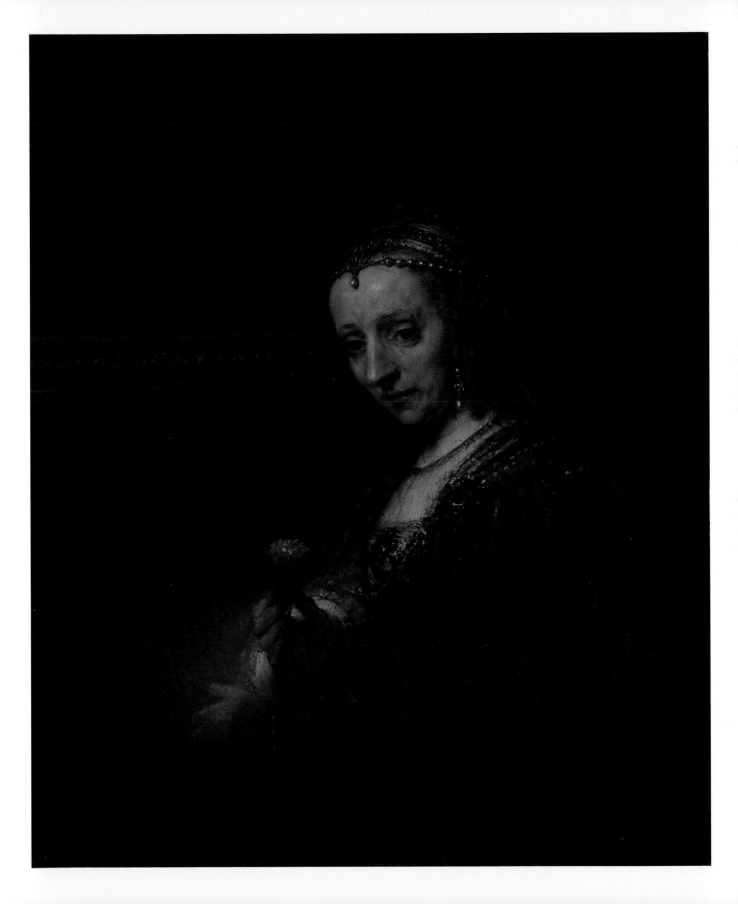

SENSUAL MUSIC
AGNOLO BRONZINO

Agnolo Bronzino, painter, poet, composer, the favourite pupil and adopted son of Pontormo, was court painter to Cosimo di Medici in Florence during the mid 1500s. He's best known for his icily elegant portraits which include a number of sexy but sinister young men; for the enamelled, jewel-like quality of his palette and the wonderful handling of his sitters' very elaborate clothes; and for his famous erotic work, *An Allegory with Venus and Cupid*—perhaps his most successful and notorious painting.

AN ALLEGORY WITH VENUS AND CUPID, 1540–45

Despite the gallons upon gallons of ink that have been expended to extrapolate its meaning, the painting—also known as *Venus, Cupid, Folly, and Time*—remains a mystery. And herein, apart from its beauty, may lie the secret of the fascination it exerts on the viewer: as no one has ever successfully translated the allegorical elements—of which there are a number—into a cohesive whole, it's up to us to speculate on who's who and what's what. Perhaps, also, this was a deliberately titillating factor on Bronzino's part: to create a talking point at the court of Francis I of France, to whom the picture belonged.

One thing, however, is certain: against a background of blue silk drapes are two beautiful people, erotically involved with each other—Venus and Cupid, both naked.

She has turned towards him—it looks like he's taken her by surprise—and one hand grasps the arrow in his quiver, while the other holds an apple, presumably the one awarded her by Paris in the infamous beauty contest that resulted in the Trojan War. He, an adolescent, not the child as which he's most often represented, is kneeling on an orange cushion and has his buttocks thrust provocatively towards the viewer, one hand firmly round Venus' far breast, its nipple visible between his fingers, the other equally firmly round the back of her head. They are gazing at each other intently, their heads are very close, their lips are parted and her tongue, protruding slightly from between her teeth, seems about to enter his mouth.

But hold on, aren't they mother and son?

A smaller cupid, with the jubilant look of a child who knows he's about to do something naughty, has a handful of rose petals which he seems about to throw over them in celebration of this arousing and incestuous union. Although you can't see this in reproductions, there's a little branch covered with thorns under his foot. One thorn has already pierced him and there's a trickle of blood between his toes, and when he lowers his foot he's going to tread on another. Is this a penalty for celebrating love? Behind him, the head of a girl with a fixed and baleful stare, green and gold draperies and the feet of a mythical beast. Is she the Sphinx? In one hand she holds a honeycomb; in the other, I've learned, the sting of a scorpion. Is that what love is? Are these its alternatives, what Priam, in Shakespeare's play *Troilus and Cressida*, calls 'the honey and the gall'?

In the background is a gloomy landscape and before it, leaning over the curtains, the head and shoulders of an angry old man, arm outstretched. The figure of Time, the National Gallery's little placard beside the picture says. At first I thought he was angry with Venus and Cupid, rapt in each other and oblivious to him:

Caught in that sensual music, all neglect
Monuments of unageing intellect.

But this is no Yeatsian *Sailing to Byzantium*; he isn't even looking at them. His gaze is focused on a woman on the far side of the picture, like him, behind the curtains. It's not easy to tell what her hands, both on the blue drapes, are trying to do, but from his, which seem to be holding them in place, we can surmise she may be trying to pull them down. She might be wearing a mask but if she is, it blends into her face worryingly and imperceptibly. So it is she with whom Time is

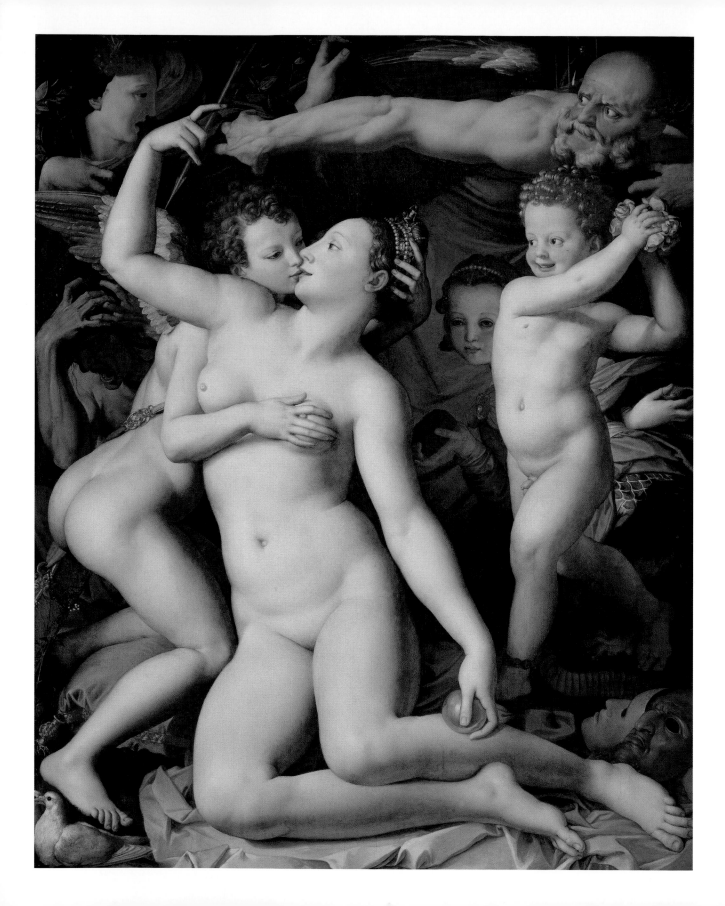

angry. But why? Because she is trying to expose Venus and Cupid? And who is she?

At Venus' feet lie a pair of masks, one male and the other female, and at Cupid's are two of his mother's doves. Behind Cupid is a figure whose face is contorted in such a rictus of despair or fury that it's impossible to tell whether it's a man or a woman. So who is this? And why the despair or the fury?

Nobody's going anywhere, nothing is about to happen: like a photograph, this is a moment fixed in time. Something *has* happened—Cupid has arrived and surprised his mother, leading to the actions Bronzino has frozen.

The reason this painting is endlessly fascinating and watchable, rather than the obscurity of its story making it boring, is because despite the ambiguous and forbidding peripheral performers, the feel of Bronzino's picture—the focus being on Venus and Cupid and the little boy with rose petals—the emotion radiating from it is one of celebration and delight. Also, it is extremely beautiful. The energy, richness and vividness of the curtains against which are set the pink and white flesh of Venus and her son give the painting a luminous and erotic opalescence.

It's also a window to another world—a requirement all good, let alone great, paintings must fulfil. And Bronzino, though often icily brilliant, is a great seducer. As Renoir said, over 200 years later: 'A painter who has a feeling for nipples and buttocks is a saved man.'

So now perhaps the ball's in our court to imagine the outcome and to surmise the significance of the supporting cast to whom mother and son are indifferent, caught in their rapt contemplation of each other. Maybe we should be thinking Donne, not Yeats:

Love, all alike, no season knows, nor clime,
Nor hours, days, months, which are the rags of time.

They are immortal, after all.

An Allegory with Venus and Cupid,
Agnolo Bronzino, 1540–45

THE FATHER OF IMPRESSIONISM
CAMILLE PISSARRO

Pissarro has been overshadowed by the big stars of Impressionism—Monet, Degas, Cézanne, Gauguin—but he's one of those artists for whom one can't but feel a deep affection and respect.

Born on the island of Saint Thomas, a Danish colony in the Caribbean, of a Sephardic Jewish family, Pissarro was sent to school in Paris at the age of twelve, but returned to the West Indies to work in the family import–export business. Already addicted to painting at an early age, he romantically, at the age of 23, ran away from home to Venezuela 'to escape the bondage of bourgeois life'. Happily, reconciliation followed, the family moved to Paris and Pissarro was able to devote himself to art—which he did with a singular dedication for the whole of his long life.

He studied with Corot and exhibited at the Salons of 1864 and 1865 as 'Corot's pupil'. This was his only contact with the establishment for many years: his art developed in a direction that made him anathema to the conventional. He met Monet, Renoir and Degas and with them organised the eight Impressionist exhibitions set up in opposition to the official Salon from 1874 to 1886.

From the distance of the 21st century, when the work of the least of the Impressionists fetches millions of dollars, it is hard to realise the opposition, prejudice, scorn and mockery that their work aroused—what courage and perseverance it must have taken to endure continual opprobrium and yet keep working!—or for how long many of them endured poverty. As late as 1891, Pissarro wrote to his son, Lucien: 'I was penniless … as a last resort I wrote to Monet who promptly sent me a thousand francs.'

Pissarro was poor for almost all his life, short of or without money to support his wife and large family of eight children. It took many years for him to achieve financial security but by 1880, when the recession caused by the Franco–Prussian War of 1870–71 had eased and people began buying pictures again, Pissarro could for the first time afford to pay models and the human figure begins to appear regularly in his work. It was not until 1897, when he was 67, that he finally achieved both acclaim and wealth. He had only six years left to enjoy it. All the Impressionists had to wait a long time before their gifts were recognised (for Sisley it didn't come till after his death) but Pissarro waited longer than most.

In 1866 he settled in the country not far from Paris at Louveciennes. He and his family, together with Monet, fled to London during the Franco–Prussian War (where both were deeply affected by Turner, Pissarro writing to his son 'isn't it senseless that there are no Turners [in the Louvre]?'), and on his return to France, he found that his home at Pontoise had been occupied and vandalised by Prussians, and that of the 1500 canvases which he had been forced to leave behind, all but 40 had been destroyed. He later moved to the village of Eragny.

Pissarro's early paintings—mainly landscapes—are, to me, very unappetising, reminding me of how really boring the countryside can be when the weather is cold or dull or wet. Muddy roads going nowhere, dull colours of grey, brown, sludge green, never a

sign of the sun—all reasons why, as a child, I stayed indoors with my nose in a book. But suddenly the palette lightens: the sun is allowed to shine, sky-blue puts in an appearance, the apple trees produce blossom, flowers grow in the fields and by the mid 1870s Pissarro is painting pictures I would love to own.

He was a generous and kind mentor: Cézanne and Gauguin worked beside him and acknowledged they learned much. Cézanne wrote: 'As for poor old Pissarro, he was like a father to me. He was the kind of man you would consult like "the Good Lord" himself.'

But generosity and kindness didn't blind Pissarro: he referred to Gauguin's paintings as 'knick-knackery' and said, 'Gauguin disturbs me very much, he is so deeply commercial'; and he finally rejected Seurat's pointillism.

He kept changing his technique: during the 1870s, when he and Cézanne worked together every day outdoors—Pissarro was passionately committed to working *en plein air*—there are some of his pictures, *The Bridge at Pontoise* of 1875 for instance, which might be by Cézanne. Similarly, when he met Seurat ten years later, he adopted Seurat's pointillist style in some of his most beautiful pictures, only abandoning it when he came to believe that the technique was a dead end: 'the dot is meagre, lacking in body, diaphanous, more monstrous than simple'.

For nearly 25 years, until their last exhibition in 1886, the Impressionists supported each other as a group of committed artists, a union of painters trying to do something new, an alliance previously unknown in the history of art. But 'the course of true love never did run smooth,' as Lysander complains in *A Midsummer Night's Dream*, and they disagreed often. Both Degas and Cézanne were difficult men and at one time or another Degas quarrelled with everyone. They were critical of each other, sometimes envious. Pissarro complained to his son that Monet's success was ruining his art: 'apparently he can't paint enough pictures to meet the demand … everything he does goes to America at prices of 4, 5, 6000 francs. All this comes … of not shocking the collectors.' Mary Cassatt, a rich American and a talented painter herself, loathed Renoir's late nudes—which I see as works of amazing golden fecundity—'He is doing the most awful pictures of enormously fat women with very small heads.'

'But generosity and kindness didn't blind Pissarro: he referred to Gauguin's paintings as "knick-knackery" and said, "Gauguin disturbs me very much, he is so deeply commercial"; and he finally rejected Seurat's pointillism.'

But despite all the quarrels, the occasional attacks of envy and what Berthe Morisot—an artist and Manet's sister-in-law—described as 'clashes of vanity', the Impressionists stuck together. Morisot's memorial exhibition in 1886 was hung by Monet, Degas, Renoir and the poet Mallarmé, personally. There was an enormous row about the positioning of a screen—Degas wanting it in one place, everyone else in another—which resulted in Degas slamming out in a fury. But they all came back the next day and worked on. When they eventually split up it was not as a result of animosities but because their artistic goals were diverging.

Pissarro was a tutor, a mentor, a critic. Passionate about art but never cruel. A life-long and committed Socialist. Perceptive and wise, this generous-spirited man was the first and a formative influence in the development of Impressionism.

BOULEVARD MONTMARTRE, MORNING, CLOUDY WEATHER, 1897

In the last decade of a long life, Pissarro painted a number of Paris street scenes. *Boulevard Montmartre, Morning, Cloudy Weather* was painted from a room on the second floor in the Hôtel de Russie looking up the Boulevard Montmartre.

It is a grey, overcast day. The trees which line both sides of the street are almost leafless so it must be early winter. A lightening of the distant sky, some pink tingeing the clouds and some blue visible behind the grey tell us where the sun is, so we're looking east. Pissarro allows the boulevard to widen slightly as it gets closer to where he and his easel are installed in the centre of the picture, looking down onto the street.

On the left of the painting, the traffic—horse-drawn trams and hackney cabs—is coming towards us; on the right, it is moving up the

Boulevarde Montmartre, Morning, Cloudy Weather, Camille Pissarro, 1897

boulevard and away. The street is busy but nothing approaching the congestion of modern-day traffic. On the pavements at either side of the road are the turret-shaped kiosks unique to Paris.

The buildings—thanks to Baron Haussmann's redesign of the city for Napoleon—are of uniform height. The shopfronts on the left are indicated by awnings and the pavement here is more crowded with passers-by than on the other side and seems narrower than on the right where, above the brown wood fascia of the shops, the stone is a pale caramel, almost honey coloured. Dark-grey slate mansard roofs rise above them and Pissarro leads our eye up to the brown chimneystacks and continues this all the way up the street on the right of the canvas to where the buildings merge into a distant grey, darker than the sky but fusing into it with the blue that Pissarro uses to merge architecture and sky.

Right in front of us is a tall lamppost, its globe dabbed with white as if it were still alight—it's gas lighting of course. In addition to the trams and carriages, pedestrians are crossing the street in greater safety than would be possible nowadays. Just up on the right is what looks like a bus shelter.

There are two men standing close to the lamppost, one a little away from us on the left, the other closer and downstage at the right. Both are dwarfed by its height and by the inevitable foreshortening of their bodies due to the height from which the artist is looking down on them.

The road itself is painted with careful streaks of grey, white and pink. The reddish brown of the shopfronts and chimneystacks is echoed in the kiosks, the lamppost and the edges of the trams, the tram wheels and the edges of the shops' awnings on the left.

Pissarro uses a dab of red in a skirt or on a hat for the people closer to us but avoids it on those further off up the street where it's too far for us—or him—to be able to distinguish colour. Brown and red relieve the overall drab grey with a very occasional touch of green. But then you realise the road and much of the stonework are honey—the surface of the road with more pink worked into it, the façades of the buildings with some lemon.

The general feel of the painting, despite the 'cloudy weather' of the title, is of light and buoyancy and although the overall

scene is one of bustle and human activity, the sky and the misty blurring as we look up the boulevard give a romantic feel to this mild winter's morning.

Well, it's Paris.

PEASANTS' HOUSES, ERAGNY, 1887

Painted when Pissarro was much influenced by Sisley's pointillist technique, *Peasants' Houses, Eragny* from 1887 depicts an idyllic summer's day in a corner of Eragny, the village where the artist lived.

We're facing a row of semi-detached houses, their gardens divided by hedges. Hedges, too, mark the limit of the front of the houses and divide them from the rest of the world—here no more than a little path coming from below the canvas at the left and winding away and off to the right, following the line of the cottages. The sun is shining from pretty much directly behind us and so directly on the scene, and it throws a big square of shadow straight onto the grass in front of the houses. It might be from a building right behind us and just to our right. At the far end of the houses another shadow can be seen on the roof and walls, probably caused by another building. This is slightly odd because there is no suggestion of our being in a village street—perhaps they're farm buildings.

The houses are surrounded by trees; bushes grow in what we can see of the garden through an open gate, so what with the lines of hedges there's a lot of green. The roofs are tiled, painted with dabs of orange, blue, pink and green, and with a stronger red mixed with dabs of yellow and blue for the chimneys. The walls are whitewashed and behind the houses, there's a blue sky with cumulo-cumbersome summer clouds.

An old woman—to judge from her stooped shoulders—is in front of the open gate, about to enter the garden. She wears a pale dress and cap, clogs and has a pannier strapped to her back.

The green of the trees, hedges, grass has yellow dabs with occasional blue, all darker and stronger in the shadowed areas of

Peasants' Houses, Eragny, Camille Pissarro, 1887

Peasant Girl Lighting a Fire, Frost, Camille Pissarro, 1888

grass and roof. Pissarro adds pink to the white of the clouds and to the blue of the sky.

What I find appealing about this painting is that there's no attempt, via the technique of pointillism, to produce an illusion of naturalism, though what Pissarro is doing is actually closer to Seurat's technique in *Bathers at Asnières* than the developed and deliberate dots of *La Poudreuse*. It's an impression, an idea of what it's like. He's not bothered by any constraints to be realistic; he just wants to give us the feel of it. That feel is soft, glowing with the gentle warmth and life of summer. It's peaceful, still, the old woman the only human intruder. But she, too, is part of it as her pannier tells us she's coming home from work; she's almost part of the landscape.

It's somewhere you'd like to be—houses, old woman, trees, clouds, sky, all of a piece. Harmony.

PEASANT GIRL LIGHTING A FIRE, FROST, 1888

In a room in the Musée d'Orsay hang a number of pictures which show the interest and concern amongst the Impressionists in the lives of working people, something not seen since the Barbizon School of a hundred years earlier. There's one of Caillebotte's best works, three men with bare torsos sanding a wooden floor; a Monet of long lines of men unloading coal from a barge; a wonderful painting of women ironing, one yawning with exhaustion, by Degas; and Pissarro's painting of two young peasant women working outdoors on a cold morning, entitled *Peasant Girl Lighting a Fire, Frost*.

This beautiful landscape was also painted in Pissarro's 'pointillist' period. It's wonderfully light and delicate, like the frosty morning it depicts. The focus is clearly on the two girls almost on top of us right in the foreground, but the sky at the very back of the canvas is far, far away. In front of it is a line of hills, some kilometres off, topped with bushy trees irregularly spaced across the ridge. A slight declivity suggests the presence of an unseen stream. Then there's a narrow meadow stretching the width of the painting. Then, again extending across the width of

'... there is no actual snow at all but the crystalline frost of a winter's morning captured in an aura of diamond blue.'

the picture, a long line of single trees, perhaps poplars. Finally, we're into the broad meadow that is the scene of the action.

There is sun, though maybe only of the watery, wintry sort, coming from off the left of the canvas, throwing long blue shadows of unseen trees across the grass and casting the elder girl's shadow across the very front of the picture and off the canvas. There's quite a wind too, coming from the same direction: it's blowing the girl's skirt and the smoke of the bonfire to the right while the five cows in the meadow at some distance from the fire are grazing facing away from it. You can almost feel the cold.

The two girls, one no more than a child, are wrapped up. The little girl, standing behind the bonfire, wears a blue dress under a thick, dark-brown coat and a dark woollen hat pulled down over her ears. The older girl wears a pink skirt with a blue apron over it and a white scarf over her head, tied beneath her chin. She is swaddled in a pink and white shawl from beneath which long black sleeves emerge. She wears clogs and has big, capable hands. She is holding a long thin branch, which she is about to break up and add to the fire, while beside and around her are quite a number of other sticks. The bonfire itself, just right of centre, is, as far as one can see from the smoke obscuring it, burning merrily and the little girl is warming her hands at it.

There is blue in the shadows cast by the sun, in the girl's apron and in the child's dress. The girl's pink skirt is made up of yellow and blue as well as pink, while Pissarro creates the green grass of the meadow with green, blue, yellow, pink and white. The only orange in the painting is in the flames of the bonfire. The background is delicately coloured and as pale as if it had been sprinkled with hoar frost.

The elder girl, because of her height and being right in the foreground, closest to us spectators, is unmistakably the focus despite the potential distraction of the orange flames. Although there's nothing forceful in their colours, the orange of the fire and the pink in the girl's skirt and shawl help us to focus.

When Pissarro and Monet saw Turner's paintings in London, they were amazed, Paul Signac tell us:

> *... at the way he succeeded in conveying the snow's whiteness ... then they saw that these wonderful effects had been got not by white alone but with a host of multi-coloured strokes, dabbed in one against the other and producing the desired effect when seen from a distance.*

The Impressionists carried on their own experiments, as in Sisley's *Snow Effect* in the National Gallery in Edinburgh, in Monet's wonderful *Boulevard Saint-Denis, Argenteuil* in Boston, but most brilliantly in this painting by Pissarro where there is no actual snow at all but the crystalline frost of a winter's morning captured in an aura of diamond blue.

I think it's an astonishing picture.

A MAN OF SORROWS
BRAMANTINO

Horace Walpole defined serendipity, a word he invented himself, as 'the art of making happy and unexpected discoveries'. This infrequent experience happened to me in the wonderful Thyssen-Bornemisza Museum in Madrid when I walked past Bramantino's *The Resurrected Christ* and skidded to a halt in astonishment.

Bramantino's real name was Bartolomeo Suardi. He became known as 'Bramantino' through his work with the architect Bramante. He was born in Milan where, apart from a sojourn in Rome from 1508, he spent his life, becoming 'ducal architect and painter' to Francesco Sforza in 1525. Not many of his paintings survive. The best known, for the cognoscenti amongst whom I clearly can't be numbered, are a number in Milan, one in London, another in Boston and this extraordinary portrait in Madrid.

The Resurrected Christ,
Bramantino, 1490

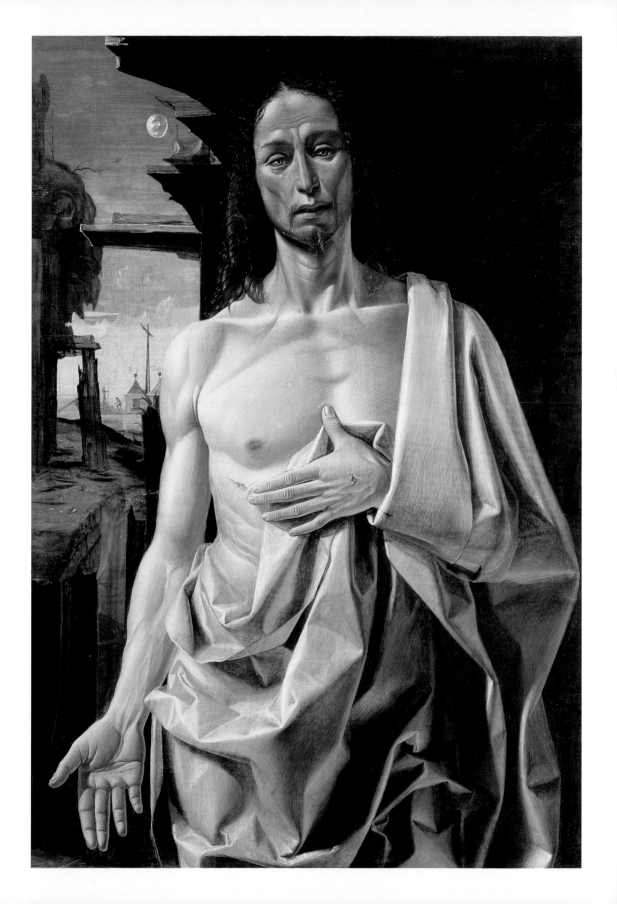

THE RESURRECTED CHRIST, 1490

The Resurrected Christ was painted around 1490 and Bramantino used the same model in *Noli Me Tangere*, a fresco in the Castello Sforzesco in Milan. Nobody seems able to put a date to that but the two figures are unmistakeably the same. This Christ has long, red hair down to his shoulders, a little beard outlining his jaw and helping to elongate his face, and a thin moustache just at the corners of his lips. He wears a white robe—or perhaps it's a winding sheet—draped over one shoulder. The folds in the robe are not altogether natural, rather devised to show off the painter's considerable skill. Christ's right hand holds the robe to his chest, the other hangs by his side, palm turned outwards.

His skin is very pale, translucent white and grey. His wounds, the colour of his lips and nipple, are visible only as pink incisions. There is no blood.

His face is very beautiful, very drawn, visibly carrying the sins of the world. The expression in his eyes is immensely, rivetingly, sorrowful and the thought occurs: is this sorrow a grief for the world's sins or is it caused by a horrified discovery of what humanity and pain mean, of what it is to be human, of the physical realisation of suffering? Something in the depth of those stricken eyes makes one pause and think and wonder.

He stands before the interior of a dark building. But behind him and to the left of the canvas, a third of the painting is exterior, a disturbing, almost surreal, cityscape. Buildings at the extreme left are in a state of great disrepair, perhaps abandoned, with trees and grass growing wild from their tops. There is a strange full moon in the sky, a sinister little glassy orb that Bosch might have painted.

Below it is a distant city, the buildings rather in the style of a pagoda. In front of the city is a wharf, the tall mast of a ship. On the wharf two figures are visible: tiny, almost stick-like. One is climbing the steps up from the dock and awaiting him is a figure in a white robe, holding a long staff. The sky in which the moon has risen is streaked with a pinkly orange red that links to Christ's hair and stigmata and nipple. There is an air of mystery about all this—wherever it is, it is an exotic, foreign place.

Although the painting of Christ is finished, either the rest of the painting is incomplete or we are not expected to look too closely, such is the magnetising presence of the marmoreal figure in the foreground. Nonetheless, what does linger in the memory is the sinister moon and the sea with the distant vista of a city, hence a suggestion of departure.

Most of all, this haunted and hauntingly unforgettable face, the lips slightly parted in grief, the eyes filled with pain, is not likely to be forgotten once seen. This is the epitome, as the Book of Isaiah tells us, of 'a man of sorrows and acquainted with grief'.

IL FURIOSO
JACOPO TINTORETTO

Jacopo Tintoretto, nicknamed *Il Furioso* for his phenomenal speed in painting, is the last of the great Venetian painters of the Renaissance. Above his studio door were the words 'Michelangelo's drawing and Titian's colour'. Though there is a legend that as a boy of fifteen he worked in Titian's studio but was sent home after a very short time—from which one can only infer that he was thought to be no good or too good—he was basically self-taught. This is an extraordinary achievement given the consummate heights he reached.

Both he and his contemporary Paolo Veronese painted enormous canvases, not for private patrons or for the state but for the *scuoli*, the Venetian equivalent of guilds or clubs. Tintoretto married the daughter of the Grand Master of the Scuola di San Rocco and later became a member of the order himself, and it is here, not without some controversy along the way, that he painted over 50 pictures. He used both perspective and light in a highly theatrical and innovative way. In *The Last Supper* his use of both is initially disorientating, it is so bold and extreme, while his use of light reminds one of Caravaggio at his most dramatic.

In 1548 he was commissioned to paint episodes from the life of St Mark, Venice's patron saint, by the head of the Scuola di San Marco, Tommaso Rangone. In the next four years he executed four—*St Mark Saving a Saracen from Shipwreck*, an enormous canvas of *The Miracle of St Mark Freeing the Slave*, *The Stealing of the Body of St Mark*—all three of which are in the Accademia in Venice—and *The Discovery of St Mark's Body*, in the Brera at Milan.

All are highly dramatic works. In the first two pictures St Mark is coming to the rescue. In one, he has picked the Saracen out of the sea, into which he had been thrown by Christian sailors in an attempt to make God send away the storm, and, flying almost horizontally himself, is depositing him gently back into the boat, the occupants of which are too busy coping with the storm to pay him any attention. In the other, he is coming to the rescue of a slave who is about to have his legs broken and his eyes put out as a punishment for worshipping the saint's relics. Here he is plunging vertiginously to earth, one arm outstretched to put a halt to the proceedings. He is descending so fast that his clothes are being blown upwards so he has firm faith in his powers of deceleration. I like the idea of St Mark protecting slaves: the Venetians, as Shylock tells Antonio in *The Merchant of Venice*, had among them 'many a purchased slave'.

Tintoretto is one of the great painters. But for me, the two remaining pictures belong to a different world, they are so intensely bold, dramatic and—most exciting of all—impressionistic.

THE DISCOVERY OF ST MARK'S BODY, 1562–66

The Discovery of St Mark's Body, painted over four years, takes place in a long sepulchre, rather like the Capulets' monument in *Romeo and Juliet*: a 'palace of dim night'. The perspective of the painting is extraordinary: from a narrow opening at the very back—a little oblong of day in which two figures, one peering into the tomb, can be seen crouching outside and which is almost the only source of light—the room opens out, widening as it comes towards us, only its right-hand side fully visible,

'We're unavoidably drawn into this painting not merely on a technical level—by the violence of the perspective, by the speed at which the floor rushes towards us and includes us in the picture—but by the elusive and mysterious story it has to tell.'

the brown and white tessellated floor rushing down at us. Light picks up the top of the cobwebby, vaulted arches, the architraves on the walls and the series of carved embrasures high off the ground in which the bodies contained in this grim sepulchre are interred. The stone is a dark marble and although it seems sometimes warm, sometimes cool, the overall effect is ominous, spooky, grim. This, properly, is not a place where you'd want to be.

To the right of the picture—which is why it's the side Tintoretto lets us see—this upper level of tombs is being searched and its bodies removed in the quest for the saint's corpse. It's grisly work and the feel is hurried and furtive. From the tomb closest to us, two men are lowering a naked body, still partly wrapped in its winding sheet, down to a third, standing at floor level. Behind them is a man in black, apparently superintending operations, holding up a solitary candle as high as he can.

In the front of the canvas, still at the right, is a strange trio: a young woman in a dull-pink dress is being thrown off balance by a man with his back to us, kneeling, his arms around her knees. Just upstage of them, another man, perhaps also in a winding sheet, one shoulder and half his chest bare, has a powerful arm wrapped around this man's waist. He, too, is kneeling, his head thrown back; unlike the woman he seems to be in anguish, but like her he is looking at St Mark.

The saint is at the far left of the canvas, one hand raised commandingly to stop what's going on. His own body lies at his feet, its head resting on a pillow.

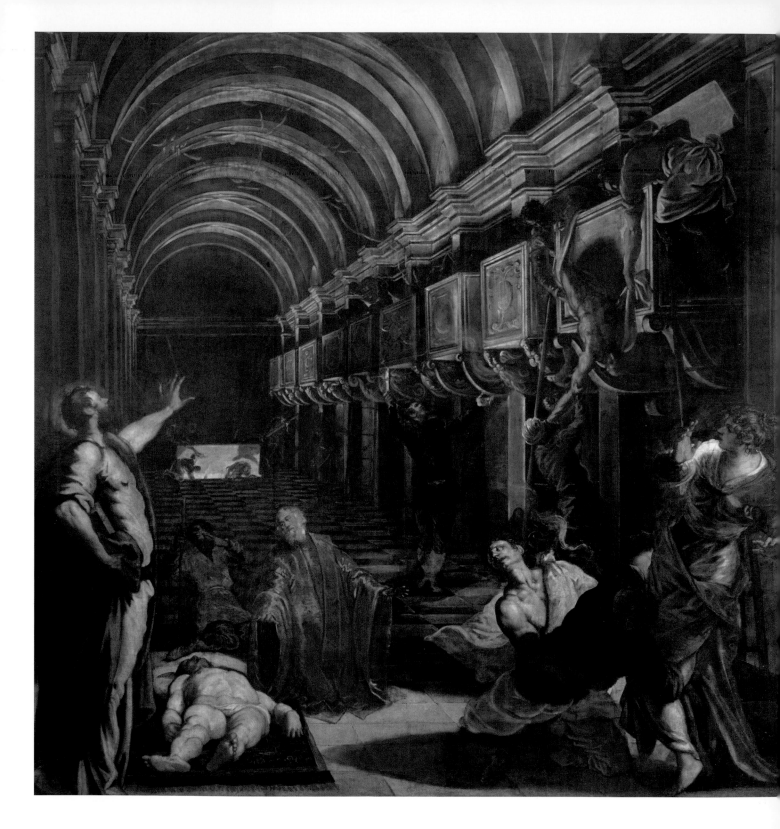

In the centre of the painting an old man in a beautiful silk robe is kneeling, arms outstretched, looking devotedly, not at the saint, but at the saint's body. Behind him and to the left is another kneeling figure, perhaps a servant, perhaps black, holding a staff in one hand, the other lifted to shield his eyes from the strong and unnatural light emanating from the saint's manifestation and from his actual body.

Tintoretto uses the dull pink to link this varied cast together. The saint, who has a black cloak draped around himself and a large book—a bible?—tucked under his downstage arm, wears a pink robe. This links to the old man in the centre, to the woman at the far right, to the man receiving the body, and to the man on the upper level handing it down to him.

We're unavoidably drawn into this painting not merely on a technical level—by the violence of the perspective, by the speed at which the floor rushes towards us and includes us in the picture—but by the elusive and mysterious story it has to tell.

The Brera catalogue helpfully tells us that the old man is Tommaso Rangone, the commissioner of the picture. It also tells us, more subjectively, that the man to Rangone's left, gazing at the saint in anguish, is possessed by the devil. And that the saint is St Mark, that the men are looking for his body, and that the body at his feet is actually his.

But suppose we haven't read the Brera catalogue, don't even know the title of the picture—I believe that one shouldn't have to read the programme to enjoy the play—what could we deduce?

Well, straight off, it's a burial vault and it's dark. There's only the patch of day at the back and the solitary candle. This suggests a certain furtiveness in what's happening, in these men removing a body from its last resting place. So, though we don't know where we are, we know these men don't want to get caught at their grave robbing.

Then we may observe that though there are four areas that are relatively brightly, if spectrally, lit, the dominant figure is the man with his arm raised in a gesture of 'Stop!' Not only is he the brightest, he's almost the only one standing and, hey, look, isn't that a halo round his head? He's a saint! Then we can see that a lot of the characters are kneeling, that the old man in the

The Discovery of St Mark's Body,
Jacopo Tintoretto, 1562–66

middle is hugely reverential while the servant behind him has reacted in such a way—hand raised to shield his eyes from the saint's light—that we can deduce not only that there's something supernatural about this saintly apparition but also that he has only just appeared.

If he's supernatural, then maybe he's dead; maybe he's come from Heaven. But why is he telling them to stop? And why is the body at his feet as unnaturally bright as he?

I could push this further to get closer to the full story but, in all honesty, I think that unless we know the story of St Mark that's as far as we'd get.

So then we'd spend a bit of time talking about the strange trio at the picture's right. And even if we'd been flush enough to buy the catalogue we wouldn't get further than learning that the anguished one is possessed by the devil. So finally we'd say, 'Oh, bugger it, what does it matter? It's a bloody amazing picture, let's stop thinking about it and let's just look at it.' Which we'd enjoy doing.

THE STEALING OF THE BODY OF ST MARK, 1562–66

We would enjoy as much or more an equally dramatic but, in impressionistic terms, bolder masterpiece, *The Stealing of the Body of St Mark*. But our enjoyment will be increased, perhaps, by some knowledge of the legend.

The pagans of Alexandria were about to burn the body of St Mark when a violent storm—whether a natural occurrence or Heaven-sent is a matter of dispute but it's very clear to me that it has been created supernaturally—allowed the Christians to steal the body and remove it to safety.

The picture shows us three men holding the saint's body, which they are about to load onto a waiting camel. Again, the painting slopes strongly down towards us. Again, there is a brown and white tessellated floor. Again, pink is the colour Tintoretto uses to link some of the characters. Again, Tommaso Rangone features, in much the same dress, this time supporting the upper half of St Mark's body, and in much the same central position.

The Stealing of the Body of St Mark,
Jacopo Tintoretto, 1562–66

'Given the fantastically emotive subject matter ... what is immediately breathtaking is Tintoretto's unsparing, unsentimental approach to the business of crucifixion ...'

We're at one end of a rectangular piazza. Furthest away from us is a black and orange sky streaked with bolts of lightning. In front is a temple, presumably pagan, tapering upwards with two what must be very large statues on either side of the building on the third floor—the cupola is about six storeys high. This, like the arcaded colonnade to the left, which is very similar to St Mark's Square in Venice, is caught in an intense lightning flash, rendering it a ghostly and intense white. People are running up the steps for the safety of the colonnade's interior. They, too, are ghostly white and are fleeing not only from the storm, which is blowing violently from right to left, but from the barely visible angels, cartoon-like, white outlines, who are creating this huge wind. White swirls on the piazza floor tell us that everything we can see is being assaulted by this supernatural tempest.

In front of the temple is a pyre of logs and faggots on which the saint's body was about to be burned, rendered impressionistically and,

one feels, at an impatient speed. To the right of the piazza is a dark building—dark because it is relatively unaffected by the storm and its angels who are concentrating on making the populace flee. In the foreground are the camel and its attendant, looming large over the three men holding the naked body of the saint.

On the floor just to the left of centre a woman in pink is desperately holding on to the camel's leading rein, though whether to prevent the camel's departure or to save herself from being blown away by the storm is hard to say. She's grasping the rein with sufficient force to make the camel turn its head towards her. Perhaps mindful of the task ahead, it doesn't look entirely friendly.

In the extreme left-hand corner of the picture is a very dark-pink curtain pulled from off the canvas into our view by a man in a slightly paler pink robe, lying on his back and holding onto it for dear life. The curtain, the sprawling man and the woman are linked by their varying

shades of pink and are sufficiently close to us to be unaffected by the lightning, although greatly affected by the wind. These pinks are similar to the colour Tintoretto uses in the Brera painting.

Relative to the hectic, swirling, tempest-tossed activity that affects the left half and background, the group holding the saint, with its attendant camel, rests in an oasis of calm, ignored by the cartoon-like angels, again sketched in with a vigorous and impressionistic haste, who are, of course, there to help them. For the same reason, perhaps, the group is unaffected by the violence of the wind.

The Discovery of the Body of St Mark is intensely arresting and dramatic with its violent perspective and dramatic lighting. But *The Stealing* is such a maelstrom of human and superhuman activity, such a hectic mélange of styles, that we feel that we're present ourselves, in that square, assailed by that storm, aghast at those angels. I rate this as one of the most exciting pictures I know.

THE CRUCIFIXION OF CHRIST, 1565

I am not a Christian so it is perhaps surprising that *The Crucifixion of Christ*, an enormous and enormously detailed work, has the same deep effect on me as it had on Henry James, who was a Christian and who described it as 'one of the greatest things in art'.

Given the fantastically emotive subject matter—the murder of a man believed by Tintoretto and by a very great number of others to be the Son of God and the Saviour of Mankind—what is immediately breathtaking is Tintoretto's unsparing, unsentimental approach to the business of crucifixion, to the mechanics involved, the work that's entailed. The foreground of the picture is littered with the paraphernalia of this form of execution, with ropes, ladders, hammers, nails, ominous chunks of wood.

The Gospels are rather confusing in their accounts of Jesus' life and death, as they all differ from each other to a greater or lesser degree. For instance, both Matthew and Mark say the women at the Crucifixion were 'looking afar off'; Luke says nothing on this score and only John recounts that 'there stood by the cross his

mother, and his mother's sister, Mary the wife of Cleophas, and Mary Magdalene'—which is an option that all painters, Tintoretto included, have followed. It's certainly both more moving and more dramatic to have them at the foot of the cross rather than 'afar off', as well as more credible. Again, only Mark says 'it was the third hour when they crucified him' but all agree that from the sixth hour to the ninth hour, when Jesus 'yielded up the ghost', 'there was darkness over all the land'.

There's quite a lot of light, however, in Tintoretto's painting but it's of an unnatural pallor, intense but unreal. It emanates from Christ, illuminating the empty space behind him, the family at his feet, spilling across the body of a man working on the second of the three crucifixions, and falling on the centurion's white horse at the far left of the picture. But the sky is dark, lit only by the impressionistic streaks of lightning—the same streaks that Tintoretto used for the Alexandrian hurricane in *The Stealing of the Body of St Mark*. In naturalistic terms, this can only be occasioned by a total eclipse accompanied by a violent storm in the middle of the day. Yet nobody in the picture is surprised or is paying attention to it.

But worrying about adherence to the Gospels or slavishly following the logic of naturalism only gets in the way: Tintoretto is making poetic choices, which is his privilege as an artist. And however total the eclipse or alarming the lightning, that's not the main event.

Christ, in the centre of the canvas, has already been crucified and the cross lifted to its upright position. On a ladder propped against the back of the cross is a man who has just dipped a sponge fixed to the end of his spear into a bowl of vinegar below him and we know he is about to lift it up to Christ, whose head—this is a man suffering, not God—is bent down to receive it so that his face is in shadow. Or is he, perhaps, gazing compassionately across at the first thief, lying to his right?

At the foot of the cross are six women, none of whose faces is visible as their heads are all bowed in grief. St Peter and St John are in profile, St Peter's attention on the Virgin, St John's face turned upwards towards Christ. Tintoretto somehow makes us aware of their agonising dilemma—how they can't not be there,

The Crucifixion of Christ,
Jacopo Tintoretto, 1565

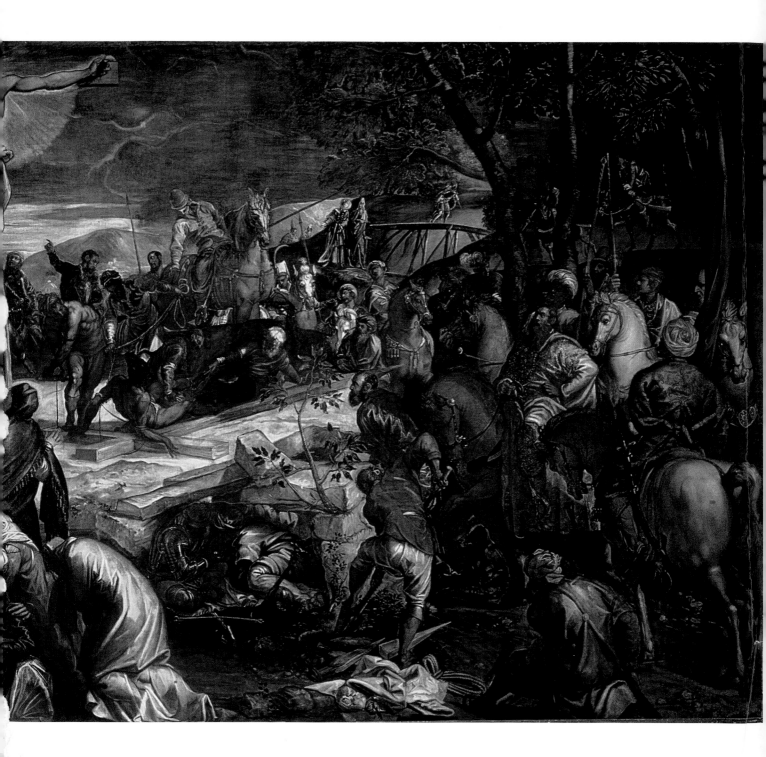

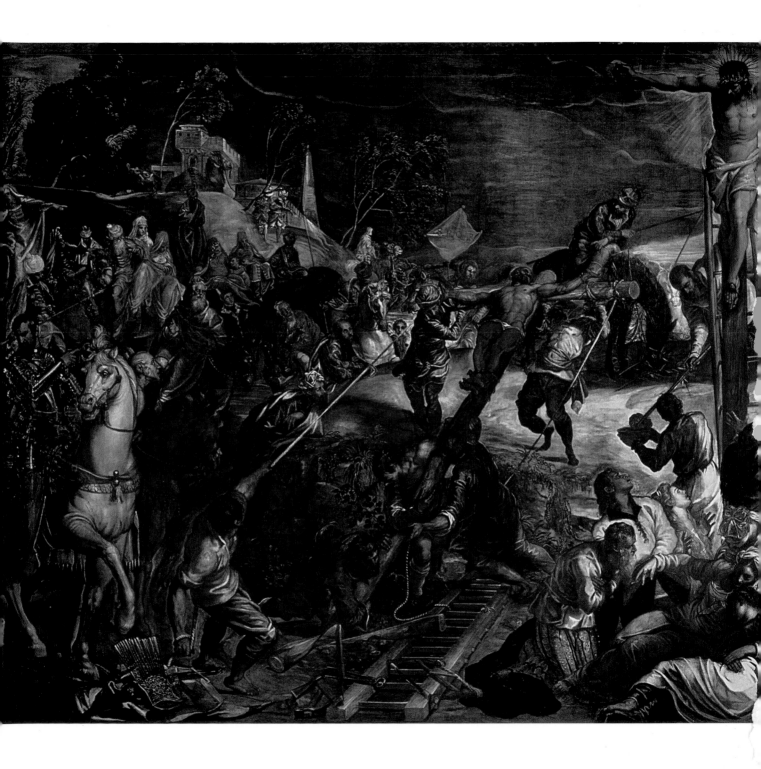

can't possibly desert him but can't bear to look up at the suffering he's enduring. I don't know how he does this but it had never occurred to me until I looked at this picture. It's wonderful that St Peter, who doubtless can't bear to look up either, is channelling his grief by focusing on the Virgin. Only St John the Beloved is able to be a direct witness.

Immediately behind the cross is a large, rectangular structure, about a metre high, stretching diagonally from the centre to the upper right of the canvas. One or two people are leaning on it to observe the spectacle more comfortably, only the upper half of a horse is visible behind it, and under it, in the right foreground, the soldiers are playing dice for Christ's clothes. As St John describes:

> *Then the soldiers, when they had crucified Jesus, took his garments and made four parts, to every soldier a part; and also his coat. Now the coat was without seam, woven from the top throughout. They said therefore among themselves, 'Let us not rend it but cast lots of it whose it shall be.'*

Tintoretto paints only two soldiers at dice. A third, in the same colour tunic as one of the players, is leaning forwards to keep an eye on the coat or the dice. The fourth may be the man digging in the ground, his back to the coat.

To Christ's right and on our left, the first thief's cross, the victim already nailed to it, is about to be raised into position. The upper part of it rests on the structure and it's going to take six men, straining and lifting and pulling, two pushing from behind and four hauling on ropes looped round their arms in front. These ropes follow the diagonal lines of the structure and are one of the means by which Tintoretto puts the focus onto Christ. Another way is the fact that in a very crowded scene, full of people and horses and activity, the large space behind Christ's cross is empty. A third is the artist's decision to place the actual figure of Christ above all the surrounding activity, so that he stands out and alone against the lowering sky.

The second thief has not even been nailed down yet. He's been forced on to the cross, which lies on the structure behind and to Christ's left, but his torso is lifted in resistance. He supports

'There's an absence of savagery or sadism, of gleeful revenge or retributive gloating: the event is scarily normal in its matter-of-fact pragmatism. Any spectators have clearly attended crucifixions before—there's an interest, naturally, or no one would be there, but there's no avidity for the suffering being witnessed.'

himself on one hand and rests on the other elbow, its hand outstretched in entreaty. None of the men surrounding him pays any attention. They are engaged in their dreadful work, some tying the lower half of him down, another about to wield what might be a hammer, a man on horseback urging them to get on with it, and a bearded man in black pointing defensively at Christ as if to say, 'We are getting on with it.'

Many people—there are no women in the scene, it is all men—have come to observe the spectacle, to see the law being executed, to witness what they regard, no doubt, as justice being done. At the extreme left of the picture is the centurion, a handsome man in armour and red tights, astride the white horse. Presumably he is the man who, as St Luke tells us, on Christ's giving up the Ghost, 'glorified God, saying "Certainly this was a righteous man."' He is pointing at Christ but his face is turned away towards the page to whom he is speaking. Far behind him is a large group of Pharisees, one of whom is also pointing at Christ although, like the centurion, like the man in charge of the third crucifixion, he is not actually looking at Christ. In fact, it is surprising how many people aren't looking at him. And at the far right of the picture, a mysterious figure, picked out in the ghastly supernatural light, is crossing a rickety bridge and leaving the scene altogether.

But the painting is not about faces, not about people, but about an event that, for Tintoretto, most of his contemporaries, and any present-day Christians, had an importance that transcends the individual.

There's an absence of savagery or sadism, of gleeful revenge or retributive gloating: the event is scarily normal in its matter-of-fact pragmatism. Any spectators have clearly attended crucifixions before—there's an interest, naturally, or no one would be there, but there's no avidity for the suffering being witnessed. Yet despite the everyday, humdrum feel of the activities of the men involved in or observing these three deaths, I have never seen a representation of the Crucifixion which made me feel the intensity of the event so forcefully.

Partly it's due to the scale of this huge painting—more than 12 metres long; partly the detail with which Tintoretto has filled it; partly the unearthly quality of the light, a halo of which surrounds the upper half of Christ's body and which is ominous and brooding, portending a day of doom, as when 'there was silence in Heaven about the space of half an hour' in the Book of Revelations. But mainly it's due to the choice that Tintoretto has made—a stroke of imaginative genius—of the moment of the Crucifixion that he has chosen to paint. Most Crucifixion scenes—those of Rubens, Mantegna, Van Eyck, to name but three—show Christ with the thieves on either side of him. The business of crucifixion is over, the hustle and bustle is ended; we're left with a tableau of pain and suffering, death yet to come.

Some painters, like Botticelli, show Christ alone, and sometimes, as in Grunewald's unforgettable Isenheim Altarpiece, as having died in terrible agony. But in Tintoretto's painting, the fearful business has only just begun—Christ has only just been crucified and raised upright, the first thief's cross hasn't yet been lifted, while the second thief is only just about to be nailed down. This is no tableau then. This is murder in action, its executants impervious to the fear and pain of their three victims. And we, the spectators, are asked to participate in an event with many hours of anguish and agony yet to come.

As Degas said, 'Art is not what you see, it's what you make other people see.'

BEAUTY AND THE BEES
SANDRO BOTTICELLI

Sandro Botticelli was a Florentine, active in the reign of the Medici family in the fifteenth century. He painted contemporaneously with Leonardo, Michelangelo and Titian. Botticelli became a supporter of Savonarola, a monk whose unbalanced and iconoclastic views caused the ousting of the Medicis—which happened to them fairly regularly—and for a few years created a sort of puritan republic in Florence. As, hopefully, with any religious fanatics who impose themselves on the rest of the world, sanity and the Medicis reasserted themselves.

Botticelli began his career working under Verrocchio but by 1480 he had his own workshop and his own instantly recognisable style. Apart from his frescos for the Sistine Chapel in Rome, he worked mainly in Florence. His art, like that of the other masters of the Renaissance, displays an idealisation of the human form and proposes an essential harmony between man and nature. But Botticelli, like Leonardo, painted with a heart-stopping and delicate tenderness. No artist has ever conveyed a mother's love for her child or depicted the Virgin and the infant Jesus with such gentleness and genuine sweetness. His most famous pictures *La Primavera* (Spring) and *The Birth of Venus*, both in the Uffizi at Florence, get closer to music than any other paintings I have seen.

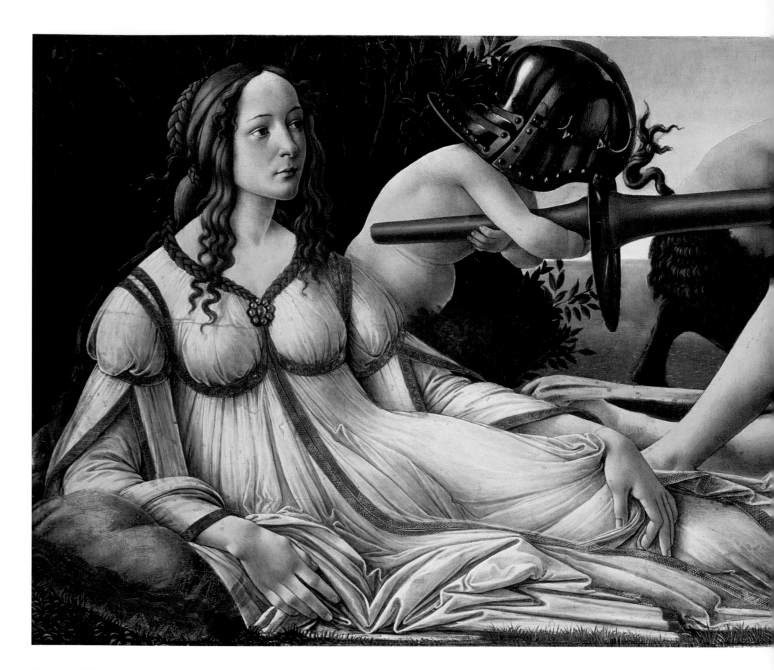

Venus and Mars, Sandro Botticelli, 1485

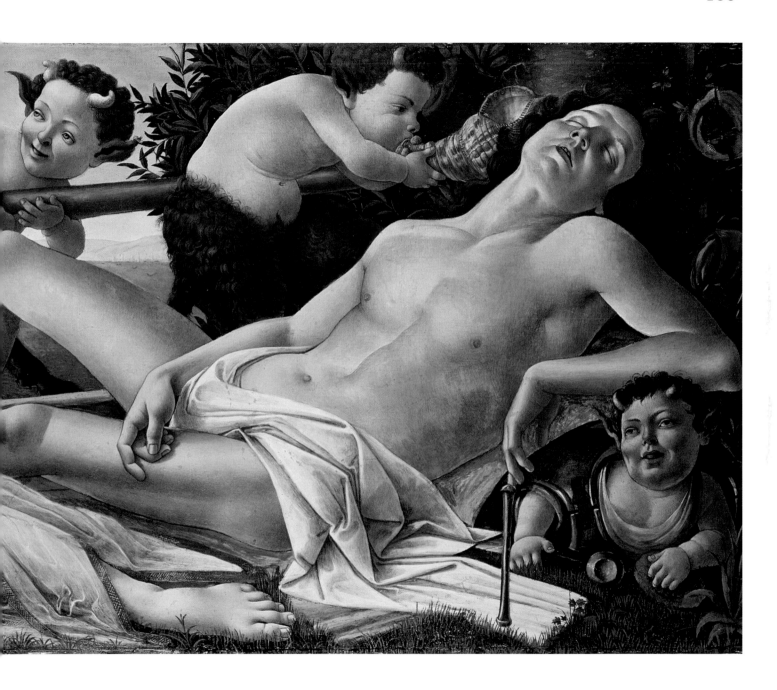

VENUS AND MARS, 1485

Venus and Mars, in the National Gallery of London, is said to portray Giuliano de Medici (who also appears as Mercury in *La Primavera*) and his mistress, Simonetta Vespucci. In this beautiful and serene painting—Venus contemplating a naked and sleeping Mars with little fauns at play around them—there is an intriguing, perplexing dichotomy.

Venus has very recently been making love with the naked god at whom she is gazing. She has, in fact, been committing adultery; so far undiscovered, we must assume, by her husband, Vulcan. And the four little fauns are not putti or angels or cupids but furry satyrs with horns, innocently mischievous maybe, but nonetheless emblems of lust.

Venus is stretched out on the left of the painting—nearly three times as long as it is deep—her right arm resting on a pinky-orange cushion, the other on her thigh. She is barefoot and is lying on a long piece of pink material on which Mars, on the far side of the picture, also rests. She wears a dress of translucent white, edged with gold, and has a little brooch of grey stones at her cleavage, one pink jewel at its centre. The dress is cut high under the bust and is edged with the same gold to outline her breasts. There is not a hair out of place in her perfectly arranged golden tresses.

She gazes tranquilly across at Mars, a beautiful young man who is in his prime, naked except for a white cloth draped tactfully across his loins. He has dark chestnut hair, is using his breastplate as a pillow and is dead to the world.

He's obviously been asleep for some time because the four little fauns are at play: one wears the god's helmet, which completely engulfs him; and he and a friend, who is looking back mischievously at Venus, have picked up Mars' lance and may be about to charge off with it. A third is holding a conch shell to the god's ear to show how deeply asleep Venus' lover is. A fourth has crawled through the armhole of the breastplate on which he is reclining and has a hand on his sword, laid carefully at his side.

Near Mars' other ear, wasps buzz round the bole of a tree to show, again, how fast asleep he is, as we don't know if the conch—an allusion to the sea from which Venus arose—has been sounded. I doubt it. Mars' sleep would be deep indeed to survive a shell being blown right in his ear and Venus would not be so composed if her lover had been disturbed. Despite one of the fauns looking back at her in guilty excitement, she seems oblivious to their antics.

Both lovers are backed by dark trees, like the dark wood encountered by Dante at the beginning of *The Inferno*, 'in the middle of our life's journey'. All is still. Mars is asleep, Venus motionless in contemplation. Only the little fauns are up and about, playing with the big man's weaponry. There's no suggestion, apart from the fauns' antics, of movement, no hint of a breeze, and the background is empty of distractions. Behind the protagonists is a green meadow, no flowers, no additional colour, just grass. Above it is an empty cloudless sky, pale blue-grey. Mars' lance is a proper jousting lance but there's no horse grazing and there are no birds in the sky. Comparing this picture with, say, the profusion in *La Primavera*, you realise that Botticelli has stripped away any elements that don't contain an allegorical significance. It doesn't matter that we won't grasp all, or perhaps any, of these—no one except an art

historian or a contemporary of Botticelli's would—but it explains, I think, the singular absence of decoration, which keeps us focused on what might be about to happen.

Since the fauns' torsos are human and are bare, and since the god is naked, over half the picture is a confusion of tangled limbs. But it's Venus, in her white and golden dress, at whom we look first. She regards Mars with an expression of calm, mixed with a certain sadness. This Venus is as far from eroticism as you can get, so much so that you would hesitate to touch her for fear that a mere and mortal hand would desecrate her purity. She seems sacrosanct, the *Venus Venticordia* who was invoked in Ancient Rome to 'turn the hearts of women to virtue and chastity'. Despite our knowledge of her relationship with Mars, which must be based on physical attraction, there is nothing about her to suggest amatory, let alone adulterous, activity.

In *The Birth of Venus* the goddess is rising, naked, from the sea, standing on a shell. She was regularly painted nude, even at this early period, the portrayal of nudity in classical antiquity or mythology being acceptable, as it was with Adam and Eve, though otherwise off limits. So why did Botticelli, in this scene of post-coital relaxation, paint Mars virtually nude and his partner fully clothed? This question, though we don't formulate it so exactly, is one that nags at we spectators, perplexes us, rivets us.

The picture is so beautiful, so gentle, so delicately humorous but … what is it about? Perhaps it is the triumph of Love over War: '*Amor vincit omnia*'. Perhaps we are intended to be concerned that peace will last no longer than Mars' sleep which, when that conch shell gets blown, is likely to be of brief duration. Perhaps it is the brevity, the only temporary respite, of peace that is the cause of Venus' sadness. Or perhaps it is that her unconcerned, tranquil gaze tells us of her acceptance of it. Whatever it is, it keeps us gazing at this wonderful and enigmatic picture.

BREAKING BOUNDARIES
GEORGES SEURAT

Georges-Pierre Seurat came from a wealthy Parisian family. He attended the École des Beaux-Arts when he was nineteen, did his military service and set up a studio in Paris in 1880, where he spent the next two years perfecting his skill at drawing.

The major influences on Seurat were three: Jean-François Millet, whose paintings of rural life were trying to capture life as it was rather than as seen by a classical rearrangement of landscape; Delacroix, whose use of colour was an inspiration to his successors (Cézanne, Monet, Degas were all greatly influenced by him); and, most importantly, the scientific treatises on colour of Charles Blanc and Michel-Eugène Chevreul. Their theories of 'complementary colour' suggested that painters should not mix their colours but instead juxtapose complementary colours: put crudely, they should not mix blue and red to produce purple, but should juxtapose, say, blue, red and yellow to produce the optical illusion of purple. This led Seurat to the innovation that made him famous: pointillism.

BATHERS AT ASNIÈRES, 1883–84

Bathers at Asnières was his first big canvas. It is 2 metres high by 3 metres wide and it shows a group of working men on their day off. When he submitted it for exhibition at the Salon of 1884 I don't feel he can have been surprised that it was rejected. The only subjects deemed suitable for such a large painting at the time were religious, historical or classical subjects. Certainly not the lower orders lounging on the banks of the Seine. So Seurat was making a deliberate political point. The Impressionists believed that it was not necessary for a picture to tell a story. Renoir, Monet, Pissarro, Sisley all wanted to capture the moment—the dance that will end, the sunlight that will be clouded over. This was the reason they began to paint *en plein air*, something ridiculed at the time. But in recording 'the moment' on such a large scale and in portraying working men, Seurat was challenging the right of the establishment to dictate what was or was not a suitable subject for art. There may also be a slyly subversive political statement in the painting.

In the background is the bridge at Clichy, a suburb of Paris, and the factories there. Above the buildings are six tall chimneys. The one in the centre spews out smoke that turns to dark blue as it drifts away to the right. To that side of the bridge are trees with a stone wall dropping directly down into the river.

To the left of the bridge are taller trees and, half hidden among them, a couple of houses, white-walled, red-roofed. Then, occupying half the painting, the riverbank slopes down towards and almost across to the right of the canvas. Just below the bridge on the left of the river are a couple of sailing boats while, on the right, further towards us, is a third sailboat near the shore and, only half his skiff visible, a solitary sculler.

More importantly, there is a ferry with a tricolour hanging limply from its flagpole but with the red, white and blue clearly visible so we can't mistake what it is. In the ferry is a boatman, white-shirted and straw-hatted, pushing his paddle to take his passengers to the far shore. These are a lady, her back to us and to the men on the bank, mostly concealed by a white sunshade, and a dark-suited man in a top hat. The sunshade and the top hat tell us, I think, that they are a lady and a gentleman. Does the flag,

an absurdly large one for such a small boat, suggest ironically that its passengers are representatives of France more valuable than the idling workers whom they are leaving behind?

Downstream of the ferry and closer to the near shore, a band of weed about the length of the boat and of much the same green as the grass floats on the water. On the main bank, which slopes down to the water's edge, are a number of working men on their day off—or that is at least a reasonable supposition, for else how could they be there? There are four older men on the bank, three younger ones in or near the water. The sun, as we can tell from the shadows of the men sitting on the grass, is coming from the right of the picture.

Furthest away from us, a man in a pinky-brown shirt, dark trousers and a straw hat is stretched out on his stomach. Next to him a man all in white and wearing a bowler hat sits gazing at the ferry. Then there's a cutting in the bank—perhaps made to allow boats to land. The earth must be chalky here because the soil exposed by the excavation is cream. On our side of the cutting a man sits on a brown cushion, barefoot, with trousers rolled up to his knees, a sleeveless under-vest and a straw hat, its band matching his cushion. He too is looking at the water.

Standing almost submerged in the river is a blond adolescent, turned away from us. Like all the men, he is pale skinned—these are factory workers, only rarely exposed to the sun. The largest figure in the picture—though not the most prominent—is a teenage boy, sitting on the edge of the bank, dangling his feet in the water. He wears red bathing trunks and his clothes—a straw hat with band to match the trunks, dark boots, and trousers with a big white towel thrown over them which helps draw the eye to him—are beside him. He has badly cut auburn air and his face and neck are a darker colour than the pale skin of his body. He sits slumped and round shouldered, an unattractive figure with a big nose and a receding chin. You feel he's lonely, his mind vacant. Or perhaps the girl he likes will have nothing to do with him and he's enduring the misery of young love.

Behind him lies a black-haired man with his back to us, leaning his face on his hand. He wears a bowler hat and his shirt has been pulled out of his dark trousers, which provides a long length

'He sits slumped and round shouldered, an unattractive figure with a big nose and a receding chin. You feel he's lonely, his mind vacant. Or perhaps the girl he likes will have nothing to do with him and he's enduring the misery of young love.'

of white, mirroring the cream of the cutting beyond him. Behind him, looking at the river, sits an orange spaniel. Seurat is always good at animals.

Further up the bank, behind him, we see a pile of clothes—perhaps belonging to the final figure, a boy standing in the river. He's the figure closest to us and, due to Seurat's compositional skill, despite being at the extreme right-hand edge of the canvas, is the focus of the painting. He wears red swimming trunks and a red hat, a blaze of colour against the white of his skin, which helps to direct us to him. Fingers intertwined, he holds his cupped hands to his lips and his head is slightly raised. He's making some sort of whistling noise—is he calling to people on the other bank or has he just discovered he can make that noise?

The overall impression is of green (the grass), blue (the sky, the water), cream and white (the bridge and buildings in the background, the sails of the boats, the chalk of the cutting, the white of the men's shirts). The feel is static,

even unanimated, as the only activities are the ferryman plying his oar in the distance and the boy whistling in the foreground. These are working men—maybe workers at the factories in the background, there's only one chimney smoking—and this is their day of rest.

But where are the women? In another picture of people on a day off, *Sunday Afternoon on the Island of La Grande Jatte*—the subject of Stephen Sondheim's musical *Sunday in the Park with George*—Seurat included many women and covered a wide social spectrum. This is just seven men on the banks of the Seine with members of the bourgeoisie being rowed away from them. One must assume this is a deliberate choice for, of course, the women are not tending the home as better-off middle-class girls do. Like their men folk, they have to work, which must be where they are today.

The composition of the painting, the way in which Seurat guides us where to look, is thrilling. There's a series of diagonals, sloping from left to right across the picture and Seurat's

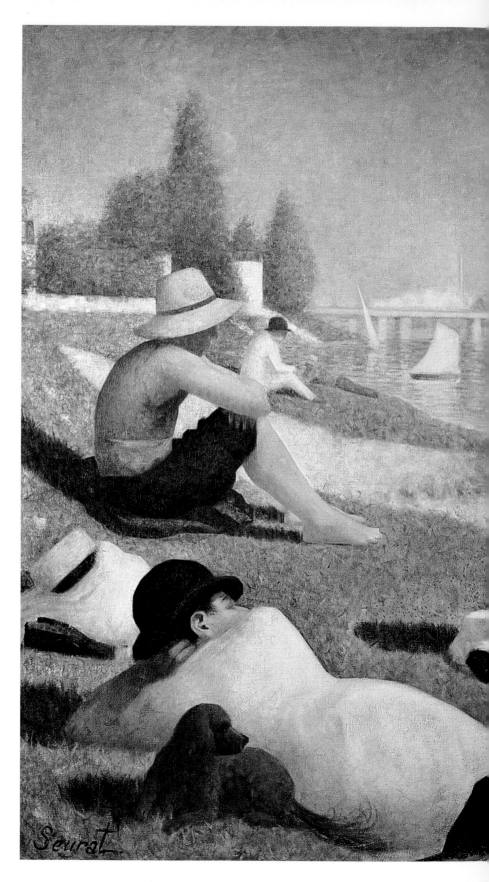

Bathers at Asnières, Georges Seurat, 1883–84

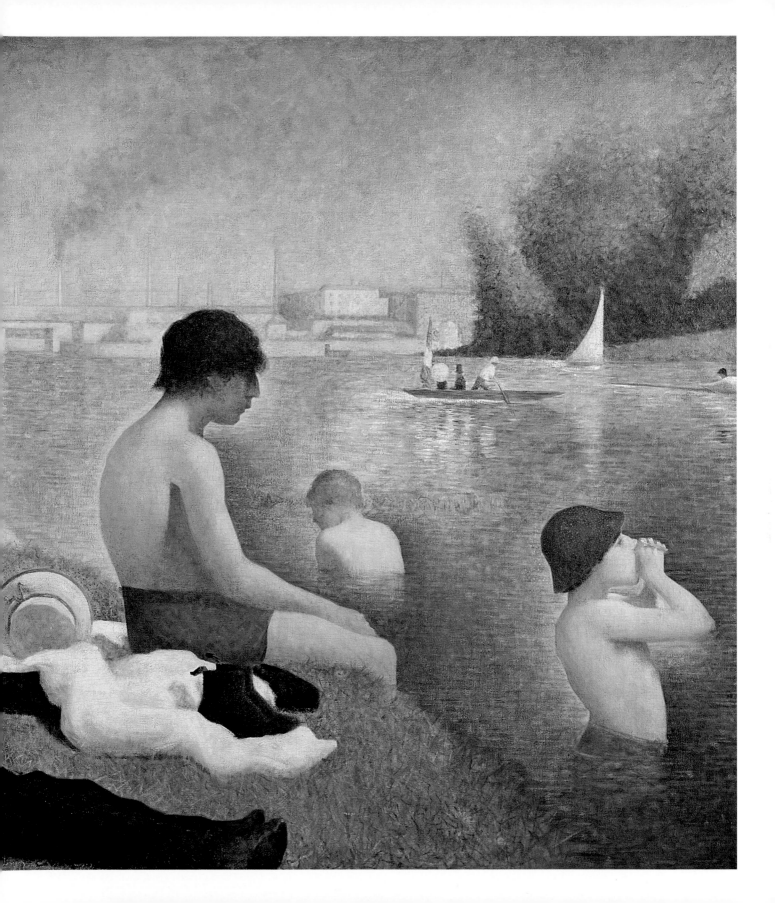

'When Seurat painted this picture in 1883–84 he had not yet perfected his technique of pointillism, or "divisionism" as he preferred to call it. But the great adventure is under way: he uses a number of colours to produce an overall hue. The green of the grass is made up of green, yellow, grey; the teenager's swimming trunks contain orange, pink, blue, the odd streak of black—but the paint is dabbed on.'

use of brown to red directs us unavoidably to the focus, the boy in the red hat standing in the water. Parallel and behind him are the adolescent's red trunks and behind that is the brown cushion, the same auburn as the young man's hair. The interruption in the green of the grass provided by the cutting also pulls our eyes down, away from the pale-blue sky, away from the white and cream bridge and factories. Below the cutting, the two piles of clothes and the long white shirt of the man with the bowler hat and the spaniel also move us diagonally down and right. And, of course, the three young men in and close to the water all have pale skins.

When Seurat painted this picture in 1883–84 he had not yet perfected his technique of pointillism, or 'divisionism' as he preferred to call it. But the great adventure is under way: he uses a number of colours to produce an overall hue. The green of the grass is made up of green,

yellow, grey; the teenager's swimming trunks contain orange, pink, blue, the odd streak of black—but the paint is dabbed on. The tiny dots, for which he must have used a fine brush, do not make their pointillist appearance until two years later and he would use this technique for the rest of his short life.

This is a very friendly picture. It's also a very beautiful picture. Nothing is glamourised, nature is not idealised. The figures are ordinary men, not particularly handsome, just men. But there's a luminous quality to it and a tension between the industrial background and these motionless men sitting on the riverbank. It is life, unidealised, unromanticised. I rate it as a masterpiece and so I sit happily in London's National Gallery, breathing it in and waiting patiently for the Japanese tourists in front of me to move on and stop blocking my view.

Seurat's influence, once he launched himself on pointillism, was enormous. Van Gogh tried out the technique in *The Restaurant* of 1887; Gauguin, who didn't approve of pointillism, did the same in his ironic *Ripipoint*; Lautrec's portrait of Van Gogh uses the pointillist technique; and Pissarro painted a number of his best pictures following Seurat's lead and wrote to his son: 'I think Seurat has something new to contribute. I am personally convinced of the progressive character of his art and certain that in no time it will yield extraordinary results.'

But in 1891, a year after Seurat completed *Young Woman Powdering Herself*, or *La Poudreuse* as it's more simply titled in French, a portrait of Madeleine Knobloch, his mistress and the mother of his one-year-old son, the boy contracted an infectious angina. Seurat caught it from him and both he and his child died. So, tragically and prematurely, ended the life of one of the most innovative and influential painters of the nineteenth century.

Three months later, an inventory of his estate was made by fellow artists, including Paul Signac, who was to carry Seurat's innovations further. Madeleine Knobloch was given a number of paintings as her share and then, possibly to avoid or even to evade Seurat's family with whom she had quarrelled, she disappeared and was not heard of again.

But all this was hidden in the future when Seurat painted this happy and affectionate picture.

LA POUDREUSE, 1890

In an imaginary, non-naturalistic room, its walls or wallpaper blue with halo swirls of light, little ectoplasmic dashes of pinky-brown and flowers to match, Madeleine is sitting at her toilette. She is a large, generously proportioned woman and the dressing table at which she sits is comically tiny. It has room only for a mirror and a little stand holding two bottles of a honey-coloured liquid—perfume, I presume. On the wall behind the mirror is a large pink flower and high up on the left of the canvas is a larky little window, its shutters opening outwards towards us. In the room revealed beyond, the background is lighter and a vase of flowers sits on a brown table.

Madeleine holds a powder puff in one hand—though there is no powder unless it's in the little compact partially concealed by her left hand. She is, properly, approaching her toilette with care and attention.

She wears a diamond or pearl earring with a blue stone at its centre and has an elaborate coiffure that balances and harmonises the plumpness of her face. She has not only a fringe and hair falling down past her shoulders but also two piles of hair on the top of her head, probably rolls of her own hair padded with horsehair as was a fashion at the time.

She wears a dark-red corset with white lace shoulder straps over a cream underskirt. Seurat has composed the cream of the underskirt with tiny yellow and blue dots, and the dark red of the corset, also made up of similar dots, consists of blue, red and yellow alternating. The white powder puff is dots of white, pink and blue and her hair dots of black, red and blue.

The painting is not critical or even ironical but there's something in it that makes you smile in recognition and pleasure. With this large and handsome woman and her fine figure, seated at a doll's table, taking the business of the application of powder so seriously, Seurat has struck a chord that must reverberate in many of us: who hasn't observed without a smile of affection their loved one taking the business of personal adornment with a solemnity more properly devoted to the destiny of nations? In this painting Seurat brings us all together and I love it and him because of it.

La Poudreuse, Georges Seurat, 1890

STUNG
LUCAS CRANACH

Lucas Cranach (the Elder: he had two sons, neither as gifted as he) was the most popular and successful painter of the fifteenth and sixteenth centuries in Germany. Court painter to the Duke of Saxony at the age of 33 and knighted by him, he must also have been a considerable businessman. He owned a number of houses in Wittenberg (where Hamlet went to university), ran a very large workshop with at least ten assistants, and owned a bookshop, a wine merchant's and a printing works, becoming treasurer and later mayor of the city. He was godfather to one of Martin Luther's children, as Luther was to one of his.

In about 1550, at the age of 78, Cranach left Wittenberg for good to be with the duke in Augsburg. There he met Titian and is said to have painted his portrait.

In the course of his very long life—81 years—he covered a good waterfront of subject matter. He was a wonderful painter of animals (his Adam and Eve in London are beguilingly surrounded by them) and his landscapes are beautiful idealised inventions. He seems to have had a less benevolent attitude to humankind—his sitters often verge towards the grotesque, often dressed in aggressive combinations of red, gold and orange. There are not many you'd want to encounter alone on a dark night. He painted a number of erotic nudes of very young, small-breasted girls—they're unquestionably sexy but, like many of his subjects, there is something feral about them. They are perhaps too young to wreak much destruction yet, but they will turn into the hard-faced, mercenary women whom Cranach seems to have relished depicting in the exploitation of lecherous, or at least amorous, old men.

His skill is immense, his artistry consummate, but I'd rather steer clear of his world.

CUPID COMPLAINING TO VENUS, c. 1527

However, his *Cupid Complaining to Venus* is an extraordinarily harmonious painting. In the far, far right distance is a castle reflected in a lake. Closer, but still far off, are high cliffs topped with trees. From these cliffs, the land slopes down to the lake. At the base of the cliffs is a copse, also reflected in the lake, at the edge of which is a red-roofed house. A blue sky, shading to almost white, otherwise Cranach's palette is subdued: grey, brown, yellow, dark green.

Much closer to us, and occupying three-quarters of the background, is a wood with very dark green trees, their leaves picked out with little streaks of yellow. Within the wood, a grey stag gazes off into the distance and what is perhaps a small ass or even a little fawn, ears pricked, gazes in our direction.

In front of the wood is a tall apple tree, loaded with golden fruit, rather like the tree Cranach put in *Adam and Eve*, just down the road from London's National Gallery at the Courtauld Institute. A stony path, perhaps coming from the distant house and winding its way towards us, is in the right foreground and disappears off the bottom of the canvas.

In front of the tree are the protagonists, Venus and Cupid. Both are naked, their pale flesh an arresting, even shocking, contrast to the dark wood backing them. Venus stands on the verge of the grass, also dark green, at the edge of the path, one leg resting casually on a low branch, one hand holding on to another high above her head. Around her neck are thick strands of gold and she wears a large cartwheel hat, trimmed with white feathers or some sort of show-business froufrou, tilted elegantly on the side of her head. Like any experienced performer, she knows to wear a hat well back from the face if the gallery are to see her. She has immaculate gold hair, lighter in shade than the gold of her necklace.

Cupid is barely half a metre tall, with wings matching the frippery in his mother's hat. He, too, is golden haired like his mother. There is a bee on his face, another on his arm, a third on his chest. In one hand he holds a piece of honeycomb and is looking complainingly, even tearfully, at his mother: the bees have not welcomed his burgling their stores and he's been stung.

'Cranach makes such a harmonious whole of this painting that one wants just to stand and look.'

Venus, though one hand is extended restrainingly, even comfortingly, towards him, is not looking at him but away, her eyes cast to the ground. She wears, in addition to the hat and the gold necklace, an expression of amused detachment.

The bright blue sky is the only strong colour apart from the pallor of the two naked bodies. The golden apples at the top of the tree link down to the yellow and gold of Venus' and Cupid's hair, the gold with which Cranach highlights the dark tree trunk, the stones and surface of the path, and the shapes of the distant cliffs.

Cranach makes such a harmonious whole of this painting that one wants just to stand and look. And look. And wonder about the animals—why are they there, what actually are they?—and about what Venus has to say to her complaining son.

There's an anonymous Elizabethan poem, *Cupid in a Bed of Roses*, which tells a similar story—though Cupid has been stung accidentally while asleep, not as a punishment for burglary. He too, like Cranach's Cupid, is tearful and his mother says, as this Venus very well might:

If so great a sorrow spring
From a silly bee's weak sting
As should make thee thus dismayed,
What anguish feel they, think'st thou, and what pain
Whom thy empoisoned arrows cause complain?

Cupid Complaining to Venus,
Lucas Cranach, c. 1527

A VENETIAN MEGASTAR
TITIAN

Venice, the longest lasting republic—at 1300 years—in the history of the world, produced a number of great painters during the Renaissance between 1400 and 1600. But none equalled the genius and the superstar status of, nor lived so long as, Titian. Courted by every Italian ruler, by the Pope, the King of Spain, the Holy Roman Emperor, he never stopped working in an astonishingly long life of over 90 years, producing pictures of amazing beauty, whether the subject was sacred or profane. He was a highly acquisitive man, but he had to be for his princely and royal patrons were, to a man and woman, very slow at paying for what they had commissioned.

Described by Vasari, the chronicler of the lives of the Italian painters, as of 'unvarying courtesy and affability', he formed a sort of sixteenth-century rat pack with the writer Pietro Aretino and the sculptor Jacopo Sansovino, a hospitable and welcoming group devoted to wine, women and every concomitant conviviality.

Titian began life as an assistant to Giorgione and was so successful so early that, much to Giorgione's fury, people used to confuse their work. He became the official and leading painter of Venice. His output was prodigious—wonderful portraits for which he was most in demand by Europe's royals, devotional works, mythological fables, beautiful women, with—in all of them—an unequalled richness of colour, whether the brilliance of a blue sky, the lustre and sheen of costly fabric or the delicate eroticism of flesh.

DIANA AND ACTAEON, 1559

The story of Diana and Actaeon is one of the most celebrated in classical mythology and has been painted very frequently over the centuries.

Actaeon, a huntsman, had the misfortune to surprise Diana, the goddess of chastity and of the chase, and her nymphs while they were bathing. In some versions the encounter isn't accidental on the man's part. Whether intentional or not however, the result was the same: Diana changed him into a stag and her hunting hounds tore him to pieces.

Actaeon is the main reason that Titian's version of this story so delights me. This Actaeon is no gym-buffed, idealised Adonis nor a Lothario of Herculean proportions. He's a very ordinary young man, dressed in a workaday tunic, hair a bit tousled and probably cut by his mother, orange stockings round his ankles and toeless sandals. Curiously, in *Diana and Callisto*—a Titian that also hangs in the National Gallery of Scotland—Callisto, the guilty party, a nymph who has broken her vow of chastity and whose pregnancy is discovered by Diana in the picture, also wears orange stockings.

Actaeon is surprised by what he's discovered—six naked women—and one hand is raised in an awkward, even embarrassed, greeting while the other has just dropped his bow, where it lies at the feet of his large black and white hunting dog who is looking up at him for instructions.

The goddess is a well-covered woman who doesn't look as if she does much hunting. She reclines on a stone pedestal, being dried off by her nymphs after a bathe in the little stream that

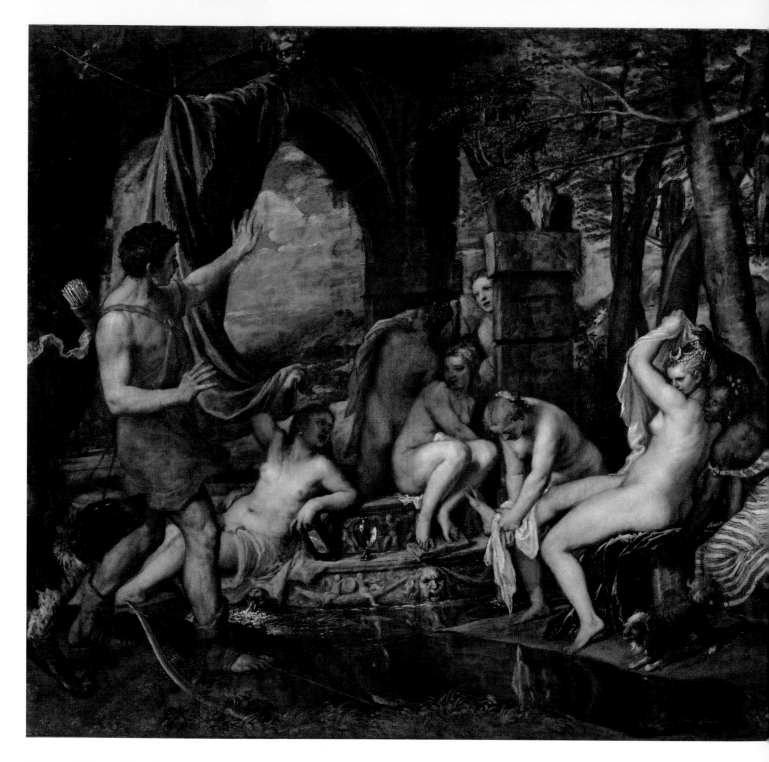

Diana and Actaeon, Titian, 1559

'She reclines on a stone pedestal, being dried off by her nymphs after a bathe in the little stream that runs diagonally across the picture. Despite her state of undress she wears a tiara of pearls with a crescent moon on her forehead so that the spectators will know who she is.'

runs diagonally across the picture. Despite her state of undress, she wears a tiara of pearls with a crescent moon on her forehead so that the spectators will know who she is. She does not look pleased: she has pulled the towel away from the nymph drying her upper half to shield her ample breasts from Actaeon. He, in turn, has just been exposed by another handmaiden having pulled aside the rose-red curtain that was protecting Diana from the sunlight coming from behind the intruder on the other side of the canvas.

There's no sign of Diana's hunting dogs but on the far right of the picture, crouched at the feet of a black nymph wearing an orange-and-white-striped dress, is a little brown and white dog, a King Charles spaniel perhaps, who is on red alert.

Only this brown and white dog is in hostile mode—Diana appears merely displeased for the moment and her attendants are surprised rather than alarmed. The nymph holding the curtain is looking back at Diana as if to say 'What now?' and the exposure of the interloper is so recent that the girl drying Diana's foot hasn't even lifted her head. As for Actaeon, he looks as if he would like to apologise for having disturbed them and go off to continue his hunting.

Alas, poor fellow, the skull of a stag, perched on top of a column just to Diana's right, is a forbidding omen of what is going to happen next. As Marlowe wrote in *Edward II*:

One like Actaeon, peeping through the grove,
Shall by the angry Goddess be transformed
And running in the likeness of an hart,
Pulled down by yelping hounds shall seem to die

The space is enclosed architecturally by a ruined building through which the bright blue sky, a colour beloved of Titian, is seen—a blue which is echoed in the blue cloth draping the lower half of the nymph who has revealed Actaeon and in the blue flowers or berries in the black girl's hair. The light is clear and its source focuses the painting brilliantly, illuminating Diana and, on the opposite side of the picture, just picking up the pink curtain and Actaeon's shoulder, arm and calves. In addition, although there's no question that the focus is on the goddess, because Actaeon is standing by the only solid block of colour in the picture, the pink curtain, we're also told at first glance that the painting is about this man and that woman. Even if you don't know the legend, the inherent drama is plain: a man has just blundered into a group of naked women. Something must be going to happen as a result, even if it's only the man apologising and leaving. Both protagonists' eyes are locked on each other and the body language of each tells a dramatic story—Actaeon's surprised, almost casual greeting and Diana's resentful shielding of her body from his view.

Paintings of many periods tell a story that the artist presupposes the spectator will know: most religious, Christian subjects; most classical or mythological tales. A knowledge of both was part of every educated person's upbringing from the fourteenth to the mid-twentieth centuries. Similarly, many paintings contain allegorical symbols, the significance of which the artist assumes his audience will share with him. But a great painting transcends these limitations by virtue of the immediacy of the dramatic story it has to tell. Naturally it will add to the spectator's enjoyment if the story or the meaning of the symbols is known, but the picture will still operate if the viewer doesn't have that information.

Titian uses both light and colour in a highly dramatic way to tell the story. The vivid blue sky in the background, the swathe of pink curtain at the left, the light leading us across to the right to focus on Diana's white and naked body, make you stop immediately—the colours call out to you. And because the sky is blue, the curtain pink and the goddess white, it's to her you're forced to go. You stop for a look—you're hooked.

THE DEATH OF ACTAEON, 1565

The end of the story is revealed in *The Death of Actaeon*, in London's National Gallery.

The cast has changed: Diana has leapt off the pedestal, donned a rose-pink, thigh-length tunic—the same colour as the curtain from *Diana and Actaeon*—shed a good 20 kilos and picked up what looks like the very bow which Actaeon had dropped in the first picture. It's certainly the same model and colour.

He, on the far side of the painting, has breeches of a similar rose colour to her tunic, though with more brown in them, so the focus is firmly on the goddess. He has the head of a stag, his chest is bare, his arms are upraised and he's being attacked by a number of large dogs. His back is turned towards us and he's leaning backwards, away from the dogs' assault. The posture, the upraised arms, tell of a defenceless and astonished despair.

The Actaeon side of the picture seems curiously incomplete. Perhaps, indeed, Titian never finished it. Nobody seems quite sure. In the background, there's a vague outline of a horse with a figure astride it and perhaps another figure standing beside it, but Titian has made it impossible to tell for certain. A further problem is Diana's posture: she holds a bow in one hand, the other being pulled back beyond her shoulder as it would be if there was an arrow fitted to the bow. But there is no arrow. She is clearly about to loose one at Actaeon or has just done so but if she has, she's missed—something which I don't think the goddess of the hunt would be likely to do—for there's no sign of an arrow in Actaeon's body. So perhaps it is unfinished. Certainly

'*Diana and Actaeon* is one of Titian's great paintings. Even if it were finished, *The Death of Actaeon* doesn't come into that category. Executed by many painters, it would be a masterpiece. But this is Titian. Only a mediocrity is always at his best.'

the King of Spain, for whom it was destined as part of seven commissioned paintings on mythological subjects, never received it.

The palette is very different to that of *Diana and Actaeon*. The sky is dark with stormy clouds and, behind the trees that occupy the background of two-thirds of the canvas, a pale and livid yellow. The trees and bushes are autumnal. Titian uses two colours to focus our attention—the rose-pink of Diana's tunic, of Actaeon's breeches, and white.

His skill makes you catch your breath. Diana, because she is very close to us in the front left foreground, is much bigger than her victim in the mid-ground right. Above her head, the thunderclouds are edged with white. Her own flesh, especially the chest and one bared breast, is very pale, as is her outstretched arm. Just behind her and further right is a pond, its ripples, which are almost waves, highlighted with white. So all these whites are moving us right to where the dogs attacking Actaeon are brown and white. Actaeon's flesh, the same brown as that of the dogs, has highlights of white on his upraised arms and, most tellingly, there's a narrow band of white around the top of his breeches. As in *Diana and Actaeon*, Titian balances the two protagonists perfectly while, again, giving the goddess precedence.

Diana and Actaeon is one of Titian's great paintings. Even if it were finished, *The Death of Actaeon* doesn't come into that category. Executed by many painters, it would be a masterpiece. But this is Titian. Only a mediocrity is always at his best.

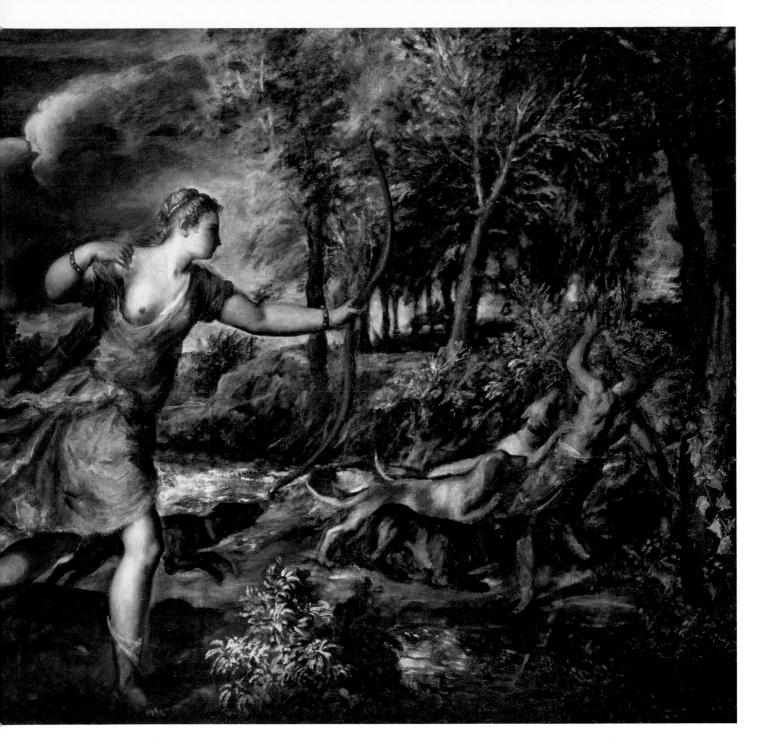

The Death of Actaeon, Titian, 1565

INNER LIGHT
PAUL CÉZANNE

Paul Cézanne was born in Provence, where he lived for most of his life. As a schoolboy in Aix, his closest friend was Émile Zola, a friendship that lasted for over 40 years until the publication of Zola's novel *L'Oeuvre*. The novel is about an unsuccessful painter, recognisably Cézanne, who commits suicide, and it ended the relationship.

Cézanne's father was a banker and Cézanne lived and painted on the family estate throughout his life. Although his father allowed him to study painting briefly, in Paris, he gave him an inadequate allowance. Until his father's death, Cézanne was obliged to live a double or even triple life: part dutiful son, living at home; part aspiring artist making occasional forays to Paris; and part owner of an apartment in Aix that remained secret from his family and where he maintained his mistress, whom he later married, and his son.

Although he was on good terms with his fellow artists of the day, Cézanne worked mainly in isolation. He would have agreed with Degas that 'to be a serious artist today, one must be immersed in solitude'. He exhibited at the fourth Impressionist exhibition and was singled out for particular derision by the critics. He found his art very hard, seeing it, right to the end, as a continual struggle to improve.

It is doubtful if any other painter of his epoch has influenced successive generations as much as Cézanne.

LAKE ANNECY, 1896

Painted in the last decade of Cézanne's life, *Lake Annecy* is one of my favourite landscapes. It is full of surprises: warm despite the predominance of blue and green; of a serene solidity despite the fact that half the picture is water; mysterious in its tranquillity and stillness.

In the left foreground, the dark trunk of a tree makes you feel the scale and distance of the painting as you look across the lake to the castle and the far shore. The water at the left of the canvas is dark with the overhanging shadow of the trees and becomes lighter from the centre to the right as it becomes free of their reflection.

The source of light, the sun, comes from the left, tipping the castle and the slopes of the mountains behind it with pink. The castle, reflected in the water, is surrounded by trees and to its right, just beyond the wood, is a small house and, at the far edge of the meadow to its right, a long barn.

It is very still. We know it's a sunny day—the Courtauld Institute's book says it's morning, to account for the pink I suppose, although it doesn't feel like that to me. Nonetheless here beneath the trees, from where Cézanne is painting and we are looking, it is cool and shaded. You can sit with this painting for a long time, entering into its unmoving calm. But—perhaps it's the castle, perhaps the expanse of water between us and the far shore—at the same time there is a feeling of expectancy. The scene is so still, so peaceful, so permanent that you feel something must be

Lake Annecy, Paul Cézanne, 1896

'You can sit with this painting for a long time, entering into its unmoving calm. But—perhaps it's the castle, perhaps the expanse of water between us and the far shore—at the same time there is a feeling of expectancy.'

about to happen, not dissimilar to the hush in a theatre when the house lights go down and we know the curtain—if there is one—is about to rise and the play begin. This is the moment, in the somnolent middle of the afternoon (or even the stillness of a pristine morning) for a boat suddenly to appear and to glide across the picture. One moment it wasn't there, the next moment it is—and you would feel, however unexpected or surprising, that this was the happening for which the picture was waiting.

Yet the painting is in no way a naturalistic depiction of a vista. This view across the lake at Annecy in Switzerland—whither Cézanne had been dragged protesting by his wife—is apparently a famous one and one of his aims was to rid it of its picture-postcard sentimentality. He certainly achieved that. He makes us aware of the monumentality of earth, something too serious for 'Having a lovely time, wish you were here'. And genius is a stimulus, hence my boat flight of fancy. Whether intentionally or not, these colours and shapes set my imagination working.

I'm not sure Cézanne would have liked me saying this—though I don't suppose he would have objected to being called a genius. He might have been pleased that the permanence, the essential shapes of trees, of the mountains, of the water's volume had been understood,

'… Cézanne is known to have preferred light to be what he called "internal", coming out of the picture. He believed that light existed in the essential shape of a tree, a mountain, a building, a body of water. And although he painted *en plein air*, he would modify what he saw literally as he came to understand its internal shape.'

because that was what he was trying to convey. He saw the transient event so lovingly and joyously recorded by Renoir and Monet as inessential.

Identifying the light source as the sun coming from the left of the canvas is perfectly natural—it's the left side of the castle and its tower that are tinged with pink, the left sides of the two mountain slopes beyond and behind it. But it's a naturalistically subjective response to the painting, while Cézanne is known to have preferred light to be what he called 'internal', coming out of the picture. He believed that light existed in the essential shape of a tree, a mountain, a building, a body of water. And

although he painted *en plein air*, he would modify what he saw literally as he came to understand its internal shape. Even the water in *Lake Annecy* is somehow solid: flat, still, motionless, an unchanging entity. Water in the work of Monet or Renoir or Sisley is in the process of change, of movement, its surface alive and dancing, made up of little dabs and dashes of paint, the effect achieved by the juxtaposition of sometimes strongly contrasting colours. Cézanne goes to work in a quite different way, using colour in slabs— something more deliberate, weighty, profound, than the light, airy dashes and dots and dabs of the Impressionists.

Although he was part of the Impressionist movement—he lived and painted with Pissarro in the early 1870s, who saw in his work 'an impression of refined savagery', and whenever he came to Paris from his home in Aix he would sit in on the discussions that took place at the cafés which the Impressionists favoured—Cézanne was actually moving away from Impressionism towards abstraction and, in his geometric structuring of nature, prefiguring Cubism. His influence has been enormous, not only on his contemporaries such as Gauguin and Van Gogh but on later painters—Matisse, Braque, Léger, and Picasso, who wrote of him: 'What matters is not what the artist does but what he is. What is of interest to us is Cézanne's restless striving—that is what he teaches us.' A difficult, anti-social man with a quick temper, he felt himself to be outside the mainstream of the Impressionists, which indeed he was. Always longing for recognition and inclusion, he had to wait until he was 56 when the dealer Ambrose Vollard held a large retrospective of his work that stunned the art world. Seven years later, Maurice Denis exhibited his *Homage to Cézanne* at the 1901 Salon, which showed a group of the leading artists of the day gathered around a Cézanne still life. I always hope that made him happy.

I don't love Cézanne in the way I love Carpaccio or Fragonard or Seurat, but I am in awe of him, of the way in which his paintings seem to breathe out light whether they are landscapes or portraits or still lifes. In some mysterious, literally illuminating way, he makes you aware of a unity in nature, of certain essential shapes that seem to be the very thing itself.

THREE EXPLORERS
RUSSELL DRYSDALE, SIDNEY NOLAN, WILLIAM ROBINSON

Australian painters are little known in Europe. Before I came to live in Australia I had heard of Sidney Nolan and Arthur Boyd—although only because they had both designed operas in London—but that was it. One of the effects, to use Geoffrey Blainey's phrase, of 'the tyranny of distance'. But in attempting to analyse the motive behind writing this book, I came to realise that my experience of Australian painting has increased my passion for art and deepened my awareness and even understanding of what makes people want to look at a picture 500 or 600 years after its creation.

The quality of light in Australia is remarkable. Only in Greece have I been so aware of its effect, of the contrast between it and light elsewhere. It is very clear, very direct. In the Blue Mountains near Sydney the vast forests of eucalypts produce a gentle haze reminiscent of the blue-green in Fragonard's work, but this European softness is rare. Though the light is often unsparing, even harsh, this is not its essential characteristic. That is rather a pristine luminosity, a feeling of ancient times when, like 'the spellbound horses' in Dylan Thomas' *Fern Hill*, we came:

> *Walking warm*
> *Out of the whinnying green stables*
> *On to the fields of praise*

This may sound over-sensitive to anyone who has endured the searing light of an Australian summer's day but I don't believe any person of sensibility could fail to be aware of its special quality. It is certainly an understanding of the spatial possibilities of this light that makes so much of Australian painting deeply attractive, a light that is both bright and clear, forthright and direct like the Australian character.

The three most important Australian painters are, for me, Russell Drysdale, Sidney Nolan and William Robinson—the latter, happily, still painting. All have looked at different areas of the Australian landscape with a new perception: Drysdale, the outback; Nolan, the desert centre; and Robinson, the rainforest. And with all three a considerable development and evolution of style is clear.

The Australian painters of the nineteenth century were deeply influenced by the Impressionists—and they liked to paint *en plein air* as most of the Impressionists did. They celebrated a pastoral Australia, a Europeanised countryside of green and rolling hills, trees strategically placed by some antipodean Capability Brown, contented cows and browsing sheep. They depicted the fertile perimeter of the continent.

A major development in the art of Drysdale, Nolan and Robinson came when all three of them journeyed inland. Robinson left the urban life of Brisbane for the luxuriant diversity of the rainforests;

Drysdale, in the mid 1940s, and Nolan, a decade later, journeyed beyond the Great Dividing Range, the mountains which separate the eastern coastal fringe, with its relatively generous rainfall, from the greater part of Australia. They travelled to the interior to observe, initially, the effects of two terrible droughts, which both recorded in letters, photographs, sketchbooks and journals as well as in their art. And what all three painters painted had never been painted before.

Although Australia is intensely urbanised—the majority of the population lives in the safety of the cities on the coast—none of these artists is concerned with city life. And, their observations made, they all painted and paint back in the studio. The enigma of Australia, its beauty and danger, is not to be found in bitumen roads and skyscrapers. The outback, the vast deserts, the forests, empty of all but a few human beings, hold the key to Australia's spiritual heart, a mystery which has little to do with the events of the past 200 years.

RUSSELL DRYSDALE

The first period of Drysdale's work—he did not, initially, think of being a painter but of managing his family's rural properties—shows European attempts to inhabit an essentially inhospitable and unwelcoming landscape. Although he is always compassionate and never patronising, the sharpness of Drysdale's observation means that humour is never far away.

Many of these early paintings are not naturalistic: their people are thin, stick-like creatures, full of energy, posed warily in almost surreal landscapes. Only when his portrayal of the human figure becomes less stylised do we realise that the landscapes—endless, barren wastes of red with human artefacts such as washing lines, bicycles, water tanks set awkwardly and incongruously within them—are the real thing.

Australia is always a surprise to the stranger. Hugh Schulz, one of the 'Brushmen of the Bush', a group of artists based at Broken Hill, a mining town in central New South Wales, told me that at his first London exhibition, he had been taken to task by the English

'The enigma of Australia, its beauty and danger, is not to be found in bitumen roads and skyscrapers. The outback, the vast deserts, the forests, empty of all but a few human beings, hold the key to Australia's spiritual heart ...'

critics for a too vivid imagination, for using a range of colours which, to a European, didn't seem credible. 'But I only painted what I saw,' he said. So with Drysdale. Though he is too technically accomplished ever to be considered a 'naïve' painter, and though he has a highly sophisticated palette, the shock is similar. Lou Klepac's seminal book on him quotes a sympathetic British critic as asking, 'Did he make this up?' One look and you understand: impossibly blue sky, improbably red earth, an infinity of distance, and a landscape not so much hostile as indifferent.

THE RABBITER AND HIS FAMILY, 1938

The Rabbiter and His Family shows an unusually friendly environment, as well as the influence of Modigliani, by whose work Drysdale was much affected when he visited Paris in the 1930s—as he was by that of Cézanne.

The rabbiter and his family are not pleased to see us and they're not going to invite us into their home. There are six of them, including the babe in arms, and they stand in a defensive group spread out so we can't get by them. They're wary of us—either they see few visitors or they suspect we may be from the Council or any of those regulatory bodies whose mission it is to bring outsiders into the pattern of social conformity. The two girls and the baby aren't old enough to have learned mistrust but the eyes of their parents and brother are bright with suspicion and hostility. Though Drysdale has painted them in a highly stylised, non-naturalistic way—sloe-eyed, slit-eyed—this in no way weakens their individuality.

The boy, maybe twelve years old, stands beside his father. He wears a white, collarless

The Rabbiter and His Family, Russell Drysdale, 1938

shirt, a brown jacket and blue trousers. Like his two sisters, he is barefoot. The image of his mother, his head is tilted questioningly to one side and his arms are folded aggressively across his chest. His hair, brown and shining, is neatly parted.

To his right is a big brown dog, looking uncertainly at us intruders. To his left and just in front of him stands his sister, a girl of perhaps eight, her head also tilted inquisitively, one arm around her father's waist, which we know makes her feel safer. In the circumstances of rural Australia, she wears a rather elaborate dress of yellow with a dark-blue pattern and creamy trimming at the neck, wrists and hemline, which goes a little incongruously with her bare feet. It probably belonged to a cousin who's outgrown it.

Father stands beside her, one blue-clad arm and one brown hand laid protectively on her shoulder, the other hooked into his belt. He wears a beige shirt with red hatching, impressionistically executed, a blue suit, big boots and a brown hat jammed down over his eyes. He is the most sunburned of the group. You wouldn't want him as an enemy but you'd like to have him with you in a tight corner because he'd get you out of it.

Beside and just behind him so she can run if necessary is Mother, her hair darker than that of her children, wearing a shapeless orange-brown dress and pale-mauve bedroom slippers adorned with darker pompoms. She holds a baby in her arms, its white shawl linking across the canvas to the boy's white shirt. The younger girl, about six perhaps, stands beside her mother. Her hair is the colour of her mother's dress; her patterned frock that of her mother's slippers. Finally, with its back to us, a smaller brown dog is scratching itself, unconcerned with non-doggy events.

The family line-up is linked by two colours. There are various shades of brown: the two dogs at either end of the group, the boy's jacket, his elder sister's dress, his father's hat, his mother's dress, and the colour of the children's hair; and there's blue: the boy's trousers, his father's suit and, in paler shades, the mother's slippers.

They have two unwelcome visitors: the father, son and elder daughter are looking at you wherever you are standing in relation to the painting, while the mother and baby are looking at another

'You don't necessarily want to know these people because they certainly don't want to know you, but the focus of the family's gaze brilliantly suggests the continuation of their world beyond the confines of the canvas and we're happy to stand gazing at them and at their property for as long as they'll let us.'

person standing to the right of the canvas. The younger girl is looking at something close to the ground and off to the left. Perhaps she just doesn't want to catch the visitors' gaze.

The group stands in a little dark-blue meadow dotted with flowers, painted with a profusion reminiscent of the flowered meadows of the mediaeval Unicorn Tapestries. Drysdale couldn't have seen these since they have been in America since 1922 but he might well have seen the 'Lady with the Unicorn' series in the Musée de Cluny in Paris.

Behind the family and to the right is a ploughed field with vegetables growing in it. Beyond it is their house, with yellow-painted walls, a dark roof and a tin water tank. On the opposite side of the painting is a barn, one wall of the same pale yellow as the house, the same dark roof, and another wall the colour of the mother's dress, into which is set a big, dark doorway.

Trees in a range of non-naturalistic colours line the background, on the edge of a green field. Beyond the field are rolling, almost cartoon-like hills, dark against a livid orange-yellow sky, linking to the warm shades of yellow, orange and brown in the line-up at the front of the painting.

These people aren't well off—witness the children's bare feet and the well-worn, hand-me-down feel of their clothes. But in addition to Dad's rabbiting, they have a house with a barn

and food growing in their field. This is an early work, painted in 1938, but it's easy to see it as the precursor of the paintings of bush life on which Drysdale embarked in the early 1940s—such as *The Crow Trap*, *Going to the Pictures*, *The Back Verandah*. *Sunday Evening*, painted in 1941, is the picture closest to *The Rabbiter and His Family*, but its family is set against a background of endless, barren country and a huge expanse of blue sky. In *The Rabbiter and His Family* the background is more welcoming, the land more tilled and tended than in these later pictures and the focus is not so much on the environment as on this odd, pre-'Addams Family' group who are at one with their surroundings.

As opposed to the formal line-up of the family with its dogs and the straight rows of hills and trees in the background, Drysdale paints triangular, curving segments of three fields: the blue meadow rising behind the family, the vegetable field sloping down and behind it and in front of the barn, a little, three-sided slice of dead grass. This irregularity gives the background great vigour, contrasting with the still, posed and poised family line-up.

The painting, in the generous naïveté of its colours, is instantly appealing. And although the family are wary and watchful, the cartoon-like nature of their portrayal is humorous and affectionate. You don't necessarily want to know these people because they certainly don't want to know you, but the focus of the family's gaze brilliantly suggests the continuation of their world beyond the confines of the canvas and we're happy to stand gazing at them and at their property for as long as they'll let us.

During and after the war, Drysdale's depiction of the human figure became less stylised and he began the series of portraits of bush people in which he takes you right inside the sitter, reminding me of Frans Hals. These are not only local types like Brandy John and Tractor-face Jackson, but also people who represent the wave of post-war immigration.

Like Rembrandt's *Man with a Magnifying Glass* and *Woman with a Pink*, I think of *Joe* and *Maria* (both painted in 1950) as a pair. Fleeing from the horrors of war and the austerity of peace, they've ended up in this little town on the edge of nowhere and no doubt are trying to make a go of 'Joe and Maria's Café', an eating place and town very similar to those in *Joe's Garden of Dreams*, painted

in 1942, which shows the proprietor and his family standing in an otherwise deserted street in front of their restaurant, 'Garden of Dreams'. Beyond them the road stretches out and away beyond the edge of town, telegraph poles receding into an endless distance. Drysdale painted a number of these country-town streets, often blazingly hot, often deserted apart from an occasional dog or a lone sheet of newspaper. Always we can imagine the road going on and on into the bush until the next little attempt at civilisation is reached. Always we can wonder: has this town been abandoned to heat and dust? As we survey the desolate hotel, the rusty cast-iron balcony, the flaking stucco, we ask ourselves: have all the people gone away and given up this place for good?

JOE, 1950

Giving up may be what Joe is considering. 'Joe' is not his real name of course but, regardless of what he was baptised back in Greece, it is easier, in this new country, to call himself 'Joe'. He's a large man with huge hands, one on his hip, the other arm leaning on a windowsill, the index finger resting pensively on his full, red lips. He's dark with thickly marked eyebrows and his black hair is perhaps starting to go thin on top. He wears a generously sleeved white shirt with a somewhat less clean white apron over it. Drysdale has put a lot of pale purple into the white of the shirt and lemon into the white of the apron so we are sure to get the point. There's blue stubble on his lips and cheeks, his large eyes are thoughtful, his mind far away. He stands behind a counter on which is a pile of paper, ready for whatever he's going to cook. He stares out of the window.

Through it we can see the corner of another building, similar to his, with a wide verandah. Just outside the window is a supporting pole similar to that in the building opposite. The main part of his view is sky: blue, gently clouded where it meets the hills far away in the distance. In front of the hills stretches flat, nondescript, barren country. Joe's expression, though thoughtful, is enigmatic. His mind could be a complete blank. Equally he could be thinking; 'Was it worth coming all this way to end up here, at the end of the

Joe, Russell Drysdale, 1950

world? Why did we exchange one barren land for another? My life's gone. Nothing's going to happen here, nothing ever happens here. And then some day we'll be old and die.' He's lost in a daydream of disappointment.

But the painting, despite the pensive nostalgia of the sitter, is not depressing: the sky is beautiful, grading from a deep blue at the top of the canvas into aquamarine, into pale, pale yellow until it meets the line of hills on the horizon. The colours of the hills and of the road outside are linked to the colours inside the room—the pile of paper, the shirt, the apron, the counter. They're oddly harmonious, interior and exterior, man and landscape. Perhaps it's that both are empty. Or perhaps Joe is like Ruth in Keats' *Ode to a Nightingale* when he writes of:

> *... the self-same song that found a path*
> *Through the sad heart of Ruth, when, sick for home,*
> *She stood in tears amid the alien corn*

MARIA, 1950

Maria, though equally pensive, looks more positive. She too may be regretful and disappointed but, in contrast to Joe, there's something about her that tells us she hasn't given up. She stands on the verandah of their café—though there's no evidence to suggest they're man and wife beyond my hunch—looking out onto the street. They're on the edge of town—which is not likely to be a very large one. There's another house a hundred metres or so away to her left, a line of fence posts linking the two buildings. On the opposite side of the road, fence posts and telegraph poles continue until they become too small and distant to see. In a pen and ink study for the picture, Drysdale put the neighbouring building much closer, virtually adjacent, and Maria was leaning against the house, her arms folded. This small change significantly increases the sense of her isolation.

She has long, dark chestnut hair and a plump but strong face, eyes and lips very like Joe's. She wears a dark-maroon dress with a white apron over it. Drysdale has worked a lemon yellow

Maria, Russell Drysdale, 1950

'The painters of the late eighteenth and early nineteenth centuries, such as Eugene von Guerard and John Glover, surveyed Aborigines at their interestingly barbaric ceremonies from the safety of afar. There was some attempt to present them as "noble savages" but although good pictures were painted by these artists, their subjects were not really regarded as human.'

into it similar to that on Joe's apron—perhaps we're to think hers is not over clean either. On her feet are sensible bedroom slippers with darker pompoms. One hand is on her breast, the elbow supported by her other hand. She is thoughtful but the expression in her eye is far from being vacant. She's working something out. Whatever it is, my final hunch is that it involves staying.

In both paintings the light is strong outside, and even though Maria is standing outside on a verandah, she is enclosed by buildings. It's as if Drysdale were saying that Joe and Maria, unlike Brandy John or Tractor-face Jackson, are indoor people and so this land stretching away into the distance must be alien to them.

Until Drysdale came along, Aboriginal people, all but dispossessed by the early settlers and their descendants, barely figured in Australian art. The painters of the late eighteenth and early nineteenth centuries, such as Eugene von Guerard and John Glover, surveyed Aborigines at their interestingly barbaric ceremonies from the safety of afar. There was some attempt to

present them as 'noble savages' but although good pictures were painted by these artists, their subjects were not really regarded as human. They were regarded as curiosities on the landscape like the kangaroo or the parrot. Thereafter no one seems to have thought Aboriginal people interesting enough to paint.

Drysdale changed that. His directorship of a family sugar company took him to Queensland on business. There he began to paint Aboriginal people with an appreciation of their individuality as human beings and an understanding of what white settlement had done to them. *Shopping Day*, painted in 1953, shows two Aboriginal women, a little girl and a boy in a deserted town very similar to the one depicted in *Joe* and in *Maria*. They are all barefoot, all wearing what are clearly their best clothes. One of the women clutches a small sack, which will presumably be the repository of their purchases. They are awkward and out of place but they are human beings with dignity.

Some of these paintings show a figure in a landscape. Whereas the white people always seem somewhat uncertain, uncomfortable, even alien in this setting, Drysdale shows us that the Aboriginal subjects belong to the environment and it to them. Other paintings show groups of people, very occasionally black and white people together as in *Boy with a Lizard* (1959) or, more importantly from a political perspective, as in *Tom and Lilah* (1963) or *The Family* (1965). In *Tom and Lilah*, an Aboriginal woman and a white man are standing in front of a tent which we can tell is their home from the double bed visible inside and from the mug the man is holding. *The Family* shows an Aboriginal woman and a white man with his arm protectively round a black child who must be his son. This was uncharted territory at the time for Australian art.

In the late 1950s a new style began to emerge in Drysdale's work—a monumental geometry, something Cézanne would have recognised. Coincidentally, perhaps, he began to paint Aboriginal ceremonies and rituals, works that celebrated the mystery and poetry in Aboriginal life. The use of colour became very free, unconnected with naturalism, which pushes the paintings into an area of abstraction. For me, the most thrilling of these canvases is *Snake Bay at Night*.

SNAKE BAY AT NIGHT, 1959

There's much colour in the picture but it is nonetheless night. Right off you're aware of three figures. The rest is shapes and colours. Red predominates, ochre, green, some white, a small but arresting slab of blue. Eventually, by just letting the painting happen to you, you realise there are three totem poles: two possibly of stone; one, in the centre, definitely of wood. There are also three Aboriginal men, painted with ritual colours and perhaps masked. We learn from Drysdale's journals that they are Tiwi Islanders at a Pukumani ceremony, or mourning ritual, on Melville Island off the coast from Darwin. They may be guardians or sentinels. They are aware of us and are wary, watchful but not hostile.

The man at the left of the picture stands halfway behind the central totem pole. He has a lot of black hair with a band of white material or paint around it and a streak of red in the middle of his forehead going down to and covering his nose. He is the youngest of the three. His face is a black blue-green, relating to the pole at the far left. His eyes, two white dots, barely visible, alas, in even the best reproductions, are looking at us. His upper arm, buttock and thigh are white. Behind him is a slab of orange that could be another pole and above that is a red orb that could be the moon.

Behind the elaborately decorated central pole, black diamond shapes, red, ochre, the streak of pale blue, is an older man, probably masked. He wears some kind of headdress, a red band at its base. Covering his nose and cheeks, a whitish ochre outlines the deep caverns of his eyes. If he is not masked, he is heavily bearded. He has strong pectorals and the lower part of his body, curiously foreshortened, is red with reflected firelight or with paint.

The third figure is definitely bearded. As with the younger man, there's a white band round the top of his forehead and he has an ochre design on his face, similar to that of the oldest, central man. His arms are painted white with a red band above his elbow on the arm we can see fully. He is sitting, one leg crossed over the other, on a rock in front of the third pole.

The painting is about mystery, magic, an event that tolerates our presence on its fringes though we might not be allowed to advance further. Drysdale's experiences on Melville Island were the inspiration for the picture but he's making a poetic statement

Snake Bay at Night,
Russell Drysdale, 1959

rather than recording an actual event. Behind the three figures, behind the three poles, is a mystery. Something that has been going on for a very long time, long before oil paint was ever applied to canvas. These men are the guardians of that mystery, which is not one in which we can share. We are made to feel awe and wonder at the antiquity of this culture. It's a picture in front of which you want to stand for a very long time.

SIDNEY NOLAN

Sidney Nolan, although he came from a less privileged background than Drysdale—his father was a tram driver and occasional illegal bookmaker in Melbourne and he himself had to seek work at the age of fourteen—was one of the best read Australian painters and probably the most widely travelled painter ever.

The greatest literary influence on him was the poet Rimbaud— his *Illuminations* and *Une Saison en Enfer*—but he was deeply affected, too, by the philosophers Kierkegaard and Schopenhauer and was an omnivorous reader. It was Benjamin Britten's setting of *Illuminations*, which he heard in Melbourne in 1932, that awakened a love of music in him and resulted in his later friendship with the composer.

As a traveller, Nolan visited America, most of Europe, Africa, Antarctica and China, in addition to extensive forays into outback Australia. No artist before the invention of the jet aeroplane could ever have hoped to see so much, let alone to paint what he saw.

Nolan worked extremely fast: he is estimated to have produced some 35 000 paintings. Reproached for his speed of execution by Edmund Capon, director of the Art Gallery of New South Wales, he said, 'Five minutes in the making, five years in the thinking, dear boy.' In one of the innumerable interviews he gave, he said, more seriously: 'I'm actually quite a careful painter though it doesn't look it ... I'm very fast at it but they are actually done on proper principles and they do last.'

His painting style seems to move in a circle. After an early and brief beginning as an abstract artist, he returned to abstraction

'His painting style seems to move in a circle. After an early and brief beginning as an abstract artist, he returned to abstraction in the last ten years of his life, returning, too, to spray painting, which he had learnt as a teenage commercial artist and sign writer.'

in the last ten years of his life, returning, too, to spray painting, which he had learnt as a teenage commercial artist and sign writer.

Like Drysdale before him, Nolan travelled a great deal in the interior of Australia—though usually, I feel, in more comfort than his predecessor—and recorded what he saw, his landscapes reaching their apotheosis in the 1950 series of paintings of the red desert heart of the continent. These awe-inspiring and, I have to say, daunting, canvases are the naked fact itself—nothing, not even the barest vegetation, intercedes between the viewer and the endless panorama of an ageless and indifferent landscape.

INLAND AUSTRALIA, 1950

Inland Australia shows a pitiless terrain of red rocks thrown up in some titanic upheaval of the earth in 'the dark backward and abysm of time',

as Prospero calls the distant past. There are paths, if that is how to describe the flatter areas of the landscape, between the ranges of hills, the outcrops of rock, the solitary and awesome stump of a mountain. The scene stretches far, far away, as far as we can see, until the hills at the very top of the picture are so far off that they are blue like the blue sky of the horizon, below which are clouds tinged with the red of the rocks. As in much of Nolan's work, the paint is used very thinly and scraped to reveal the white of the flat terrain. One can't deny the vista's beauty but I'd rather look at it from a safe distance than enter it.

In Drysdale's work there is a humanism that Nolan, perhaps due to his poetic attraction to the mythic, either lacks or does not attempt to achieve. Even his portraits are not personal but menacing, even savage, impressions. Drysdale's landscapes are rarely empty—he is concerned with how the human being copes with the unyielding reality of the bush. Even a sizeable

Inland Australia, Sidney Nolan, 1950

canvas like *The Rabbiters*, painted by Drysdale in 1947, in which two human figures are dwarfed by the rocks surrounding them, is about precisely that. The artist creates something archetypal out of them but essentially they're just people. Nolan's landscapes, when inhabited, contain figures of history, legend, even myth: Ned Kelly and the gang, the explorers Burke and Wills, Mrs Eliza Fraser and the convict Bracefell. Kelly, of course, is Australia's own and particular myth, whether outlaw or folk hero, but in these pictures Nolan put something of himself, an outsider like his admired Rimbaud.

Sometimes Nolan is directly ambiguous as in the enigmatic *Fraser Island*, in which a naked man is emerging from a dark sea. The man is questioning, accusatory even, and as often with Nolan, menacing. But who is he? Is he Bracefell, whom Mrs Fraser betrayed to the police after being rescued and befriended by him? Is it Nolan himself, smarting after the break-up of his relationship with Sunday Reed? He's a bit of both, perhaps. But still remains an enigma.

RIVERBEND I, 1964–65

Enigmatic, too, is what for me is Nolan's most unforgettable work, *Riverbend I*, nine large panels telling, it seems, the story of Ned Kelly's murder of Constable Scanlon, one of the posse hunting him. Begun in 1964 and completed in 1965, *Riverbend* is set in country to which Nolan felt a strong affinity, the Goulburn Valley where his father and grandfather—who had been one of Kelly's pursuers—had worked a block of land and where he himself spent the first year of his life.

So we enter the room, sit on the nice bench thoughtfully provided, and gaze. The panels are all the same size (152 centimetres high and 122 centimetres wide) and from our seat it seems that the first and the last five panels are empty—just the river in the foreground, winding its way along the wall, trees edging it and stretching away up into the hills behind it. In the second panel, Scanlon is in the river astride his horse, downstage centre. He is bearded and wears a helmet somewhat like a solar

'So we sit and gaze some more, mesmerised by what is, literally, a panorama of a river winding its way along nine large panels, twisting, bending, and finally, in the last two paintings, making quite a steep curve and disappearing off the edge of the last picture.'

topee. He is looking about him, out beyond our left shoulder, but seems relaxed. The horse is drinking from the river. Upstage right in a little inlet, Kelly is waiting in ambush. We know it is Kelly because he wears his iconic black square helmet. He is holding his gun and appears to be naked. In the third panel, Kelly has moved forward to the centre. He is standing almost up to his groin in the water. The horse is nowhere to be seen. Scanlon's body floats in the river, dead or dying. He has lost his helmet and, more surprisingly, his beard. In the fourth panel, Kelly, rifle slung across his back, is seated on the horse, which stands in the shallow water. Horse and rider are looking up into the bush. Scanlon's body has sunk, perhaps. In the remaining pictures, search as we may, Kelly has gone. He's made his getaway and vanished into the hinterland.

So we sit and gaze some more, mesmerised by what is, literally, a panorama of a river winding its way along nine large panels, twisting, bending, and finally, in the last two paintings, making quite a steep curve and disappearing off the edge of the last picture. The trees share the painting: sometimes, as in the seventh panel, occupying most of the canvas; sometimes, as in the last, taking up only about a third of it. We're mesmerised because the human drama—a murder—is diminished to an incident by the water and the trees, by the endlessness of nature. We can't imagine the river ending, it just flows on and on, away from us.

The palette is brown, white, a dull almost sludge-green for the trees. There's more brown and white in the river because the trees, of course, are reflected in it, but there's a subdued blue too. The water is shallow and absolutely

still. There are no ingratiating birds or animals—did Nolan ever condescend to paint a kangaroo?—just trees and water.

Then we get up so we can have a look at Nolan's brushwork. He's used the paint very thinly; there are many little dabs and streaks, some long smears of brown for the trees. The sun is shining but, like all forests, this is a place of light and shadow.

We move closer to the first panel—hang on! What's this? Camouflaged almost to invisibility, Kelly, helmeted but otherwise naked, his rifle somehow displayed prominently across the top of his chest, stands at the edge of the water and the left of the painting holding a naked, bearded, helmeted Scanlon. Scanlon doesn't seem to be struggling though one leg is crossed over the other and Kelly must have him in an arm-lock from behind. What does this mean? Have we misread the whole thing? But no; looking at the second panel, the story is as first seen: Kelly in the background, lying in wait; Scanlon in the river, astride his horse. Third panel: no, we got that right too—Kelly forward, having fired his rifle, Scanlon's body in the water, horse gone. Well, naturally the shot would have alarmed it, though, as we learn from the fourth panel, it doesn't go far. On to the fourth panel: Kelly's seated on Scanlon's horse, down left—but wait! Another big surprise. Again concealed by the shifting light in the trees, the body of Scanlon, a good 6 metres up in the air, is whizzing down towards the river, diagonally towards Kelly, both arms outstretched. This immediately brings to mind Tintoretto's picture of St Mark hurtling from the sky to rescue a persecuted slave. But as this must be Scanlon's ghost; it's not likely to be coming to Kelly's aid. So is Nolan saying that this murder will bring about Kelly's end?

It's clear he thought better of these two strange, perhaps symbolic, images, became aware that they didn't help the telling of the story, because in the second version of *Riverbend*, painted the following year in 1966, he didn't include them. But he didn't take them out of the first version. Why not? Artists rework their paintings frequently. I find it odd that nothing I've read—which suggests it can't be that much, I guess—raises this as a difficulty or even as a surprise. Maybe it's my particular hobbyhorse, imbued with what I regard as the theatre's primary task: to tell a story and to tell it clearly. And whereas that's the reason people

From left to right: *Riverbend I*, Panels 1, 2, 3 and 4, Sidney Nolan, 1964–65

go to the theatre, to be told a story, they don't necessarily look at a picture for the same reason. Many pictures are narrative but as many are not. The mystification arises from the fact that *Riverbend* purports to tell a straightforward story and then does not. So naturally we're going to start asking, 'Why did he do that? What does he mean?'

The reason may lie in the fact that Nolan didn't like or approve of preplanning much: 'Painting is only worthwhile if you don't know the outcome. When you start a painting you must never know what the end result is going to be. You should end up with something looking at you that you have never seen before.' Here is an ongoing difference between artists in how they approach their art. While Degas, for example, would not have agreed with Nolan—'No art is less spontaneous than mine'—Delacroix certainly would: 'Execution should always be extempore. Execution will be beautiful only on condition that the painter lets himself go, discovers as he paints.'

So perhaps Nolan allowed his unconscious to do the talking; hence the deviation from what apparently set out to be a narrative. It doesn't definitively solve this enigma but I like enigmas—the mystery keeps you engaged with a painting. And this doesn't detract from the appeal of this wonderful series of panels because the main players are not affected. The river and the bush just go on. And on. And ... we're reminded of our insignificance in the greater scheme of the earth.

CHINESE MOUNTAIN LANDSCAPE WITH THREE BOATS, 1982

A similar feeling is evoked by one of Nolan's last paintings: *Chinese Mountain Landscape with Three Boats*. For this large landscape, completed in 1982, Nolan used acrylic and lacquer spray. In the left foreground are three mountains. Behind them, their bases in the centre of the picture, are five more, two of them leaning, curved, to the left. Between these two groups of mountains we must assume there is a mighty river obscured by cloud and mist, for from the right of the canvas three boats, tall-masted sailboats, perhaps junks, emerge. They are the same dark, nearly black,

Chinese Mountain Landscape with Three Boats, Sidney Nolan, 1982

colour of the mountains but are more obscured by the river mist. Beyond these barren and forbidding peaks is a cloudy sky. The scene is suffused with cloud, patches of blue and, along the course of the river, a transparent yellow. You feel there's a wind blowing from right to left: that's the direction in which the boats are heading and even the mountains bend to the left.

When I saw this painting in a retrospective exhibition of Nolan's work, it affected me deeply. It has a delicate beauty, an aura of other-worldness; and while it is in no way a naturalistic painting, is not telling a story, there is nonetheless an enigma, the mystery of the unknown, of these three boats journeying upriver through a region of high mountains shrouded in mist and cloud, the darkness of the boats suggesting the emergence of day, of a beginning.

Looking at this, one of Nolan's last paintings, I think of the closing of Rimbaud's *Une Saison en Enfer*, which I read as a drama student in Paris and by which I was greatly moved:

> *And come the dawn, armed with a fervent patience, we'll enter the cities of glory.*

I hope Sidney did.

WILLIAM ROBINSON

William Robinson has led a very different life to Drysdale and Nolan. Like Drysdale, he did not initially intend to become a painter. He was first drawn to be a pianist; even now, he practises for several hours a day. Born in Queensland, where most of his working life has been spent, he taught art in Brisbane from 1957 until 1989 when he devoted himself to painting full time. Due to professional and family commitments he has not travelled as extensively as Drysdale, far less Nolan, who effectively became an expatriate. Like both, however, he has painted an area of Australia never really painted before. Furthermore, he has lived in the landscape which he has painted, so it is in a very real sense 'his' country. His painting, particularly from 1990 onwards, is

'His painting, particularly from 1990 onwards, is the perfect exemplar of the dictum that it is only through the particular that a universal statement can be achieved.'

the perfect exemplar of the dictum that it is only through the particular that a universal statement can be achieved.

He says a major influence on his early work was the Post-Impressionist artist Pierre Bonnard and this is plain to see in the soft, luminous interiors and the shaded, tropical Queensland gardens in his paintings of this period. The human figure, which has now almost completely disappeared from his work, is an integral part of these canvases: he and his wife, Shirley (the last survivors of human representation in his painting), his children, a visiting vicar, friends, family pets in lived-in, domestic circumstances. Many of the paintings look in at a window or out to a garden.

In 1970, he and his large family moved to a farm at Birkdale and his style changed completely. He painted landscapes of and around his new home in bright colours, with an almost cartoon-like vigour, including a mass of domestic animals and birds—the pictures make you laugh out loud with pleasure. The paint is used thickly and exuberantly. Somewhere, though you may have to look for them, are the artist and his wife. His use of perspective, which in his later work unveils the cosmos, is quirky and unusual.

FARM I, 1982

In *Farm I*, painted in 1982, we're standing on top of a hill, looking down into a valley at the bottom of which is an attractive white house. Behind it is a small grove of trees and there are trees, too, framing either side of the canvas. Behind and beyond the house, the land slopes upwards, disappearing off the top of the canvas before the summit of the other side of the valley has been reached. The grass in the immediate vicinity of the house is lush and green and has been mowed. There's a palm tree growing in

Farm I, William Robinson, 1982

an angle of the building and on the patio are the family's pug and a mystery figure. This could be a large black dog or it could be Shirley sitting in a rocking chair. She's usually included in the pictures in which Robinson himself appears—but if it is her, why is she in shadow? The pug isn't.

The scene teems with animal life: cows, goats—mainly white but a few black and white ones and a skewbald—ducks, geese, chickens, roosters with their red coxcombs providing a splash of colour, as do the flowers of a flame tree to the left of the painting. Even a big white turkey contributes the red of its wattles. There are some little black and brown bantams but many of the birds are white on the green of the grass. Although most of the assembled company are going peacefully about the business of eating, looking for something to eat or simply snoozing, a couple of pairs of geese are engaged in unfriendly confrontation, necks outstretched in anger, wings spread in defiance. The ingenuity of the perspective adds to the fun—you think 'How can those cows be so big?' Then you realise that the artist is painting from a position high up one side of the valley, essentially at the same level as the seemingly enormous cows. So of course they're big if you compare them to the house because the house is much further away, down at the bottom of the valley.

As we move away from the house and up the hill, the grass becomes yellow and grows higher. It masks the animals, the cows and goats, the further up we go until, in the topmost part of the scene, you see only a white ear, a pair of brown eyes, the ridge of a bovine spine. And there, directly behind the house and almost at the top of the picture, is Robinson himself, up to his thighs in the long grass, in black trousers, a white shirt and a yellow hat. You don't notice him at first because he is surrounded by the heads or tails of white and mostly grass-submerged goats. Berthold Brecht once said, rather surprisingly, 'The theatre needs no other passport than fun. But this it has got to have.' He would have liked this picture a lot.

In 1985, the Robinsons moved again, deeper into the country, to a 200-acre property at Beechmont. Five years later, Bill Robinson gave up teaching art, after 32 years of it, and devoted himself to painting full time. At Beechmont, he painted, almost exclusively, the countryside in which he lived—'The power of nature is not observed from the armchair of suburbia', he said. Again, his style changed.

FOUR SEASONS, 1987

In the four canvases of *Four Seasons*, the earlier cartoon-like element persists but the use of perspective, the usual way of looking at life, has changed radically. Robinson is now seeing the world, and compelling us to see it, from different perspectives simultaneously. The depiction of land, trees, animals, birds, sky, water is seen in only a limitedly logical way. Though the spectator is of necessity looking at the canvases straight on from a vertical position in the normal way, we are also looking at them from standing and vertical, prone and horizontal, upside-down, all at the same time.

The time of day changes within one painting. The sky runs mainly through the centre of each of the four pictures. The landscape, trees, water appear both at the top and bottom of the canvases as they might if we were lying down and looking upwards. The effect is puzzling, enchanting, disorientating, slightly dizzying. Night and stars appear at the edges of the first and last of the four canvases. In the left-hand side of the first, the night transmutes into day; in the final canvas, the sky moves from day in the centre, to sunset and then to night at the far right. There is a degree of naturalistic observation; it's just that within one canvas we're being asked to take in a number of normally and naturalistically different scenes and times at one and the same moment.

As we look across the paintings, moving from Panel 1 to 4, the colour of the grass changes: brown, brown-yellow, yellow-green, a tinge of green at the right edge of the second canvas changing to a lush radiance in Panel 3 and finally, in Panel 4, to a more vivid shade, then fading to brown as the sunset falls across it from the right. The greens in Panels 3 and 4 are a most unusual hue, a green I've only seen once before, in some early Miro paintings in the Metropolitan in New York. It's a very soft but almost metallic colour, not dissimilar to the green of early verdigris on bronze or like a light jade. It's at once perfectly natural for grass and highly arresting—that green draws you to the pictures and carries you into the events awaiting you.

In Panel 1 there's a flock of red and green king parrots in the forest growing downwards into the sky from the upper right. The sky occupies the centre of the picture as it does in the other three

Four Seasons, Panel 1, William Robinson, 1987

Four Seasons, Panel 2, William Robinson, 1987

'The only life is wild: a number of black birds, an eagle suspended above a meadow, its shadow reproduced on the grass below; a big brown snake moving towards a deep declivity edged with trees which virtually bisects the landscape.'

panels. In the forests below are two creeks, almost rivers, flowing down the canvas and joining up to make a V shape at the bottom. They bring watered green streaks to the otherwise withered and wintry grass. In the lower centre of the daylight section of the picture a big kookaburra flies towards the stream. A dirt track that is also visible in Panels 2 and 3 puts in an appearance at the far left, beside a pond in which stands a black and white cow, fully mirrored in the water and balancing a brown and white, similarly mirrored, in Panel 4. Also reflected in the wintry pool are stars. For at the extremity of the picture it is night in the upper half as it is night in the lower half of the final painting. In the darkness of the far left is a small

mob of wallabies going about their nocturnal business and this animal wildlife mirrors a pair of dingos at the perimeter of Panel 4.

In Panel 2, the road features again, appearing from around the side of a mountain and winding down and across the canvas to disappear off it at the right and to re-emerge in Panel 3. The only life is wild: a number of black birds, an eagle suspended above a meadow, its shadow reproduced on the grass below; a big brown snake moving towards a deep declivity edged with trees which virtually bisects the landscape. The edge of this gully is red with flame and above it the trunks of the trees are blackened by fire. In a safer area to the left, a big goanna is crawling up the bare, grey trunk

of a eucalypt. To the right and also safe, a blue and red rosella is perched on a tree, while closer to the danger of bushfire we can see its mate. From the landscape upside-down at the top of the picture is a spurt of what looks like flame and, from our conventional viewing perspective, smoke blows downwards and then billows in a circle back to the top of the canvas. Two more trees are on fire at centre right and the sky is tinged with an ominous smoky pink.

The next canvas (Panel 3) contains six ponds. There's been some good rain. In the middle of the painting and of the sky there is a segment of rainbow, upside down from we spectators' perspective, falling like a thunderbolt towards earth. Great banks of cloud share the sky with the rainbow and from the darkest part, looming down onto the landscape, there's a flash of lightning and sheets of rain are falling, while the ponds at the right of the canvas are splodged with big drops. In the upper world of the picture, the rain is ceasing and moisture and sunshine create the rainbow, while in the 'normal' vertical world, there's a storm. Along the dirt road that loops and winds its way around the canvas a number of cows, well spaced out and taking their time about it, are moving from left to right and making, I think, for Panel 4.

But the canvases are and are not one, are and are not continuous, are and are not logical. So this may well be an observation pursuing naturalism further than the artist would like. Though I suspect that, like the playwright Harold Pinter's reply to the question 'Mr Pinter, what does (your play) *The Birthday Party* mean?' Bill Robinson too would answer: 'What does it mean to you?'

Panel 4, we learn from the artist, is autumn: 'life is renewed ready for winter'. It travels from daylight to sunset as we look across from the left and upwards, then to starry night as we move down. Between sunset and night, one spur of land is plunged into dusk where the dingos are sniffing the night air. Unless you are lying on your back to look at the painting, three birds fly upside-down into the sunset. There are a number of ponds or dams. The largest is shallow, for there are tussocks of grass and a big brown and white cow, heavy with milk, is standing in the middle

Four Seasons, Panel 3, William Robinson, 1987

Four Seasons, Panel 4, William Robinson, 1987

'Across the top of the ridge, astride a prancing horse, Bill and Shirley, both waving to us, are riding, off into the sunset certainly but also, I think, home for tea.'

of it, fully reflected in the water. The sky is blue in the left of the pond, then tinged with sunset at the right. Cows of varying hues are dotted about the undulating landscape; four birds, kookaburras from their speckled grey plumage and white breasts, sit together on a big, bare branch. And across the top of a ridge, astride a prancing horse, Bill and Shirley, both waving to us, are riding, off into the sunset certainly but also, I think, home for tea. In the daylight at the far left of the painting, there's a little sliver of rainbow. The progress of the riders makes us imagine a fifth painting which is their destination—perhaps the house depicted in *Farm 1*. The landscape is relatively cultivated—good pasturage—becoming progressively less

and less cleared by human hand as we move backwards across the paintings until in the first two we are in the bush.

The work is called *Four Seasons* but it's actually three and a half seasons. Robinson says that, moving from left to right, Panel 1 is spring, Panel 2 early summer, Panel 3 summer and Panel 4 autumn. He also explains that the viewer is led from canvas to canvas by the movement of birds. Green and red parrots at the right hand side of Panel 1 lead us into Panel 2 and early summer where, again at the right of the canvas, crows attacking an eagle carry us to summer and Panel 3. Here the movement to the fourth painting is marked by the progress of the storm, moving off to the right, leaving the

'Partly because of the physical space the four paintings occupy, it's as if the viewer is actually walking through this changing country while a childlike delight continually grabs our attention at a detailed history of a year in the bush.'

rainbow at the centre to mark its progress. Robinson refers to the cows as 'my' cows and says that the movement of the sequence to the right is balanced by leaning the trees to the left.

The two sections of starry night in the first and last pictures, with their bovine and aquatic ruminants and their wild animals, bring a unity to these four remarkable and innovative paintings that make us look at landscape in a new way. Partly because of the physical space the four paintings occupy, it's as if the viewer is actually walking through this changing country while a childlike delight continually grabs our attention at a detailed history of a year in the bush.

In Robinson's third and current style of painting, the delight that is apparent in *Farm I* and in *Four Seasons* is transmuted into a sense of wonder at the immensity and strength of the planet. Between 2003 and 2004, he created

an enormous canvas—6.5 metres long and 1.5 metres deep—*Dome of Space and Time*, the last, he says, of his 'Creation' series. The first of these huge paintings was *Darkness and Light* (1988), followed by *Man and the Spheres* (1991), *Water and Land* (1991), *Earth and Sea* (1995) and *The Ancient Trees* (1997).

These paintings—all triptychs—redefine the word 'landscape'. Robinson is aware of the immense and powerful skeletal frame of our planet, not just its verdant and arboreal coverings. He makes us conscious of the titanic forces of energy that have shaped and are still shaping the earth.

He speaks, we must hope, to an audience attuned to what he has to say. I saw *Dome of Space and Time* when it was on loan to the Queensland Art Gallery in 2005 (it has yet to find a permanent home) and I remember no one strolling past the painting and pausing only briefly for a casual glance. People stopped and

looked: properly, seriously, looked. It was as if it required our attention and as if, too, we needed to soak up what the artist was telling us. Robinson wrote as an introduction to the painting:

> *I have endeavoured to show the revolution of the earth through space and time ... the picture implies an ongoing existence apart from what is seen, i.e. the twists of the earth can be implied outside the painting from what is seen inside the frame ... the observer is in the landscape ... and is not an outside observer looking into framed static space.*

This painting would not have been possible, of course, until the early seventeenth century by which time it had been generally agreed that the earth was round and not flat and that it revolved around the sun, not the other way round. And if we accept as a general view in the eighteenth-century Joseph Addison's dictum that 'We find the works of nature still more pleasing the more they resemble those of art,' the Age of Enlightenment would have rejected it too. Even in the nineteenth century only the most adventurous minds—Delacroix, Turner, Monet—would have responded to the ambitious adventure that Robinson proposes to us.

I mention Monet because, when considering Robinson's 'Creation' series, I always think of Monet's 'Waterlilies'. It's a pertinent comparison: superficially because of their number—eight paintings of similar dimensions to the 'Creation' triptychs, though some are double the length of *Dome of Space and Time*. Less superficially, perhaps, because the imaginative breadth and achievement of both move me to tears. It's also the palette—the lists of paints used by the two artists contain a number of unusual and similar colours: cadmium yellow, rose madder, cobalt blue, cadmium green. Monet's paintings, as you look round the two huge rooms dedicated to them at the Orangerie in Paris—'the Sistine Chapel of Impressionism' as André Masson called them—also cover day and night, sun and shadow, light and dark. Reflecting that Robinson's painting has yet to find a home makes me think it probable that Monet's *chef d'oeuvre* might have been in a similar situation without the determination of Clemenceau, France's prime minister at the time.

DOME OF SPACE AND TIME, 2003—04

Dome of Space and Time shows a panorama of Robinson's country at Springbrook in northern New South Wales, moving from the Nerang River near Beechmont at the left across to Tallanbanna and on to Mount Warning at the far right. The predominating colours are the yellow of sunlight and the purple of sunset: these occur right across the three canvases. The pictures show sky, sea, mountains, the diversity of the rainforest, sunrise, sunset and stars. The trees and rocks on the mountains and hillsides are picked out by bursts of sun revealing dazzling swathes of orange-brown, a sudden flash of the green of ferns and foliage. There are no animals, birds or human beings. You feel these

Dome of Space and Time, William Robinson, 2003–04

creatures are too transient to earn a place here, for this is about the planet Earth, Gaia, turning through space.

In the first panel it is dawn in the upper left, night and stars down right. The day soars up and across the centre canvas, wheeling down across the third to descend again to night in the bottom right-hand corner. The green, purple, blue of night, the white and yellow of day, the variety of colour, the shape of the earth with its hills and valleys and distant sea are hauntingly beautiful. 'My God,' you think as you stand before it, 'this is us. This is our planet. We live here.' And once you've gazed wonderingly for a spell the thought occurs, 'May it continue so.'

ENVOI

So here we are at the end of this book in which I've tried to share the important place that the art of painting has had in my life, the life of a theatre worker also trying to be an artist—albeit an interpretative rather than a creative one. Also, like the artists about whom I've written, continually striving to do it better. The greatest accolade one can receive is to have someone say, 'You changed my life.' I think that's what we're all trying to do—we want our work to enlarge people's lives, to expand their horizons.

In 1994, in a public conversation with the art historian and publisher Lou Klepac, at the Ray Hughes Gallery in Sydney, William Robinson said:

> *I think the greatest responsibility of painters now—paintings have always been about political issues or personal issues in some deep way—is the issue of the earth … not urban issues and city streets issues but the issue of the air, the water, all of these things. These are the real political issues now.*

So it's good to end with a living artist, one who not only paints exceptionally beautiful pictures but who also has something urgent to say about the greatest crisis now confronting mankind.

Art is always, and always must be, about now.

ACKNOWLEDGMENTS

I would like to offer special thanks to Caroline Blakiston, Peter Cooke, Lou Klepac, Bruce Semler, John Turnbull, my editors Anouska Jones and Sophia Oravecz, and all the other lovely people at Murdoch Books.

APPENDIX:
THE PAINTERS AND THEIR PAINTINGS

The following is an alphabetical list of the artists in this book, together with their featured pictures. I have also included the current location of each painting, in case you fancy visiting them yourself.

Sandro Botticelli (1445–1510)
Venus and Mars (1485)
egg tempera and oil on poplar, 69.2 x 173.4 cm
National Gallery, London

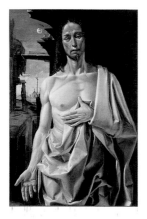

Bramantino (Bartolomeo Suardi)
(1465–1530)
The Resurrected Christ (1490)
oil on panel, 109 x 73 cm
Museo Thyssen-Bornemisza, Madrid

Agnolo Bronzino (1503–72)
An Allegory with Venus and Cupid (1540–45)
oil on wood, 146.5 x 116.8 cm
National Gallery, London

Michelangelo Merisi da Caravaggio (1571–1611)
Supper at Emmaus (1601)
oil and egg tempera on canvas, 141 x 196.2 cm
National Gallery, London

Michelangelo Merisi da Caravaggio (1571–1611)
Supper at Emmaus (1606)
oil on canvas, 141 x 175 cm
Pinacoteca di Brera, Milan

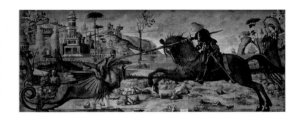

Vittore Carpaccio (1455–1526)
St George and the Dragon (c. 1507)
oil on canvas, 141 x 360 cm
Scuola di San Giorgio degli Schiavoni, Venice

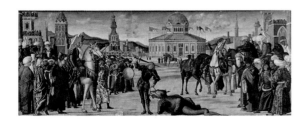

Vittore Carpaccio (1455–1526)
The Triumph of St George (c. 1507)
oil on canvas, 141 x 360 cm
Scuola di San Giorgio degli Schiavoni, Venice

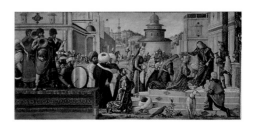

Vittore Carpaccio (1455–1526)
The Conversion of the Selenites (c. 1507)
oil on canvas, 141 x 285 cm
Scuola di San Giorgio degli Schiavoni, Venice

Paul Cézanne (1839–1906)
Lake Annecy (1896)
oil on canvas, 65 x 81 cm
Samuel Courtauld Trust, Courtauld Institute of Art Gallery, London

Lucas Cranach (1472–1553)
Cupid Complaining to Venus (c. 1527)
oil on wood, 82.1 x 55.8 cm
National Gallery, London

Russell Drysdale (1912–81)
The Rabbiter and His Family (1938)
oil on canvas, 61.5 x 76.7 cm
National Gallery of Australia, Canberra

Russell Drysdale (1912–81)
Joe (1950)
oil on canvas, 71.1 x 91.5 cm
Private collection

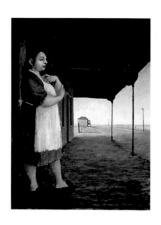

Russell Drysdale (1912–81)
Maria (1950)
oil on canvas, 99 x 76.2 cm
Private collection

Russell Drysdale (1912–81)
Snake Bay at Night (1959)
oil on canvas, 127 x 101.6 cm
Tasmanian Museum and Art Gallery, Hobart

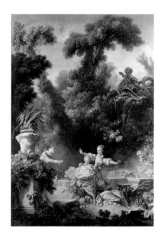

Jean-Honoré Fragonard (1732–1806)
The Pursuit (1771–73)
oil on canvas, 317.8 x 215.5 cm
The Frick Collection, New York

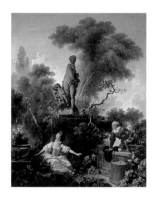

Jean-Honoré Fragonard (1732–1806)
The Meeting (1771–73)
oil on canvas, 317.5 x 243.8 cm
The Frick Collection, New York

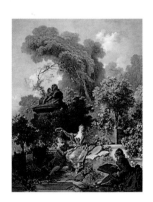

Jean-Honoré Fragonard (1732–1806)
The Lover Crowned (1771–73)
oil on canvas, 317.8 x 243.2 cm
The Frick Collection, New York

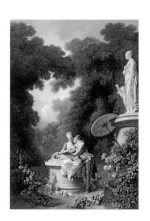

Jean-Honoré Fragonard (1732–1806)
Love Letters (1771–73)
oil on canvas, 317.1 x 216.8 cm
The Frick Collection, New York

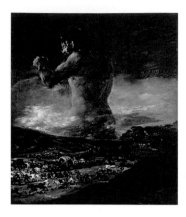

Francisco Goya (1746–1828)
The Colossus (1811)
oil on canvas, 116 x 105 cm
Prado, Madrid

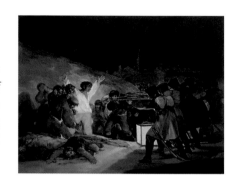

Francisco Goya (1746–1828)
*The Executions of the Third of
May, 1808* (1814)
oil on canvas, 268 x 347 cm
Prado, Madrid

Francisco Goya (1746–1828)
'The Black Paintings' (1821–23),
originally murals on plaster, remounted on canvas

The Witchy Brew
oil on canvas, 53 x 85 cm
Prado, Madrid

The Dog
oil on canvas, 131 x 79 cm
Prado, Madrid

Saturn Devouring One of His Sons
oil on canvas, 146 x 83 cm
Prado, Madrid

Duel with Clubs
oil on canvas, 125 x 261 cm
Prado, Madrid

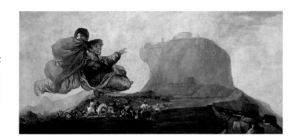

Asmodeus
oil on canvas, 127 x 263 cm
Prado, Madrid

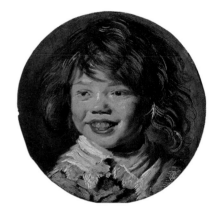

Frans Hals (1580–1666)
The Laughing Boy (1625)
oil on canvas, 30.45 cm diameter (circular painting)
Royal Cabinet of Paintings, Mauritshuis, The Hague

Frans Hals (1580–1666)
*The Regentesses of the Old Men's
Almshouse* (1664)
oil on canvas, 172.5 x 256 cm
Frans Hals Museum, Haarlem

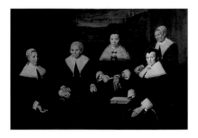

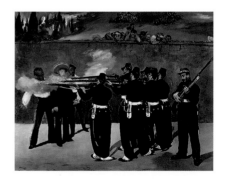

Edouard Manet (1832–83)
The Execution of the Emperor Maximilian (1868–69)
oil on canvas, 252 x 305 cm
Stadtische Kunsthalle, Mannheim

Sidney Nolan (1917–92)
Inland Australia (1950)
oil on hardboard, 121.5 x 152 cm
Tate Gallery, London

 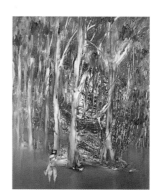

Sidney Nolan (1917–92)
Riverbend I, Panels 1, 2, 3 and 4 (1964–65)
oil on board, nine panels, each panel 152.5 x 122 cm
Australian National University Art Collection, Canberra

Sidney Nolan (1917–92)
Chinese Mountain Landscape with Three Boats (1982)
acrylic and lacquer spray on canvas, 183 x 160 cm
Private collection

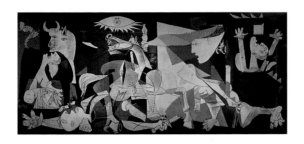

Pablo **Picasso** (1881–1973)
Guernica (1937)
oil on canvas, 349.3 x 776 cm
Museo Nacional Centro de Arte Reina Sofia, Madrid

Pablo Picasso (1881–1973)
Massacre in Korea (1951)
oil on plywood, 110 x 210 cm,
Musée Picasso, Paris

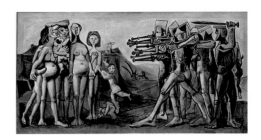

Camille Pissarro (1830–1903)
Peasants' Houses, Eragny (1887)
oil on canvas, 59 x 71.7 cm
Art Gallery of New South Wales, Sydney

Camille Pissarro (1830–1903)
Peasant Girl Lighting a Fire, Frost (1888)
oil on canvas, 92.8 x 92.5 cm
Musée d'Orsay, Paris

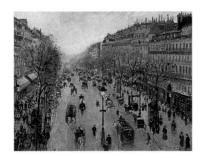

Camille Pissarro (1830–1903)
Boulevard Montmartre, Morning, Cloudy Weather (1897)
oil on canvas, 73 x 92 cm
National Gallery of Victoria, Melbourne

Rembrandt van Rijn (1606–69)
The Polish Rider (1655)
oil on canvas, 116.8 x 134.9 cm
The Frick Collection, New York

Rembrandt van Rijn (1606–69)
Woman with a Pink (early 1660s)
oil on canvas, 92.1 x 74.6 cm
The Metropolitan Museum of Art,
New York

Rembrandt van Rijn (1606–69)
Man with a Magnifying Glass (early 1660s)
oil on canvas, 91.4 x 74.3 cm
The Metropolitan Museum of Art, New York

William Robinson (1936–)
Farm I (1982)
oil on canvas, 131.5 x 193.5 cm
Private collection

William Robinson (1936–)
Four Seasons, Panel 1 (1987)
oil on canvas, 137.5 x 188 cm
Queensland Art Gallery, Brisbane

William Robinson (1936–)
Four Seasons, Panel 2 (1987)
oil on canvas, 137.5 x 188 cm
Queensland Art Gallery, Brisbane

William Robinson (1936–)
Four Seasons, Panel 3 (1987)
oil on canvas, 137.5 x 188 cm
Queensland Art Gallery, Brisbane

William Robinson (1936–)
Four Seasons, Panel 4 (1987)
oil on canvas, 137.5 x 188 cm
Queensland Art Gallery, Brisbane

William Robinson (1936–)
Dome of Space and Time (2003–04)
oil on canvas, 152 x 640 cm
Collection of the artist

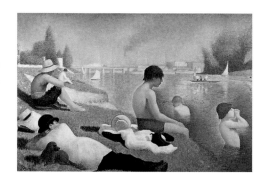

Georges Seurat (1859–91)
Bathers at Asnières (1883–84)
oil on canvas, 201 x 301.5 cm
National Gallery, London

Georges Seurat (1859–91)
La Poudreuse (1890)
oil on canvas, 95.5 x 79.5 cm
Samuel Courtauld Trust, Courtauld
Institute of Art Gallery, London

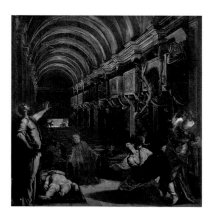

Jacopo Tintoretto (1518–94)
The Discovery of St Mark's Body (1562–66)
oil on canvas, 157.4 x 157.4 cm
Pinacoteca di Brera, Milan

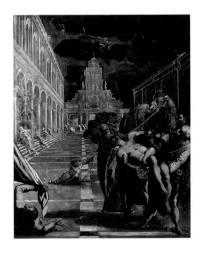

Jacopo Tintoretto (1518–94)
The Stealing of the Body of St Mark (1562–66)
oil on canvas, 397 x 315 cm
Gallerie dell'Accademia, Venice

Jacopo Tintoretto (1518–94)
The Crucifixion of Christ (1565)
oil on canvas, 536 x 1224 cm
Scuola Grande di San Rocco, Venice

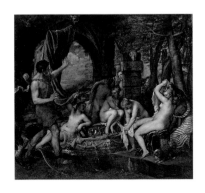

Titian (Tiziano Vecellio) (1488–1576)
Diana and Actaeon (1559)
oil on canvas, 93 x 97 cm
National Gallery of Scotland, Edinburgh

Titian (Tiziano Vecellio) (1488–1576)
The Death of Actaeon (1565)
oil on canvas, 175.8 x 197.8 cm
National Gallery, London

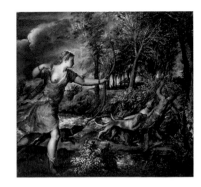

PICTURE CREDITS

Diana and Actaeon, Titian (Tiziano Vecellio), purchased jointly by the National Galleries of Scotland and the National Gallery, London, with the aid of the Scottish Government, the National Heritage Memorial Fund, The Monument Trust, The Art Fund, and through public appeal, 2009.
Dome of Space and Time (William Robinson) courtesy of William Robinson and Philip Bacon Galleries.
Four Seasons (William Robinson) commissioned 1987 with funds from the Australian and New Zealand Banking Group Limited on the occasion of Australia's Bicentenary 1988, Queensland Art Gallery. Image courtesy of William Robinson and Philip Bacon Galleries.
Farm 1 (William Robinson) held in private collection. Photographed by Jenni Carter.
Joe and *Maria* (Russell Drysdale) held in private collection. Images courtesy of the National Gallery of Victoria.
Alamy: pages 76–7
Bridgeman Art Library: pages 20, 24, 28–9, 33, 52–53, 58–9, 60–1, 67, 68, 71, 79, 82–3, 84–5, 86–7, 100, 120, 123, 127, 132–3, 140–1, 144, 156, 160, 182, 189
Corbis: pages 41, 45, 46, 149

TEXT CREDITS

Every effort has been made to trace and contact the copyright holders prior to publication. If notified, the publisher undertakes to rectify any errors or omissions at the earliest opportunity. The Publisher gratefully acknowledges the following sources:

Page 4: 'Letter to Lord Byron', copyright 1937 by W.H. Auden, 'Spain 1937', copyright 1940 and renewed 1968 by W.H. Auden, from *Collected Poems*, W.H. Auden. Used by permission of Random House, Inc.
Page 7: 'Most of the time now we settle for half and I like it better.' *A View From The Bridge*, Arthur Miller, 1956.
Page 7: 'Make voyages. Attempt them. There's nothing else.', *Camino Real* by Tennessee Williams. As 'Ten Blocks from Camino Real' (a one-act play), copyright © 1948 by the University of the South. As 'Camino Real,' revised and published version, copyright © 1953 by the University of the South. Reprinted by permission of Georges Borchardt, Inc. for the Estate of Tennessee Williams.
Page 34: 'Don't look at a picture, reaching out with your eyes, let the picture look at you. Some detail, which I call "a port of entry", will jump out and engage your attention', *The Naked Lunch*, William S. Burroughs, Grove Press, 1959.
Page 35: 'Spain 1937', *Another Time*, W.H. Auden, Faber and Random House, 1940.
Page 74: 'Whispers of Immortality', *Collected Poems 1909-1962*, T.S. Eliot, Faber & Faber, 1974.
Page 78: '...somewhat like Katharine Hepburn far gone in old age', *Goya*, Robert Hughes, Alfred A. Knopf/Vintage, 2003.
Page 89: 'Someone ought to stand with a hammer at the door of every happy contented man, continually banging on it to remind him that there are unhappy people around and that however happy he may be ... sooner or later life will show him its claws ... ' page 22, *The Kiss and Other Stories* by Anton Chekhov, translated by Ronald Wilks (Penguin 1982) Copyright © Ronald Wilks, 1982. Reproduced by permission of Penguin Books.
Page 165: 'Fern Hill', *Deaths and Entrances*, Dylan Thomas, Dent, 1946. Reproduced with permission from David Higham Associates.

BIBLIOGRAPHY

Bacchesi, Ed, *Bronzino*, Rizzoli, 1973

Benesch, Otto, *Rembrandt*, Skira, 1957

Berenson, Bernard, *The Passionate Sightseer*, Thames & Hudson, 1960

Berger, John, *Ways of Seeing*, Penguin, 1972

Bonnafaux, Pascal, *The Impressionists – Portraits and Confidences*, Weidenfeld & Nicholson, 1986

Cabanne, Pierre, *Edgar Degas*, Pierre Tisné, 1958

Clark, Kenneth, *Leonardo da Vinci*, Penguin, 1959

—— *Civilisation*, John Murray, 1969

Clay, Jean, *Romanticism*, Phaidon, 1981

Druick, Douglas W. and Zegers, Peter Kort, *Van Gogh and Gauguin – The Studio of the South*, Thames & Hudson, 2001

Düchting, Hajo, *Seurat*, Taschen, 2000

Dupont, Jacques and Mathey, François, *The Seventeenth Century*, Skira, 1951

Erftemeijer, Antoon, *The Frans Hals Museum*, Ludion, 2003

—— *Frans Hals*, Ludion, 2004

Essers, Volknar, *Matisse*, Taschen, 2002

Fern, Lynn, *William Robinson*, Craftsman House, 1995

Ferrari, Enrique, *Goya*, Thames & Hudson, 1962

Heckes, Frank I., *Reason and Folly*, National Gallery of Victoria, 1990

Howard, Michael (ed.), *The Impressionists—By Themselves*, Conran Octopus, 1991

Hughes, Robert, *Goya*, The Harvill Press, 2003

Janson, W.W., *The Picture History of Painting*, Thames & Hudson, 1928

Junquera, Juan Jose, *The Black Paintings of Goya*, Scala, 2003

Klepac, Lou, *The Drawings of Russell Drysdale*, National Gallery of Western Australia, 1980

—— *Russell Drysdale*, Bay Books, 1983

—— *William Robinson*, The Beagle Press, 2001

Lee, Simon, *David*, Phaidon, 1999

Leighton, John, *100 Masterpieces in the Van Gogh Museum*, Van Gogh Museum Enterprises, 2002

Levey, Michael, J., *From Giotto to Cézanne*, Thames & Hudson, 1962

Leymarie, Jean, *Impressionism*, Skira, 1955

Myers, Bernard, S. (ed.), *Encyclopedia of Painting*, Hutchinson, 1956

Murdoch, John, *The Courtauld Institute*, Courtauld and Thames & Hudson, 1998

Murphy, Richard, *The World of Cézanne*, Time Life, 1968

Pearce, Barry, *Sidney Nolan*, Art Gallery of New South Wales, 2007

Perez Sachez, Alfonso E., *The Prado*, Scala, 2000

Pignatti, Terisio, *Carpaccio*, Skira, 1958

Prideaux, Tom, *The World of Delacroix*, Time Life, 1966

Raynal, Maurice, *The Nineteenth Century*, Skira, 1951

—— *Picasso*, Skira, 1953

Read, Herbert, *A Concise History of Modern Painting*, Thames & Hudson, 1959

Robb, Peter, *M*, Duffy and Snellgrove, 1998

Ruhmer, E, *Cranach*, Phaidon, 1963

Russell, John, *The World of Matisse*, Time Life, 1969

Schama, Simon, *Rembrandt's Eyes*, Allen Lane and Penguin Press, 1999

Smith, Geoffrey, *Russell Drysdale*, National Gallery of Victoria, 1997

—— *Sidney Nolan—Desert and Drought*, National Gallery of Victoria, 2003

Suh, H. Anna (ed.), *Vincent Van Gogh – A Self-portrait in Art and Letters*, Black Dog & Leventhal, 2006

Thullier, Jacques, *Fragonard*, Skira, 1967

Valcanoer, Francesco, *Jacopo Tintoretto and the Scuola di San Rocco*, Starti, 1983

—— *Carpaccio*, Scala, 1984

Wadia, Bettina, *Botticelli*, Hamlyn, 1970

Williams, Jay, *The World of Titian*, Time Life, 1968

Wilson-Smith, Timothy, *Caravaggio*, Phaidon, 1998

INDEX

Page numbers in *italics* indicate
Illustrations.

Published in 2009 by Murdoch Books Pty Limited

Murdoch Books Australia
Pier 8/9
23 Hickson Road
Millers Point NSW 2000
Phone: +61 (0) 2 8220 2000
Fax: +61 (0) 2 8220 2558
www.murdochbooks.com.au

Murdoch Books UK Limited
Erico House, 6th Floor
93–99 Upper Richmond Road
Putney, London SW15 2TG
Phone: +44 (0) 20 8785 5995
Fax: +44 (0) 20 8785 5985
www.murdochbooks.co.uk

Publishing Director: Kay Scarlett
Project Editor: Sophia Oravecz
Designer: Hugh Ford

National Library of Australia Cataloguing-in-Publication Data

Author: Cottrell, Richard
Title: Looking at paintings : a private view / Richard Cottrell.
ISBN: 9781741964868
Notes: Includes index.
 Bibliography.
Subjects: Art appreciation.
 Painting--History.
 Painting--Technique--History
Dewey Number: 701.1

A catalogue record for this book is available from the British Library.

Printed in 2009. PRINTED IN CHINA.